A COMPLETE GUIDE TO
SPECIAL EFFECTS MAKEUP

A Complete Guide to Special Effects Makeup
– Conceptual Creations by Japanese Makeup Artists –
by Tokyo SFX Makeup Workshop
ISBN: 9781781161449

Published by Titan Books
A division of Titan Publishing Group Ltd.
144 Southwark Street
London
SE1 0UP

First Titan edition: May 2012
10 9 8 7 6 5

Original layout and cover design:	Kazuki Kamiyama
Planning and editing:	Sahoko Hyakutake (Graphic-Sha Publishing Co., Ltd.)
Editor:	Yuko Sasaki
English edition layout:	Shinichi Ishioka
English translation management:	Língua fránca, Inc.
Project coordinator:	Kumiko Sakamoto (Graphic-Sha Publishing Co., Ltd.)

Did you enjoy this book? We love to hear from our readers. Please email us at readerfeedback@titanemail.com or write to us at Reader Feedback at the above address.

To receive advance information, news, competitions, and exclusive offers online, please sign up for the Titan newsletter on our website: www.titanbooks.com

A CIP catalogue record for this title is available from the British Library.

Printed and bound in China.

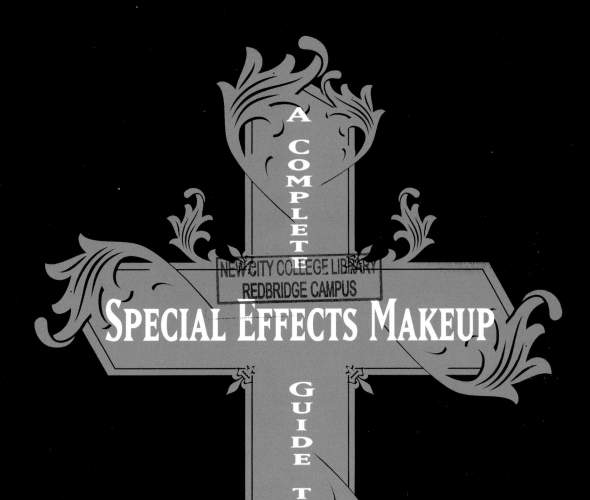

A COMPLETE

GUIDE TO

SPECIAL EFFECTS MAKEUP

Contents

004 Creature Gallery

019 Chapter 01 Basic Makeup and Cuts, Gashes & Scars

Basic Makeup and Common Looks

020 01 Young Girl

021 02 Touch of Impishness

022 03 Goth Look in the Style of Wednesday Addams

023 04 Shojo Manga-Look

024 05 Goth Eyes

Hair

026 01 Well-bred, Ladylike-Look

027 02 Lolita-Style Braids

028 03 Genteel Ringlets

Cuts, Gashes & Scars

029 01 Arm Scratches Created Using Paint

030 02 Flesh Carving Created Using Brushes

031 03 Scars Created Using Keloskin

032 04 Welts Created Using Cabosil

033 05 Chest Cross Created Using Wax

034 06 Face with Deep Gashes

036 07 Metal Objects Buried in Flesh: Bolt in the Arm

037 08 Lacerated Neck

038 09 Pierced Collarbones

039 Chapter 02 Masks

040 Flamboyant Mask with Feathers

042 Masquerade Ball Mask with Pearls and Feathers

044 Hard, Skull-Fragment Mask

046 Mask Made of a Purchased Skull and Clay with a Proboscis

048 Gruesome Leather Mask Reminiscent of a Medieval Torture Device

050 Cloth Mask of a "Little House on the Prairie" Style Girl

052 Paper Mask Reminiscent of an Elementary School Student's Arts-and-Crafts Project

054 Artificial Flower Used as an Accent on a Modifiable, Easy Mask
056 Mask of a Nun with Googly Eyes Attached Directly to Latex
058 Otherworldly Mask of Sharp Metal Reflecting on White Flesh
062 Advanced-Level Mask Made Using a Vacuform
064 Unique Accessories and Shoes

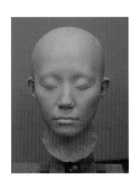

070 Chapter 03 Making Molds

071 Mold-making Process
072 Making a Mold of a Face
074 Making a Mold of a Hand
075 Making a Mold of Teeth
076 The Process from Sculpting to Completing the Foam Latex Appliance
079 Hollywood-Style Mold-making

081 Chapter 04 Practical Application

082 Catlike Hands
086 Catlike Ears
088 Fangs
091 Elongated Fingers
093 Artificial Eyes
096 Demonic Ears
100 Zombies
106 Cat
109 Fantastic Creatures
116 Body Carvings
124 Vampire

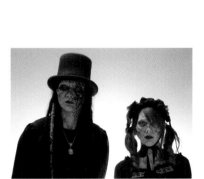

Appendix

128 Making Sculpting Tools
129 Interview with the Special Effects Makeup Master of Japanese Horror, Yuuichi Matsui
133 Special Effects Makeup Glossary
135 List of Materials Vendors
136 Author's Profile

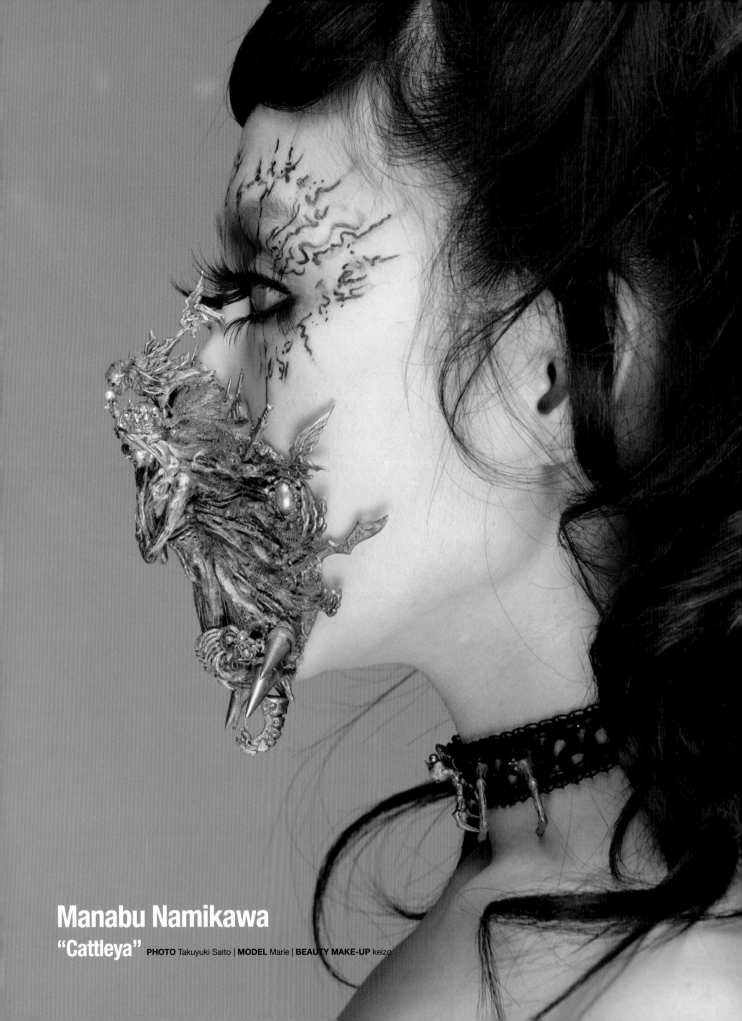

Manabu Namikawa
"Cattleya"
PHOTO Takuyuki Saito | **MODEL** Marie | **BEAUTY MAKE-UP** keizo

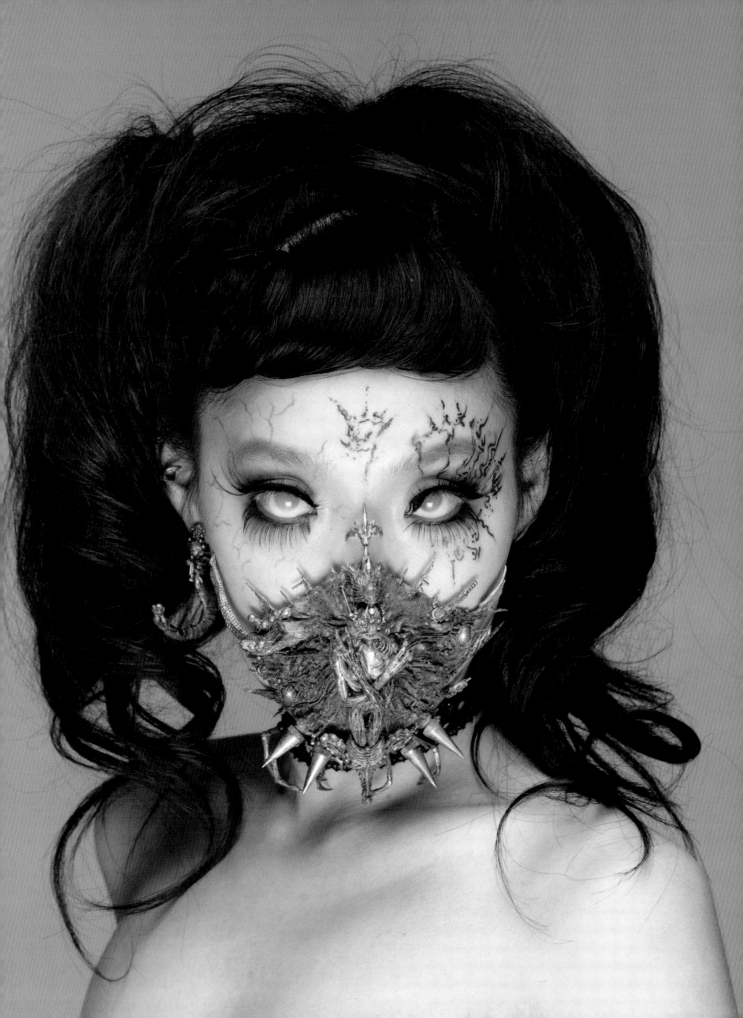

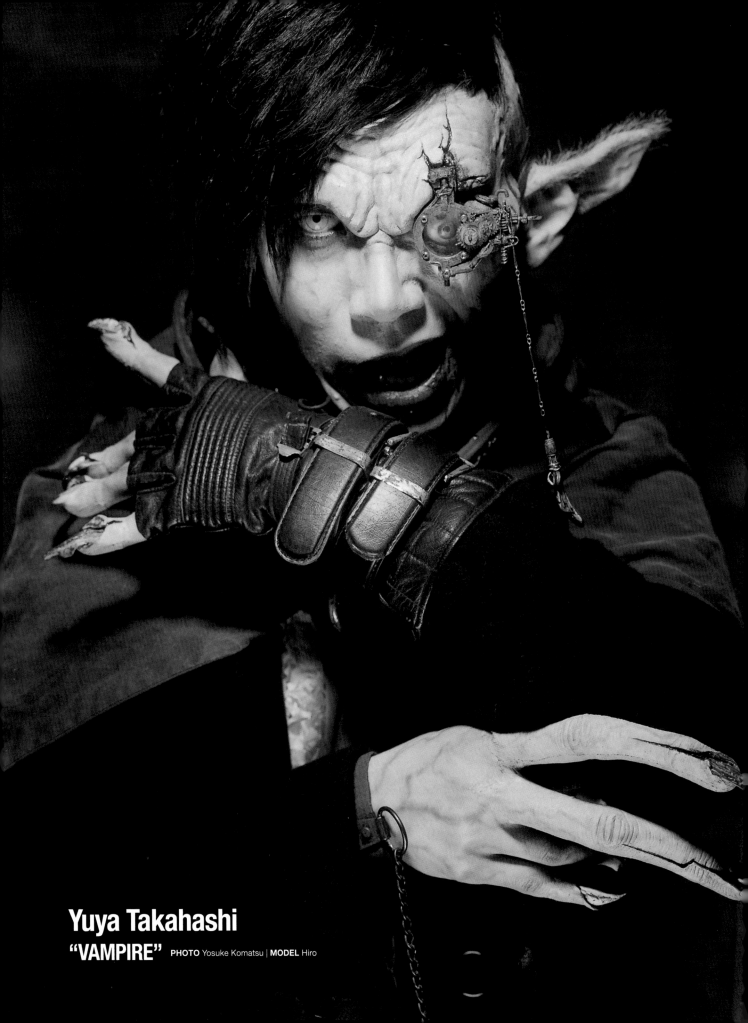

Yuya Takahashi
"VAMPIRE" **PHOTO** Yosuke Komatsu | **MODEL** Hiro

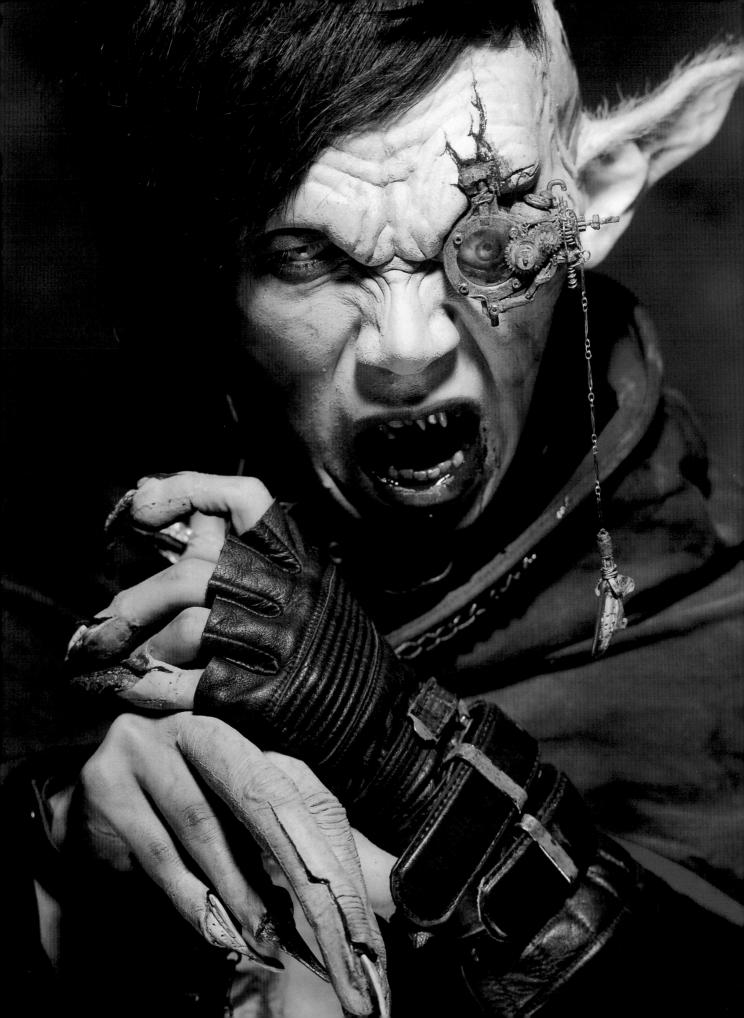

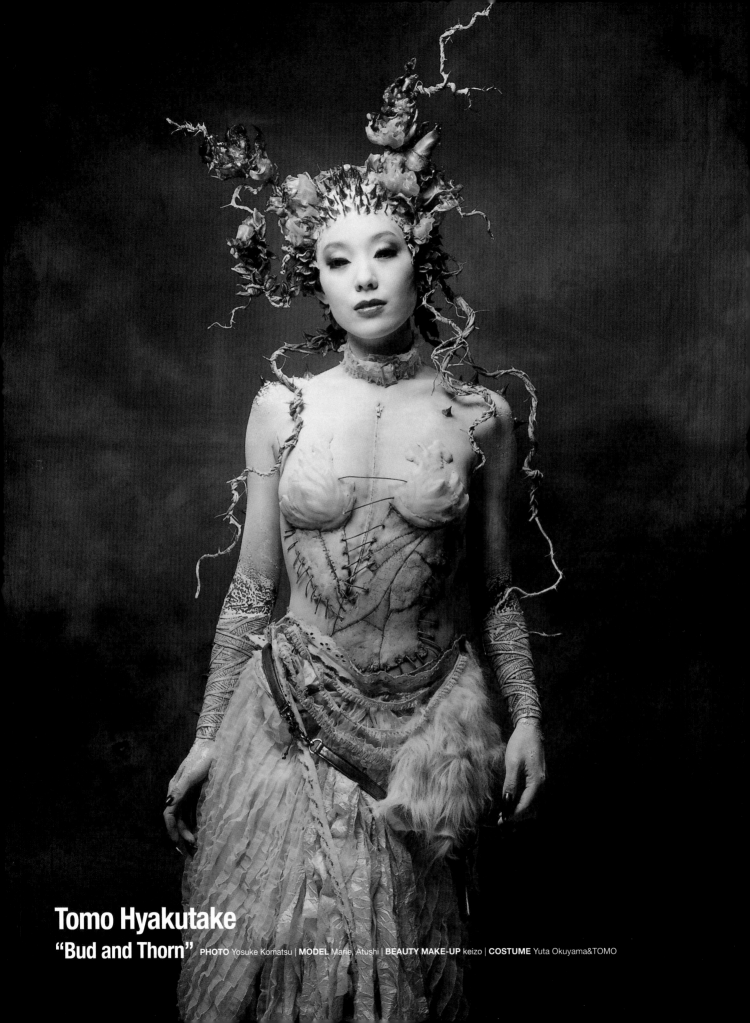

Tomo Hyakutake
"Bud and Thorn"
PHOTO Yosuke Komatsu | **MODEL** Marie, Atushi | **BEAUTY MAKE-UP** keizo | **COSTUME** Yuta Okuyama&TOMO

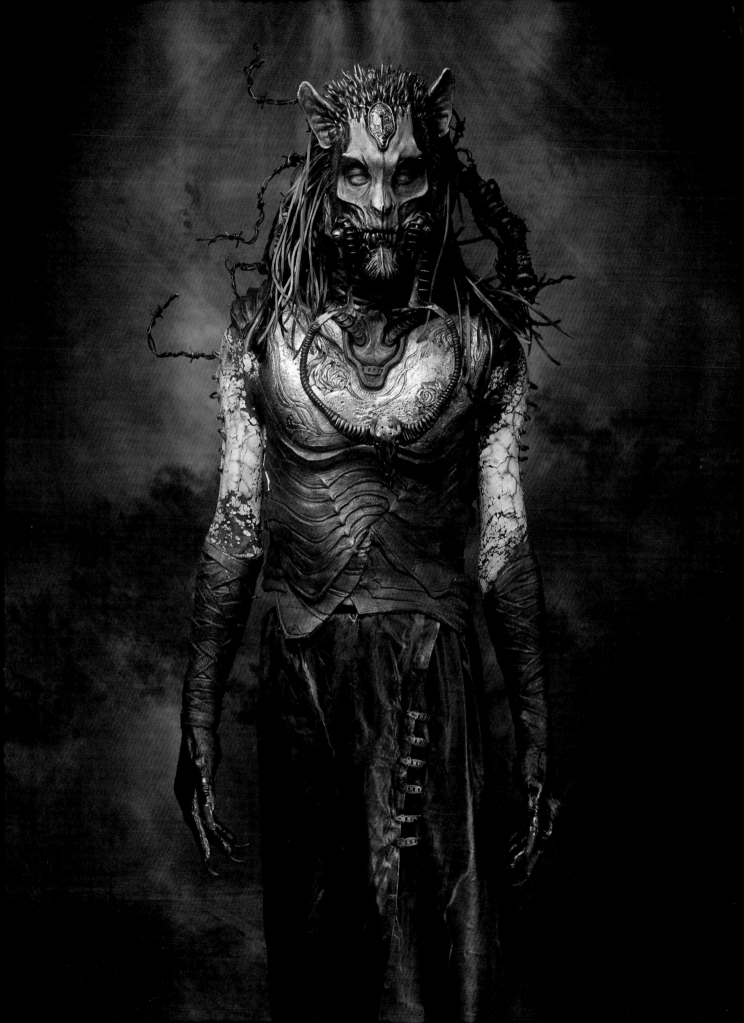

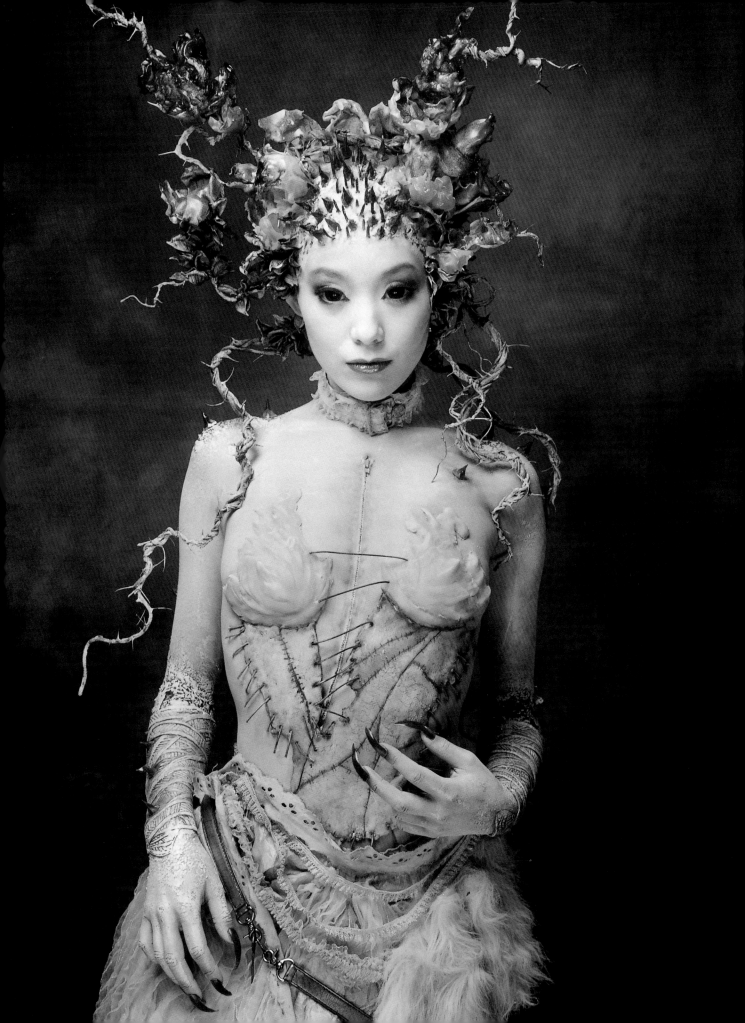

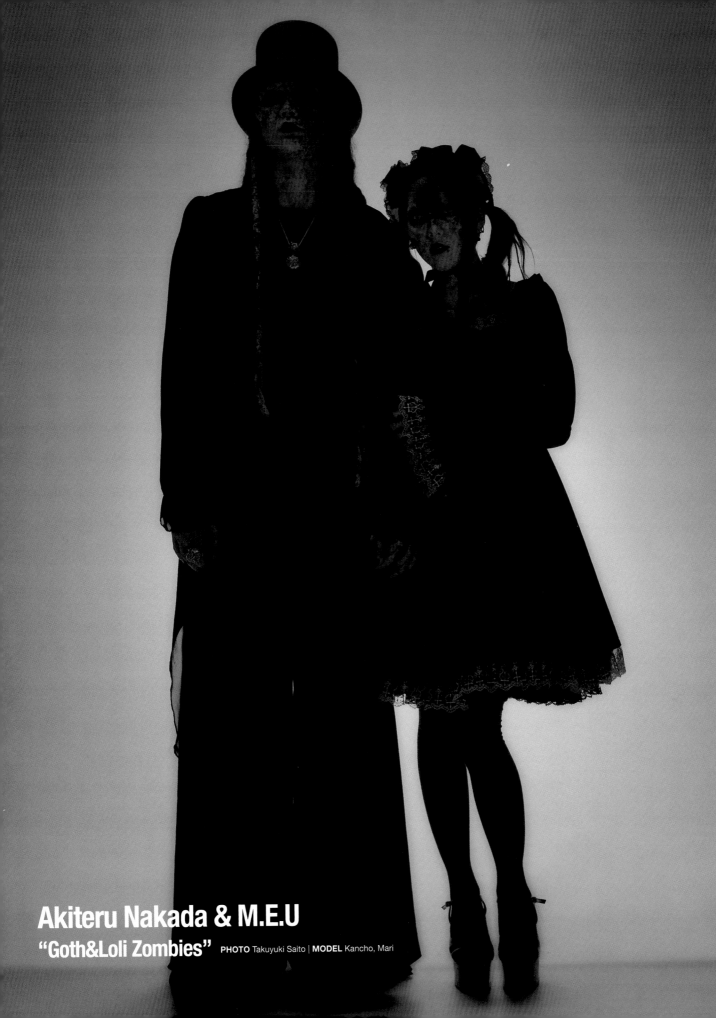

Akiteru Nakada & M.E.U
"Goth&Loli Zombies" PHOTO Takuyuki Saito | MODEL Kancho, Mari

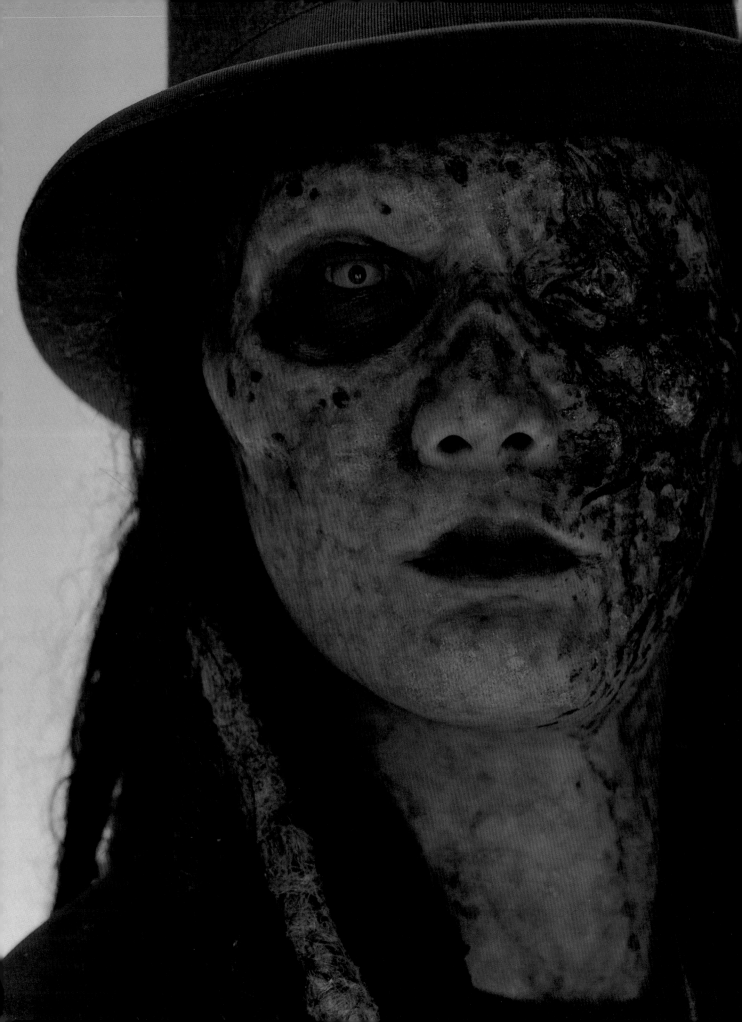

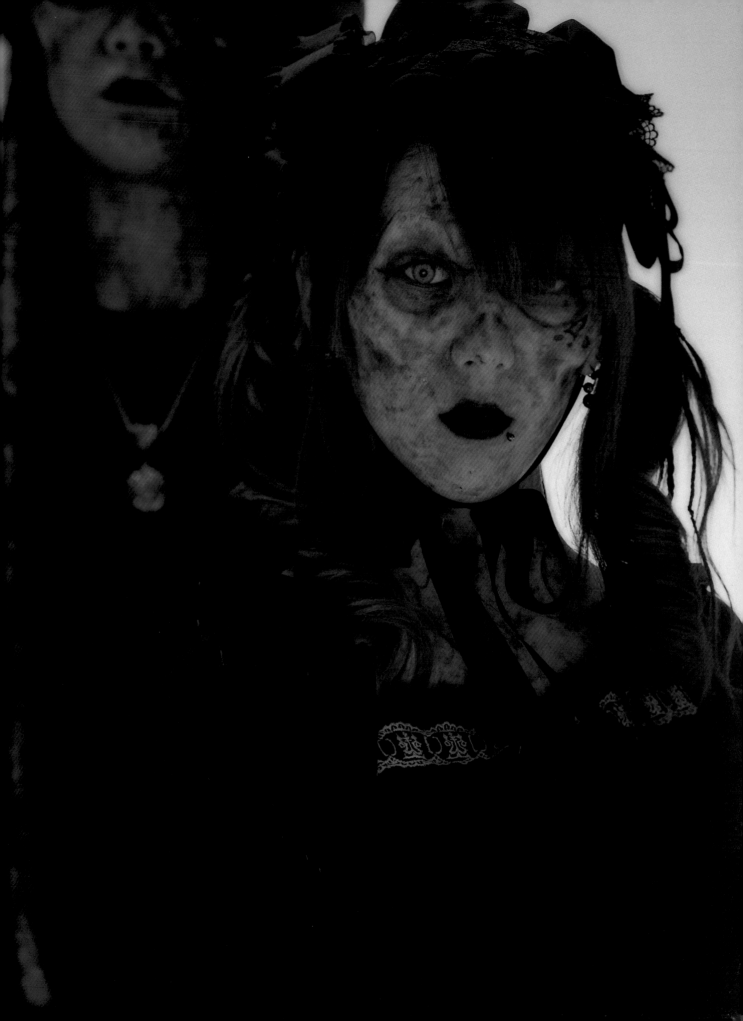

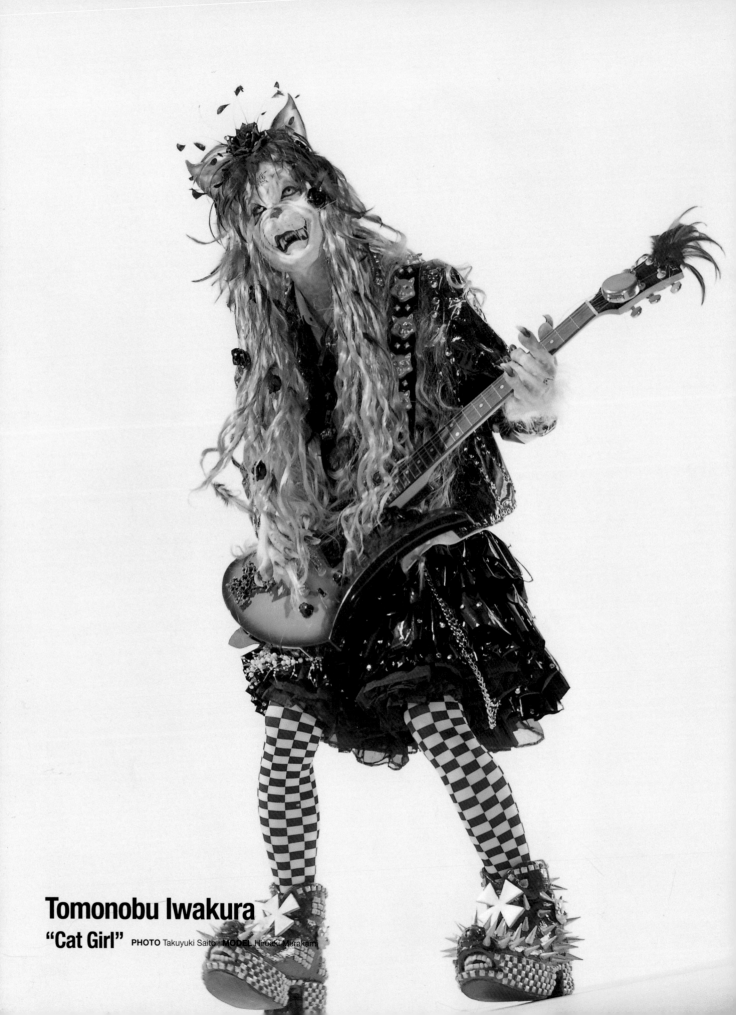

Tomonobu Iwakura

"Cat Girl" PHOTO Takuyuki Saito | MODEL Hiroaki Murakami

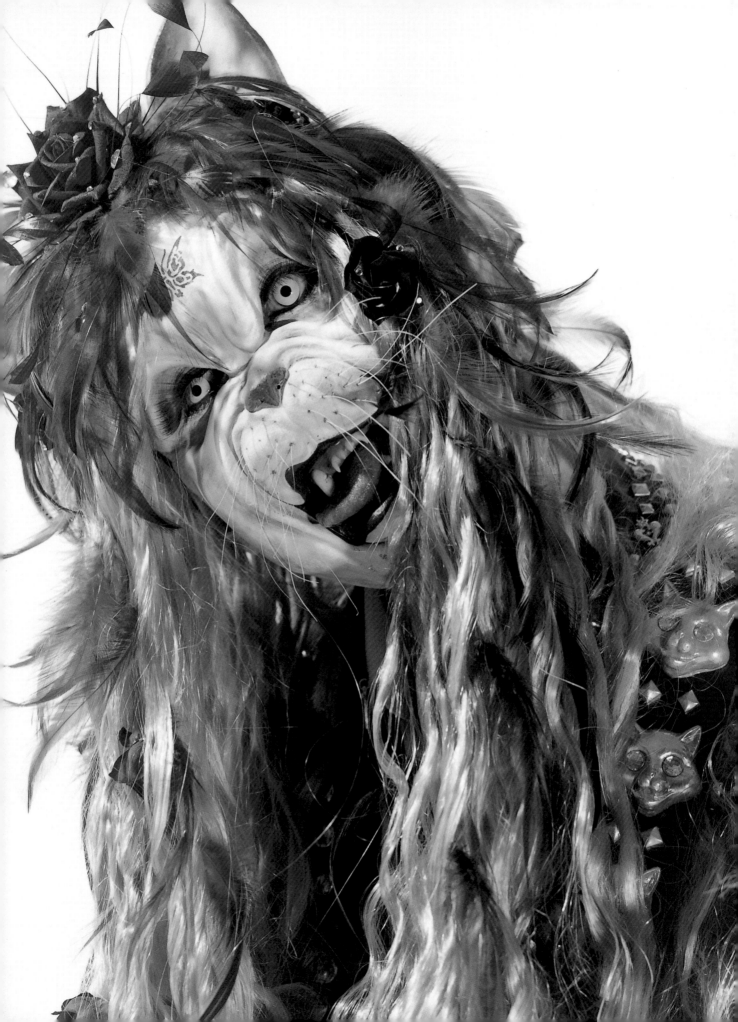

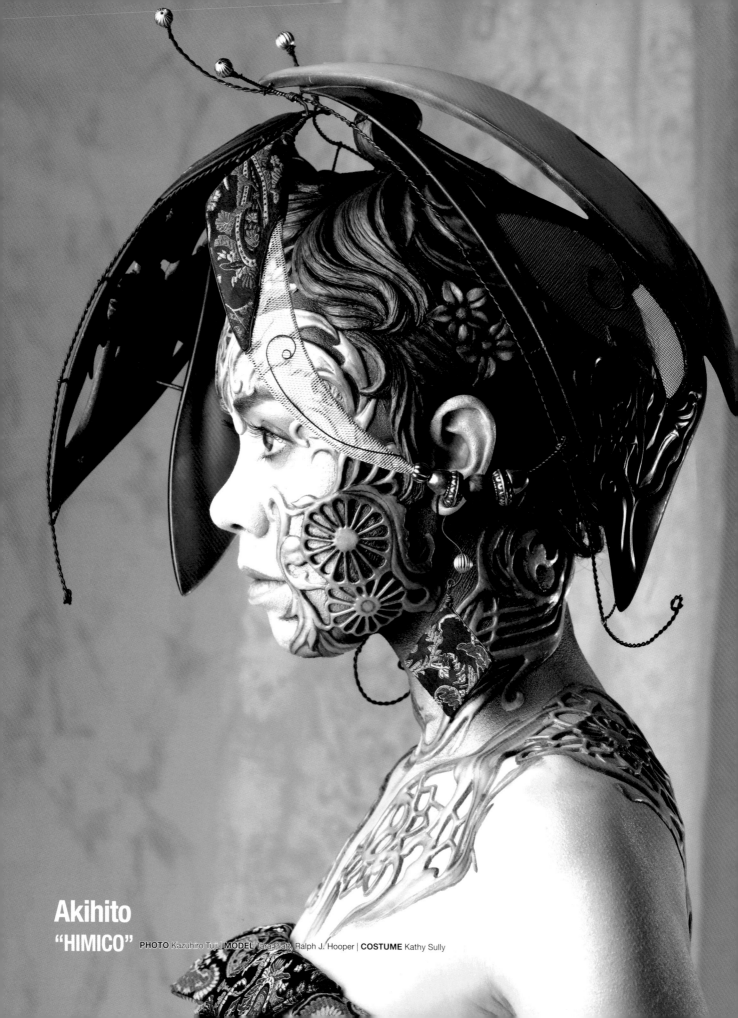

Akihito
"HIMICO" **PHOTO** Kazuhiro Tuji | **MODEL** Tara Platt, Ralph J. Hooper | **COSTUME** Kathy Sully

"ARA"

"Hu-Bi"

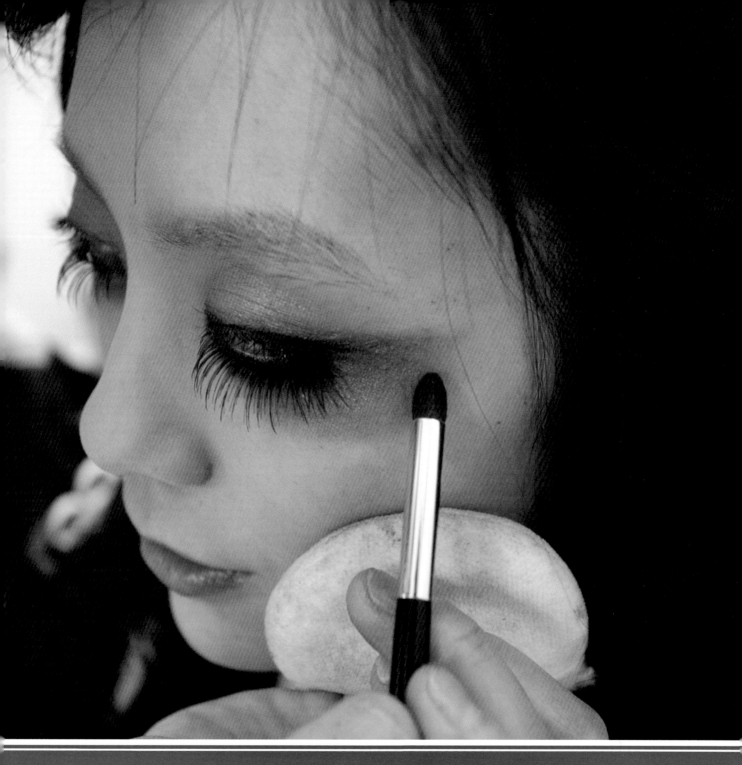

Basic Makeup and Cuts, Gashes & Scars

Chapter 01

Basic Makeup · Featured Artist: Keiko Nakanishi

This section starts by presenting the basic look that forms the foundation for all other looks. When recreating any of the variation makeup looks that appear on the following pages, always begin with the basic look presented on this page. Feel free to select whatever foundation and eyeliner best suits the model's skin tone.

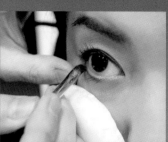

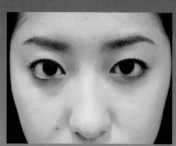

1. Apply a liquid foundation, concealer, and then a dry, pressed foundation in that order. White foundations tend to make the face look big, so select a foundation that matches the model's natural skin tone. After applying the dry, pressed foundation, use face powder to add highlights.

2. Apply black liquid eyeliner to the rim of the upper eyelid so as to fill in the gaps between the individual eyelashes. Since using solely a liquid eyeliner tends to over-accentuate the eye, and because we, makeup artists have a predilection for applying eyeliner as a line, apply black pencil eyeliner over the liquid eyeliner and then smudge with a cotton swab to soften the line.

3. Apply black eyeliner to the lower eyelid's rim, starting from the outside corner from the eye and stopping approximately at the iris's center.

Basic Look Cosmetics Used
- Foundation (liquid foundation)
- White face powder to create highlights
- Stick concealer
- Eyeliner
- Eyebrow pencil

4. To complete the basic look, use an eyebrow pencil to shape the eyebrow.

Look 01 Young Girl

This look emphasizes a sense of lovely femininity in the model. Make effective use of a glossy color for the lips and pink for the cheeks so as to evoke a sweet, fresh atmosphere.

Cosmetics Used
- Two types of false eyelashes: One regular set and one set for the corners of the eyes (If false eyelashes specifically for the corners of the eyes are unavailable, then overlap two layers of regular eyelashes.)
- Pink lipstick
- Pink lip gloss

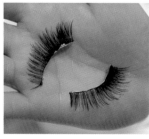

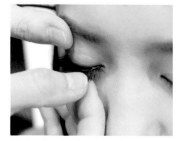

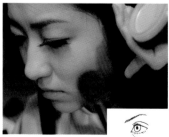

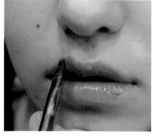

1. Using eyelash adhesive, apply regular, inexpensive false eyelashes that you can find at your local drugstore over the model's own eyelashes to create girlishly long eyelashes.

2. Once the adhesive gluing the two layers of false eyelashes from step [1] has finished drying, take a cotton swab and remove any oil or powder from the eyelid. Then apply the eyelashes to the eyelid's rim.

3. Lightly apply pink to the cheeks. Apply the blush using a large brush and using strokes following the directions that the arrows indicate in the diagram. Blend the blush's borders.

4. Apply pink lip gloss rather than lipstick. As a final touch, add an extra layer of gloss to the area of the upper lip that protrudes the most to create a more sensual look.

Look 02 Touch of Impishness

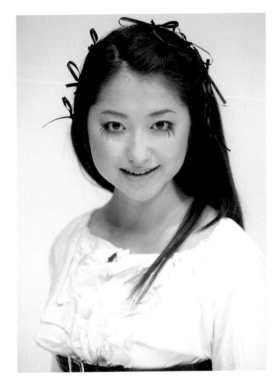

This look is an expansion on Look 01. The long lower lashes make the bottom portion of the eye appear even lower than it actually is, thereby making the eye look bigger. This creates a flirtatious, impish atmosphere. Giving the model bangs that end at the eyebrows would also suit this look.

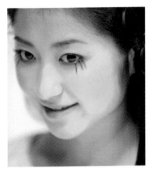

Cosmetics Used

- False eyelashes
- Eye shadow
- Blush
- Lipstick

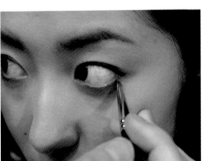

1. After making up the model in the "basic makeup" look presented on page 20, apply orange eye shadow so that it covers the entire lower eyelid, from the where black eyeliner has been applied to the eyelid rim. Blend where the black eyeliner and the orange eye shadow touch.

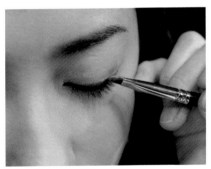

2. Once the adhesive gluing the two layers of false eyelashes from step [1] has finished drying, take a cotton swab and remove any oil or powder from the eyelid. Then apply the eyelashes to the eyelid's rim.

3 . Apply orange to the cheeks, using outward strokes and creating a triangle.

4. Make four clusters of two to three false eyelashes.

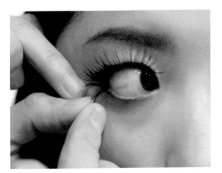

5. Attach two clusters of false eyelashes to the far corner of each lower eyelid.

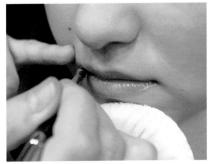

6. Apply pinkish-beige lipstick. Use a natural tone for the lips in order to emphasize the eyes.

Look 03 Goth Look in the Style of Wednesday Addams

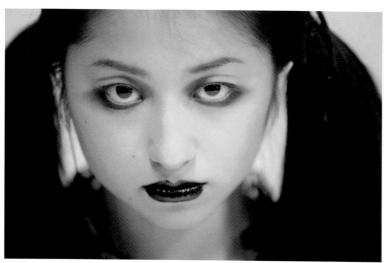

This look is reminiscent of Wednesday Addams, the daughter with the warped personality who came known to us through the movie, The Addams Family. Despite the overall black tones, the key points for this look lie in the downward slanting eyes and plump lips, which evoke a childlike atmosphere.

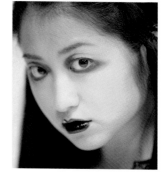

Cosmetics Used
- Black eyeliner
- Black eye shadow
- Black lipstick
- Lip gloss

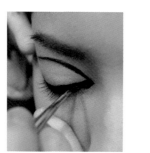

1. After making up the model in the "basic makeup" look presented on page 20, have the model close her eyes and trace the contour of the most sunken region in black eyeliner.

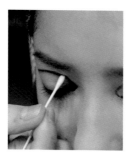

2. Use a cotton swab to blend the black eyeliner.

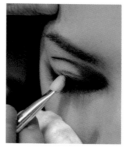

3. Apply black eye shadow, filling the space between the contour drawn in black eyeliner in step **1** and the inside corner of the eye. Blend the eye shadow as if creating a shadow on the eye (apply the eye shadow using strokes that trace over the contours created in eyeliner).

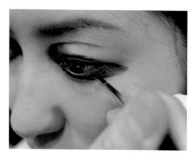

4. Create a lower eye contour underneath the lower eyelid. Allow the lower eye contour to extend past the far corner of the eye to give the eye a downward-slating appearance.

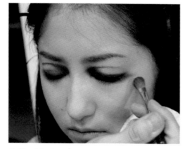

5. Use black eye shadow to soften the entirety of the lower eyelid contour.

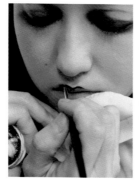

6. Color the lips using either black lipstick or lip liner. Apply lip liner to the lower lip's contour so as to straighten the lower contour. This gives the model an old-fashioned look. (The key point is to prevent black lipstick or lip liner from straying above or outside of the actual upper lip. The lip color should be applied only to the upper lip itself.)

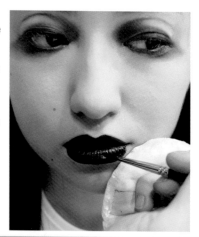

7. Add lip gloss to finish.

Look 04 Shojo Manga-Look

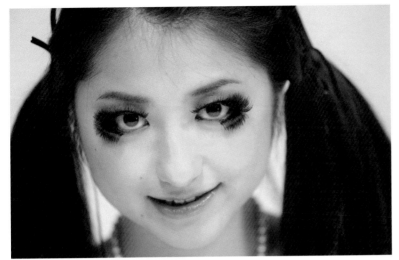

This look consists of a double layer of false eyelashes and extra eyelashes added to the eyes' outer corners. Adding classic ringlets reproduces the look of a shojo manga character from the 1970s with full, luscious eyelashes and twinkling, big eyes.

Cosmetics Used

- False eyelashes (Two layered pairs of eyelashes will be applied. Use one pair of standard length and one pair of long lashes.)
- Black eye shadow
- Matte blush (rose tone)
- Pink lipstick
- Lip gloss

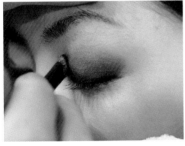

1. After making up the model in the "basic makeup" look presented on page 20, apply black eye shadow to the entire upper eyelid.

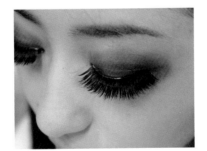

2. Apply eyelash adhesive to two layers of thick false eyelashes and apply the dual layer to the upper eyelid.

3. Create one more set of false eyelashes in the same manner as in step 2. This time, form a "V" with the lashes.

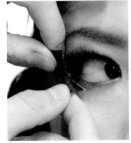

4. Apply the "V" shaped lashes to both the upper and lower eyelid of the eye's far corner.

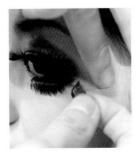

5. The apex of the "V" will open. Add extra lashes to fill in the open gap.

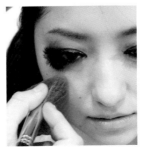

6. Apply pink blush to the cheeks, starting with one cheek, brushing the blush across the nose, and finishing on the other cheek, as illustrated in the diagram above.

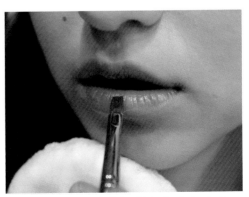

7. Apply a pinkish beige lipstick, retaining the lips' natural forms. Apply clear lip gloss to finish.

Look 05 Goth Eyes

The most fundamental element of a Goth look is using black around the eyes. The addition of contact lenses tremendously heightens the macabre atmosphere. Key points for this look are to carefully apply the foundation and to omit applying blush to the cheeks. Using a garish red or other vivid color would greatly alter the resulting look.

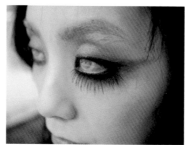

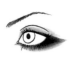

Cosmetics Used

- Long false eyelashes
- Corner lashes
- Black eye shadow
- Gold eye shadow
- Black waterproof eyeliner

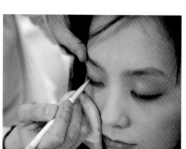

1. Apply a foundation that matches the model's natural skin tone. Apply black liquid eyeliner to the rims of the upper and lower eyelids, coloring in the gaps between the eyelashes.

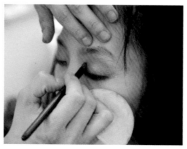

2. Cover the upper eyelid in gold eye shadow.

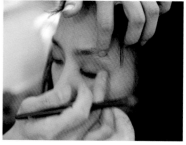

3. Use either the middle finger or the ring finger to blend the eye shadow. Professional makeup artists tend to use the middle finger, because the middle finger consistently provides the softest touch. However, if you happen to be applying makeup to yourself, feel free to go ahead and use the finger that you find most comfortable for blending.

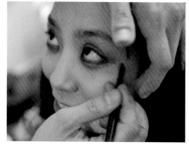

4. Apply gold eye shadow to the corners of the bottom eyelids. Use a black eyeliner pencil to apply eyeliner to the lower eyelids.

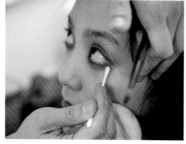

5. Use a cotton swab to soften the contour created in eyeliner.

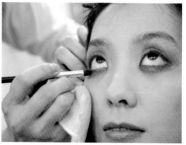

6. Add extra gold eye shadow if more is needed or if the eye shadow applied has been rubbed off.

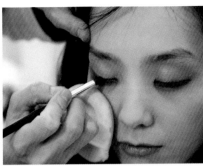

7. Apply black eye shadow to the upper and lower eyelids.

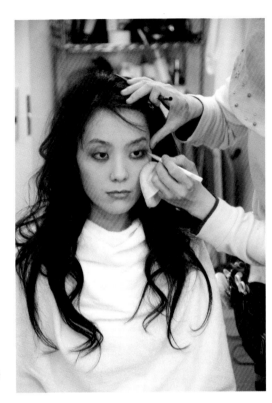

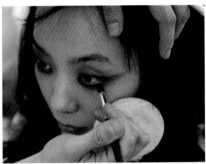

8. Apply the black eye shadow over the gold eye shadow so as to extend the contours of the eyes' outer corners.

9. Apply extra black eyeliner to the corner of the eye where lacking.

10. Rinse white contact lenses with solution and then place them onto the eyes. The white contact lenses cause the wearer to lose vision, so if you are making up yourself, wait until the very end to apply the lenses.

11. Affix short false eyelashes to the outer corners of the upper eyelids.

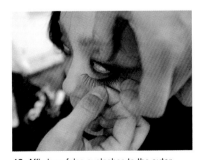

12. Affix long false eyelashes to the outer corners of the lower eyelids.

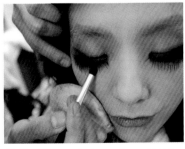

13. Blend the eye shadow on the upper and lower eyelid so that they connect. This will make the eyes look attractive even when the model is gazing downward.

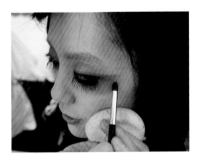

14. Double-check the allover visual balance and apply extra eye shadow where needed.

Hairstyle 01 Well-bred, Ladylike-Look

This is a simple hairstyle where the hair on both sides is parted into two and then bows are applied in a staggered pattern. The greater the number of bows added, the more lavish the hairstyle will appear. However, take careful note that adding large, brightly colored bows will end up making the hair look gaudy.

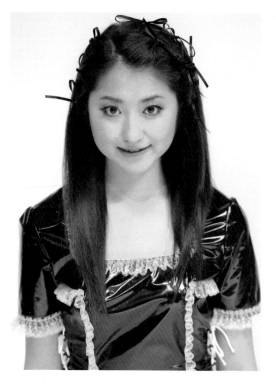

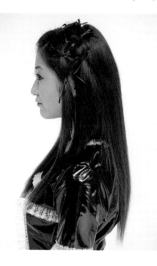

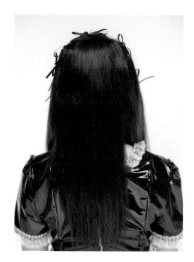

1. Use a hair straightener to straighten all of the model's hair. This hairstyle looks prettiest with perfectly smooth, straight hair, so it would be worthwhile to use a hair straightener even on a model who already has straight hair.

2. Part the hair on each side into two.

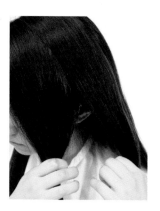

3. You will be tying the hair in three positions on the front row and three positions on the back row, staggering where you tie the hair. To start, tie the top of the front row of hair.

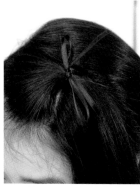

4. Tie a thin black ribbon to the hair, knotting it into a bow.

5. Grasp the tied lock of hair and add to it some of the loose hair underneath. Tie the tied lock to the loose hair with an elastic.

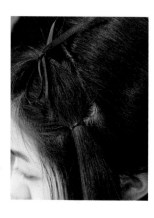

6. Tie a ribbon to the hair as described previously. Add bows to the second row of hair in three locations in the same manner as the first. You have now completed one side of the head. Repeat the same process for the other side.

Hairstyle 02 Lolita-Style Braids

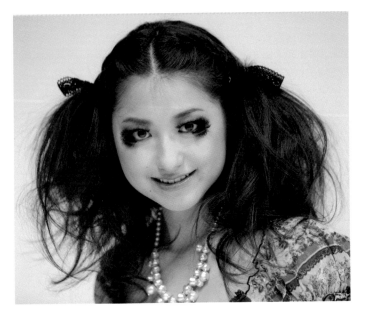

This is a voluminous, teased look with waves and braids. A bow appears high on each side of the head. Positioning bows on both sides of the model's head and at a level higher than her eyes evokes the atmosphere of an elementary-aged schoolgirl.

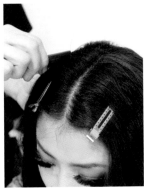

1. Part the bangs at the center into two.

2. Divide the hair on each side of the head into three even parts.

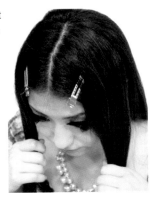

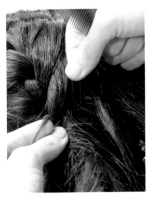

3. Braid the hair on each side of the head, starting from the top of the head and finishing just above the ear. Tie the hair with elastics.

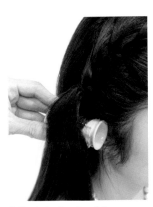

4. Use hot rollers to roll the remaining hair beneath the braids. Roll the hair horizontally.

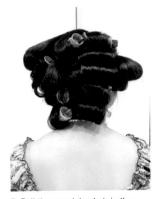

5. Roll the remaining hair in the back of the head with medium to large-sized hot rollers. Roll the hair in horizontal rows.

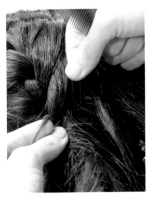

6. To hide the hair elastics used to hold the braids in place, take a lock of hair on each side of the head and pull it over the elastic. Fasten the lock of hair with a bobby pin.

7. Once the hair has finished setting, remove the hot rollers. Tease the hair, working with only a small amount of hair at a time as you proceed. Last, apply hairspray, and a black, lace bow with a bobby pin to each side.

Hairstyle 03 Genteel Ringlets

This hairstyle, which consists of bangs, ringlets, and a bun, frequently appeared on shojo manga* characters in the 1970s. Treating long bangs in the same manner shown here will enable you to give the bangs a shorter, softer look. Adding a generous amount and variety of ribbons and allowing then to trail down the back creates a sweet, feminine look.

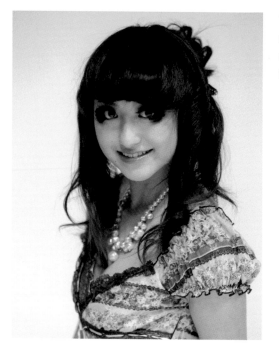

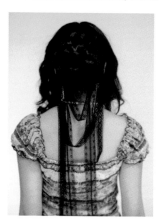

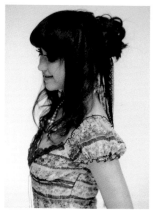

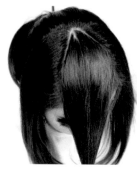

1. Divide the hair into four parts: two sides, a back, and a front.

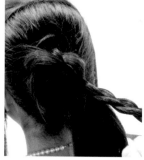

2. Tie the back into a ponytail and then divide it further into multiple parts. Plait each into a braid of identical thickness. The braids should be loosely plaited. To achieve this, pull on the plaited hair in random locations to create the appearance of loose braids.

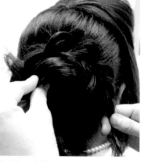

3. After plaiting the ponytail into multiple loose braids, wrap each braid around where the hair was originally tied back to create a bun and fasten with bobby pins.

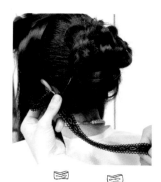

4. Attach a strip of lace tape approximately 2 meters (approximately 6 1/2 feet) in length to the hair, fastening it with bobby pins as shown in the diagram. Tie the lace tape.

5. Weave the lace tape into the bun while checking the overall visual balance.

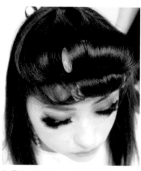

6. Take the bangs, divide them into three parts, and roll them horizontally in hot rollers. If the model has a heavy layer of bangs, roll the bangs in two layers as shown in the photo.

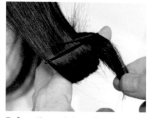

7. Once the curls have finished setting, wrap the hair around your index finger, continuing until the lock is rolled up all the way to the hairline and then fasten it with bobby pins. Fold the bangs approximately one-third of the up so that the bangs curl inward on each side like an inverted heart, as if cupping the center. Fasten the bangs on both the right and left with bobby pins. Wrap the central portion of the bangs around your index finger, curling it upward.

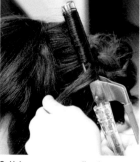

8. Using a narrow curling iron, create ringlets on both sides of the head, working with small amounts of hair at a time as you proceed.

Cuts, Gashes & Scars
01

Arm Scratches Created Using Paint

These are the sort of scratches covering a large surface of the skin that might occur when skin is scraped along asphalt or dirt. All it takes is a little paint to create the illusion of painful scratches. Add blue to represent bruising or change the shapes of the scratches to suit the situation.

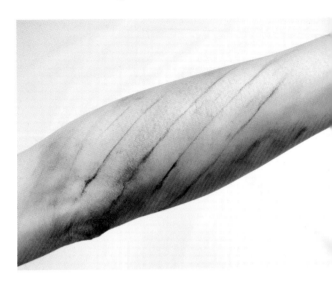

Materials: Grease paint (red, blue, white, and a light flesh tone), and blood paste
Tools: A detail brush and sponges

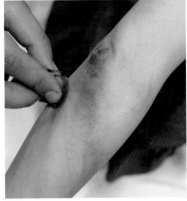

1. Apply red and blue grease paint at a ratio of 4:1 to a sponge. Do not mix the paint. Rub the sponge across the arm in the direction that the scratches supposedly occurred. If the grease paint forms clumps on the arm, leave it alone. (The clumped grease paint may suggest where the skin has scraped against gravel.)

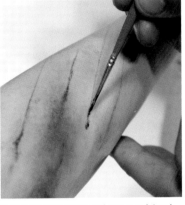

2. Mix blood paste with red grease paint and, with a detail brush, paint scratches over the previously applied grease paint.

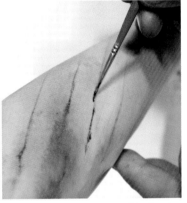

3. Randomly apply small globs of blood paste to the scratches to create the illusion of blood that has welled up and congealed. This makes the scratches appear realistic.

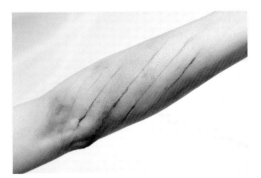

4. Mix white and flesh tone grease paint to create a flesh tone that is lighter than the model's. Apply this mixture to the arm, starting from the border of each scratch and moving across the undamaged regions of skin, gradating the grease paint as you work. This will create the three-dimensional look of raised skin.

What is "grease paint"?
Grease paint is grease-based makeup that is creamy in texture, spreads on well, and does not come off easily. Grease paint is frequently used in theatrical performances, movies, and photography. It comes in scores of colors, ranging from white to red or black. Grease paint can be blended to produce any colored desired and is indispensable to creating foundations for special effects makeup.

Cuts, Gashes & Scars
02 Flesh Carving Created Using Brushes

This replicates the look of an intentionally inflicted wound created by carving into the flesh with a razorblade. Carvings like this are not limited to hearts. Provided that the shape is simple, a vast array of designs is possible, including skulls, crescents, and stars. The key point here is to use solely straight lines, as if the wound had truly been created with a razorblade. Other possibly effective touches are adjusting the skin color close to the cuts and adding extra globules of blood paste.

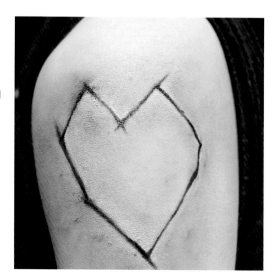

Materials: Grease paint (red, blue, white, and a light flesh tone), and blood paste
Tools: A detail brush, a flat brush, and sponges

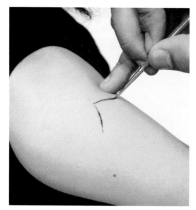

1. Mix red grease paint and blood paste at a ratio of 1:1. Take a detail brush and draw the basic shape using only straight lines. Use sharp, tapered strokes to create the illusion that a razorblade produced the cuts.

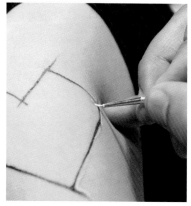

2. Use crude strokes to prevent the lines from forming smooth connections. If the shape's silhouette becomes smooth, then the "cuts" will look like nothing more than paint.

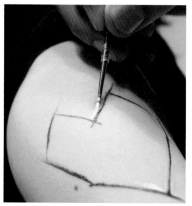

3. Mix white and flesh tone grease paint to create a flesh tone that is lighter than the model's. As when creating the illusion of scratched skin, apply this very light flesh tone to the skin where it just abuts the cuts.

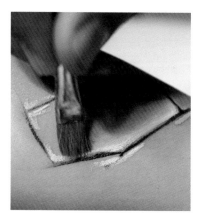

4. Apply this mixture with a flat brush, starting from the border of each cut and moving across the undamaged regions of skin, gradating the grease paint as you work. Blend the mixture of white and flesh tone grease paint with the model's actual skin.

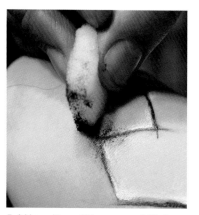

5. Add a smidgen of blue grease paint to the 1:1 mixture of red grease paint and blood paste. Apply this mixture to a sponge and dab the sponge around the cuts. As time passes, the color will take on an overall reddish tinge.

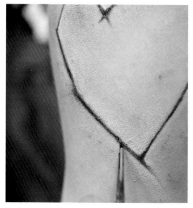

6. To create the illusion of the cuts varying in depth, apply blood paste to the detail brush and apply blood paste to the cuts, varying the amount. Areas with the added blood paste will look like deeper cuts.

Scars Created Using Keloskin

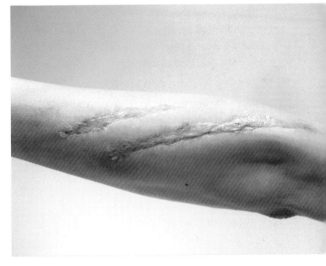

This creates the illusion of severe scratches that have healed. Keloskin is a liquid cosmetic used in special effects makeup, used to portray scar tissue resulting from scratched or burnt flesh.

Materials: Keloskin and grease paint (red, brown, white, and flesh tone)
Tools: A detail brush, a flat brush, and a blow dryer

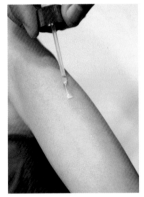

1. Establish the directions of the scars and apply thick layers of Keloskin.

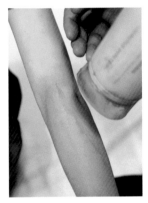

2. Blow dry the Keloskiin.

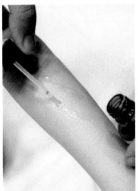

3. Once the first application of Keloskin has finished drying, apply a second layer. The more Keloskin you apply, the deeper the injury will appear (i.e. the more clearly defined the wound will become).

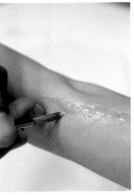

4. Create a mixture of white and flesh tone grease paint to produce a light-colored flesh tone. Apply this mixture where the borders of the Keloskin and the model's skin meet.

5. Blend the mixture applied in step [4] into the model's skin.

6. The scar should now have a sense of three-dimensionality.

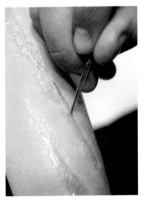

7. Mix red and brown grease paint to create the color of a scab. Use a detail brush to trace the borders of the Keloskin with this new mixture. The contours created should appear uneven.

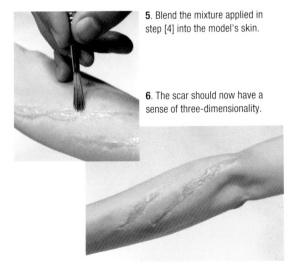

Keloskin

Keloskin is a product of Mitsuyoshi Cosmetic Co., Ltd. and may be purchased at a store near you that specializes in theatrical and special effects makeup.
Caution: Do not use Keloskin around the eyes.

Latex is a spreadable substance that contains natural rubber as a component. It retains flexibility even after it has dried, and special effects makeup artists use it extremely frequently. Latex varies tremendously in price. The reader should feel free to use the cheapest available when reproducing the looks featured in this book.

Cuts, Gashes & Scars
04
Welts Created Using Cabosil

This shows how to create the illusion of welts such as those caused by sharp nails or class, a compass needle, or the like being dragged across the skin. Cabosil is made from silica fiber to fill in gaps and smooth out seams. Picture the scars on Edward's face from the movie Edward Scissorhands when creating welts or scars with Cabosil.

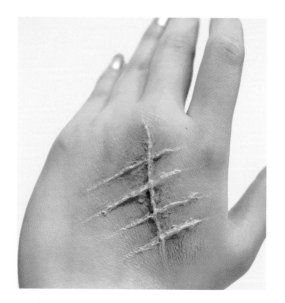

Materials: Powder (regular talcum powder), latex, Cabosil, Pros-Aide, and grease paint (flesh tone, white, red, and brown)

Tools: A blow dryer, sponges, a spatula (putty knife), a blush blush, a flat brush, a detail brush, and a medium-width brush

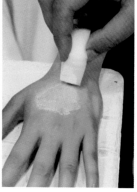

1. Using a sponge, dab latex onto the area to be made up.

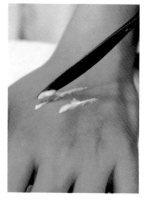

2. Mix Cabosil and Pros-Aide until they reach a consistency similar to toothpaste. Use a spatula to apply the paste in desired scar or welt.

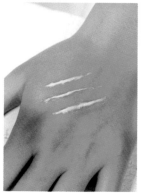

3. The trick is to have both ends of each scratch mark taper.

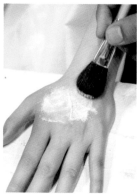

4. Dab talcum powder over the paste to relieve the stickiness.

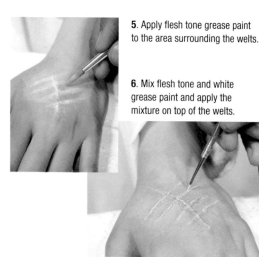

5. Apply flesh tone grease paint to the area surrounding the welts.

6. Mix flesh tone and white grease paint and apply the mixture on top of the welts.

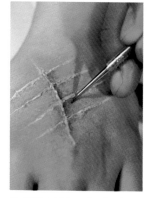

7. Apply a mixture of red and brown grease paint to the welts' sides, gradating and blending it with the model's own skin.

Cuts, Gashes & Scars
05 Chest Cross Created Using Wax

This creates the illusion of a deep cut made by a knife where the skin was torn open and then tried to heal itself, moving back in again but was unable to, leaving a protruding scab. Feel free to play around with a variety of shapes as we suggested with the heart carved into the shoulder presented earlier. The trick here is to produce a sense of three-dimensionality. Latex performs the same role as starch or paste for this wound.

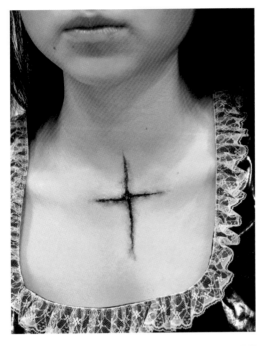

Materials: Latex, Plus Art (nose-and-scar wax) blood paste, and grease paint (black and red)
Tools: A blow dryer, sponges, a spatula (putty knife), a blush brush, a flat brush, a detail brush, and a medium-width brush

1. Apply latex in the shape of the wound.

2. Blow dry the latex thoroughly.

3. Shape the wound in Plus Art and then apply it to the model's skin. Here, the wound is in the shape of a cross that rises in relief from the skin.

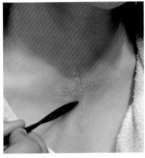

4. Using a spatula, blend the Plus Art wound with the model's skin.

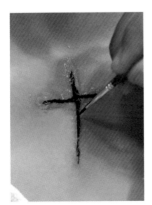

5. Using blood paste alone would cause the wound's color to become overly light, which would make the wound appear shallow, so apply black grease paint on top of the wound.

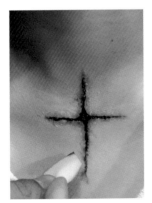

6. Apply red grease paint to a sponge and dab it around the wound.

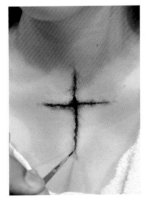

1. Paint blood paste over the black grease paint applied in step **5**.

Plus Art is clear wax that is soft, has the consistency of putty, and allows makeup artists to create scars easily using a spatula. Plus Art may be purchased at Mitsuyoshi and other stores selling special effect makeup.

Cuts, Gashes & Scars
06

Face with Deep Gashes

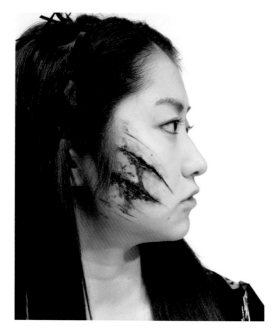

This shows how to create deep, gaping gashes of the kind that sharp claws create when slashed across the face. Adding gashes like these to a beauty enhancement look, such as the basic makeup introduced on page 20 heightens the visceral impact.

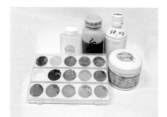

Materials: Talcum powder, latex, Plus Art, blood paste, and grease paint (black and red)
Tools: A blow dryer, sponges, a spatula (putty knife), a blush brush, a detail brush, and a flat brush

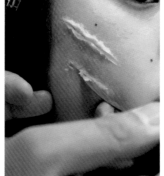

1. Apply latex to the face in the shapes of the gashes and then apply wax so that the gashes lie in relief.

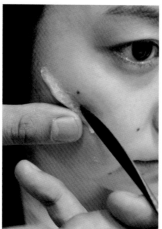

2. Blend the Plus Art with the model's skin.

3. Using a spatula, created gaping gashes in the molded Plus Art.

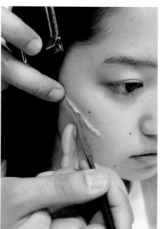

4. Create gaping gashes for all of the Art Plus moldings.

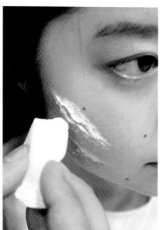

5. The face shifts considerably as the model changes facial expressions, so apply latex over the gashes to ensure that remain properly adhered to the model's face.

6. Dab talcum powder over the gashes to relieve stickiness.

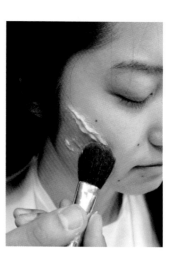

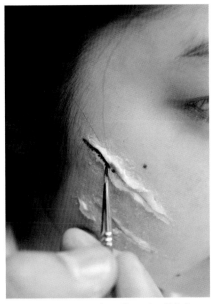

7. Apply black grease paint to the gashes' interiors with a detail brush.

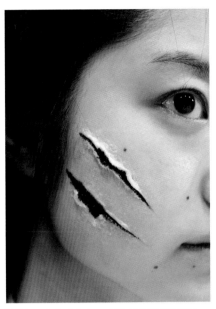

8. Color only the interiors of the gashes' openings, created in step **4**.

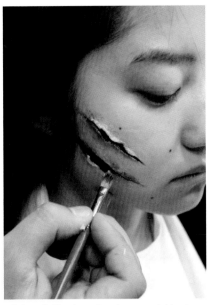

9. Using a flat brush, apply red grease paint to where the model's skin meets the gashes' borders.

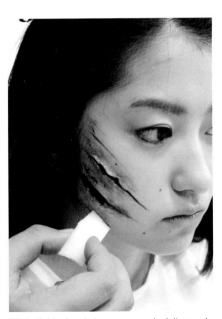

10. Apply blood paste to a sponge and rub it around the gashes.

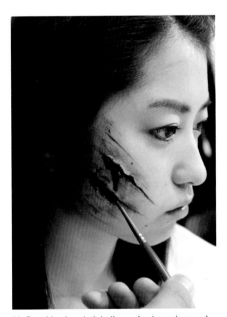

11. Pour blood paste into the gashes' openings and allow it to flow outside.

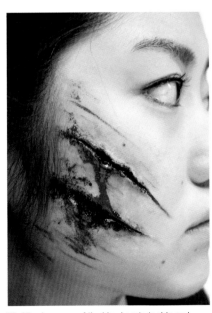

12. Allowing some of the blood paste to drip and smear far down the model's jaw enhances the sense of realism.

Metal Objects Buried in Flesh: Bolt in the Arm

Special effects makeup allows you to create the illusion that nails, screws, bolts, and other objects you would never really hammer into the body are buried into the model's flesh. The bolt appearing on this page was created by coloring a plastic bolt, cast using a mold and then affixing it to the model's skin. What you see here is a variation on the bolts seen sticking out of the Frankenstein monster's neck.

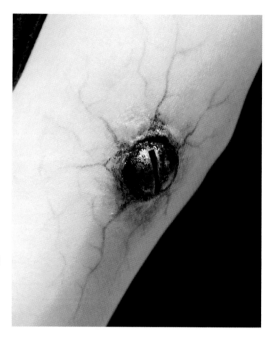

Materials: Resin cast, silicone (KE-12), clear lacquer spray, hobby paint (black and gold), a screw, blood paste, grease paint (red), latex, Plus Art, and a paper cup

Tools: A blow dryer, sponges, a spatula (putty knife), a detail brush, a flat brush, and a craft knife

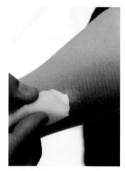

1. Dab latex onto the skin where the bolt will be affixed.

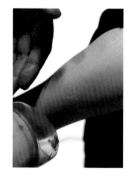

2. Blow dry the latex.

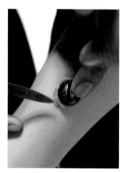

3. Apply Plus Art to the model's skin in an area that is larger than the bolt. Insert the bolt into the Plus Art, and build up the surrounding Plus Art so that it covers the bolt's circumference.

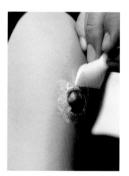

4. Dab extra latex around the bolt to reinforce it.

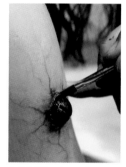

5. Paint blood vessels onto the model using a detail brush and red grease paint. Add blood past to the bolt.

How to Make a Fake Bolt

1. Punch a hole into the bottom of a paper cup and insert a real bolt approximately the same size as that desired.

3. Once the mixture has solidified to approximately the consistency of an eraser, turn the cup over and pull out the screw.

4. Combine resin casting agent 1 with resin casting agent 2 at a 1:1 ratio and mix well. Pour into the hole of the silicone mold. Once it has hardened to the consistency of a stiff plastic, you will be able to remove it easily from the mold. Color the bolt as desired to finish. Applying lacquer spray to the mold prior to pouring in the resin cast will allow you to reproduce the same bolt any number of times and remove them easily.

Materials: Bolt, 1 kg. (2.2 lbs.) of silicone rubber (KE-12), 1 to 3 grams (approx. .03 to .1 oz) of silicone curing agent (catalyst), two-part resin casting agents, lacquer spray, acrylic paint (hobby paint is acceptable)

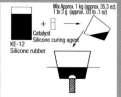

Mix Approx. 1 kg (approx. 35.3 oz):
1 to 3 g (approx. .03 to .1 oz)

+ Catalyst
Silicone curing agent

KE-12
Silicone rubber

2. Combine approx. 1 kg of silicone rubber (KE-12) with 1 to 3 g of silicone curing agent (catalyst) and mix well. Pour the mixture into the paper cup so that the top of the bolt is completely covered.

Cuts, Gashes & Scars
08
Lacerated Neck

This introduces how to create a stitched-neck effect like that displayed on Sarah in The Nightmare before Christmas. The stitched lacerations are created in foam latex and then attached using a medical adhesive. Turn to the chapter beginning on p. 70 for more information on mold-making.

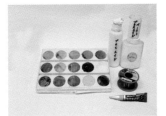 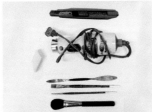

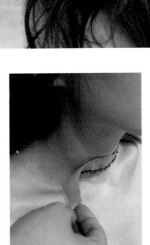

Materials: Stitched laceration cast in foam latex, solder wire, Pros-Aide (or other medical adhesive), grease paint (red and flesh tone), instant adhesive
Tools: A blow dryer, sponges, a spatula (putty knife), a detail brush, a flat brush, and a craft knife

1. Laceration created in foam latex

2. Cut the solder wire in pieces approximately 8 to 9 mm (about .31" to .35") and attach the cut pieces of wire to the foam latex using an instant adhesive, as shown in the above.

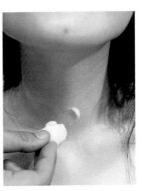

3. Apply cream to the model's neck to protect her skin.

4. Dab Pros-Aide here and there on the model's neck and tentatively put the prosthetic into place to make sure that the positioning is correct.

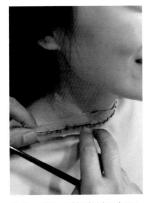

5. Once the positioning has been established, apply Pros-Aide (or other medical adhesive) to the entire area, and slowly press the prosthetic into place to keep it nice and straight.

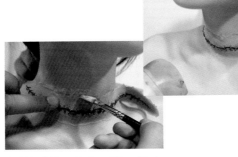

6. Add a light application of Pros-Aide to where the prosthetic's edge meets the model's neck so that it firmly attaches to the model.

7. Blow dry the prosthetic.

8. Apply talcum powder. Paint the laceration with red grease paint. Gradate the grease paint up to the point indicated in the photo. Apply flesh tone grease paint over the red grease paint and blend.

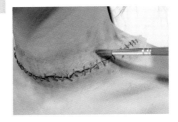

Cuts, Gashes & Scars
09 Pierced Collarbones

This duplicates the look of collarbone piercing, worn as a painless fashion accent. They allow the wearer a certain range of movement. The trick to making the piercings appear authentic is to use actual metal.

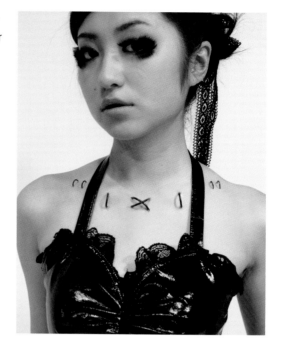

Materials: Pros-Aide, acrylic paint (black), wire (wire of any type will suffice, alternatively try using pliable gardening wire)
Tools: Sponges, a blow dryer, and a detail brush

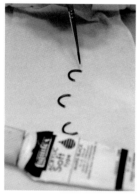

1. Using acrylic paint, paint the wire any color desired (black was used here).

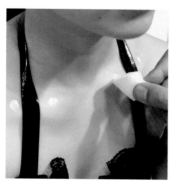

2. Dab Pros-Aide here and there, approximately where you intend to attach the piercings.

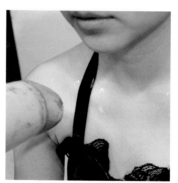

3. Blow dry the Pros-Aide.

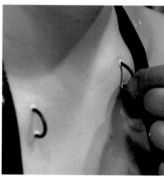

4. Attach the wires.

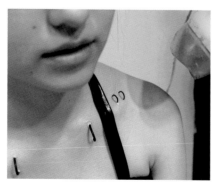

5. Use wires of varying diameters, while checking the overall visual balance.

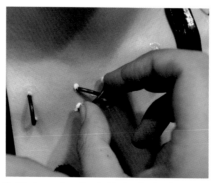

6. Attach crossing wires just below the jugular notch or at another similarly prominent location.

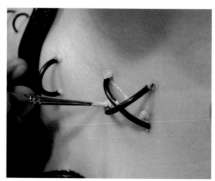

7. Use Pros-Aide to glue the wires to each other to prevent them from shifting off center.

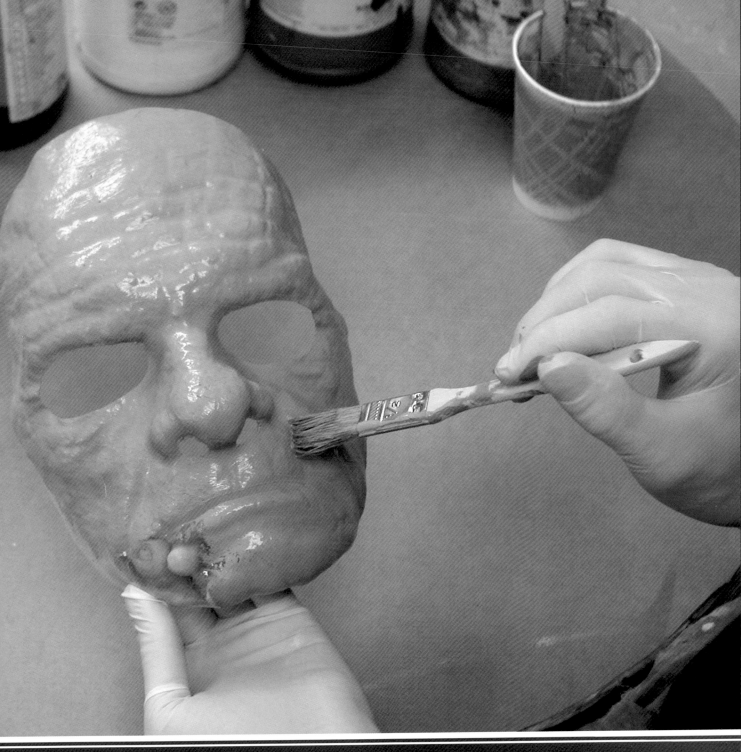

Flamboyant Mask with Feathers

Owl

Yuya Takahashi

This flamboyant, owl-inspired mask made of feathers is perfect for wearing on Halloween or during Carnival. Feathers are attached to flow down the back of the head. Most of the feathers are warm colors with purple appearing occasionally as a visual accent. White is positioned next to saturated colors, thereby providing a mutual contrast that allows both the white and the saturated colors to stand out.

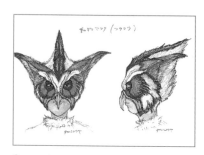

Concept

To portray a bird, whose enchanting beauty fascinates and captivates all who view him/her.

Materials: Watercolor paint (Neocolor), a sponge mat, G-Bond (dental adhesive), a urethane mat, Gum Vans Color, feathers (dyed), fabric starch, instant adhesive, a mask to function as the base (any commercially available toy mask that can be purchased at a party goods store, etc. will suffice) Neocolor may be used as a substitute for Gum Vans Color; however, if cracking or crazing is a concern, then Gum Vans Color is recommended, as it contains rubber.

Tools: Scissors, a brush (airbrush), sponges, a house paintbrush or hake style brush, [when creating the base mask yourself, then you will also need Roma Plastilina clay, a spatula (putty knife), a knife, a bust of a human head (as a dummy to wear the mask), and plaster]

Process

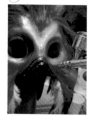

1. Construct a cowl to cover the model's head using sponge mat sold at a craft supplies shop or hardware store. This cowl will enable you to attach feathers to the back of the head. Use G-Bond to attach the cowl to the mask. Feel free to use a store-bought mask as the base. Apply color using either an airbrush or a brush and watercolors (Neocolor was used on this mask).

2. The trick to creating highlights for the beak and brows is to add white from the forehead and across the "bridge of the nose" (i.e. toward the beak). Apply paint to a sponge and pat the area described, remembering to gradate the white carefully. Add white underneath the eyes and yellow to the "eyebrows." Match the shades to those of the feathers.

3. To create the beak, cut a triangle out of the urethane mat and coat it with black latex. Once the latex has solidified, glue it to the mask with G-Bond. Use an instant adhesive to attach the feathers, and set the contours of the feather's barbs with fabric starch.

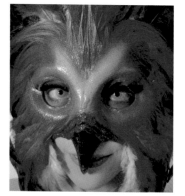

4. Color the model's skin surrounding the eyes orange when the model is wearing the mask. Visualize an orange panda when coloring the model's eyes. The model in the photo above is wearing yellow contact lenses to achieve a fully coordinated look.

Making the Base Mask

The above procedure is written assuming that a store-bought mask will be used as the base to simplify the process. However, Takahashi actually made the base mask by hand for the owl mask pictured. Starting from scratch results in a base mask that has a gentle fit that the model may wear for many hours without becoming uncomfortable. It also enables you to create a mask with greater detail, such as adding wrinkles to the skin over the beak, etc. For those readers who feel up to the challenge:

1. Create a cast of the model's face. (Turn to the chapter beginning on p. 70 for more information on mold-making.)
2. Cover the cast with clay and sculpt the mask's exterior surface into the clay. At this point, add wrinkles and other details.
3. Cover the carved clay with plaster to make a mold.
4. Remove the clay and, using a sponge, pat layers of latex dissolved in red watercolor to the interior of the plaster mold, building up multiple layers.
5. Have on hand some gauze to use as reinforcement. Spread the gauze across the inside of the mask. Soak a sponge in the latex prepared in step 4, and then pat the latex onto the gauze. Repeat this process three times to build up the latex in layers.
6. Once the latex has solidified, remove it slowly, applying talcum powder to the latex as you work. (This is to prevent the layers of latex from sticking to each other.)
7. To create the rear portion, cover the head in sponge mat as if putting on a hood. Use G-Bond to glue the sponge mat to the latex mask. Sculpt the beak into the clay at the same time you carve the rest of the face. When applying latex to the mold's interior, use different colors for the beak and the face.

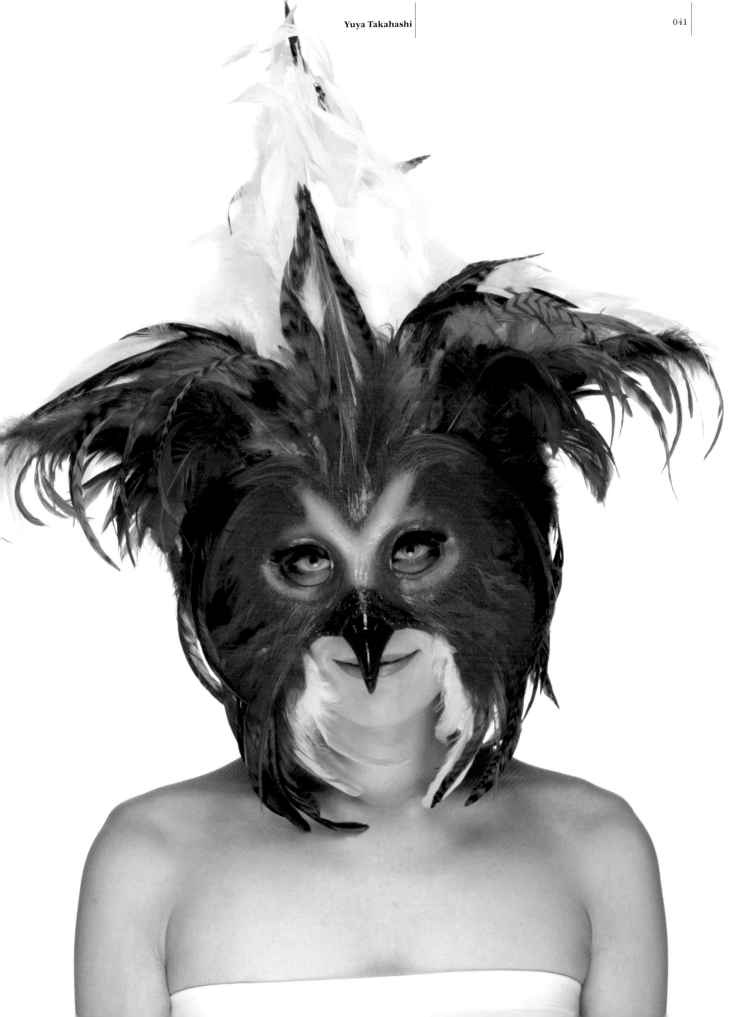

Masquerade Ball Mask with Pearls and Feathers

Face

Tomonobu Iwakura

This is a lightweight, stiff mask of fiberglass, adorned with pearls and feathers. Exquisite in its contrast of white against blue, this mask is the sort one might wear to a masquerade ball. Fabricating the base mask does take skill. So, if you prefer to make the process easier, feel free to purchase a commercially available mask instead and to color it with an airbrush and decorate it.

a. Inspiration Sources

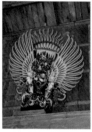

Concept

The idea was to portray the turbulent emotions, teeming in our hearts, so the face was divided into two to portray a duality of emotions.

Materials: Plaster base mask, modeling clay, silicone, gauze, plaster, polyester resin, methyl ethyl ketone peroxide, epoxy putty, Tamiya Color Acrylic Paint (gold), pearls, twigs, feathers, artificial flowers, adhesive, and an airbrush
Tools: A house paintbrush or hake-style brush, scissors, a file, a scale

Process

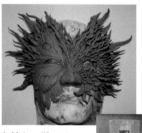

1. Make a lifecast of the model's face. (Turn to the chapter beginning on p. 70 for more information on mold-making.) Sculpt the base mask in modeling clay.

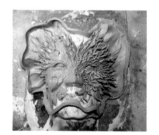

2. Apply acrylic lacquer spray to the sculpted clay (the spray acts as a mold release). Build up walls around the sculpted clay to complete the mold for when the silicone is poured.

3. Pour the silicone over the mold.

4. Combine the polyester resin with a thickening agent until it has the consistency of putty. Next mix in methyl ethyl ketone peroxide (a curing agent) and smooth it over the reverse side of the silicone cast.

5. Once the polyester has hardened, pat down a fiberglass mat (exceedingly fine glass fibers woven into a sheet approximately the thickness of handmade paper) over it.

6. Using a house paintbrush or a hake-style brush, apply a mixture of polyester resin and methyl ethyl ketone peroxide, combined at a ratio of 100:1, over the fiberglass added in step [5].

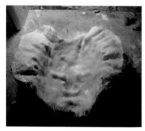

7. Set the mask aside to let it harden.

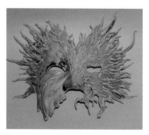

8. Once the mask has hardened, smooth over any air bubbles with epoxy putty and color the mask with an airbrush. Add the feathers, artificial flowers, and pearls with an adhesive, paint the branches with gold-colored Tamiya Color Acrylic Paint, and attach the branches to the mask in a nimbus pattern to finish.

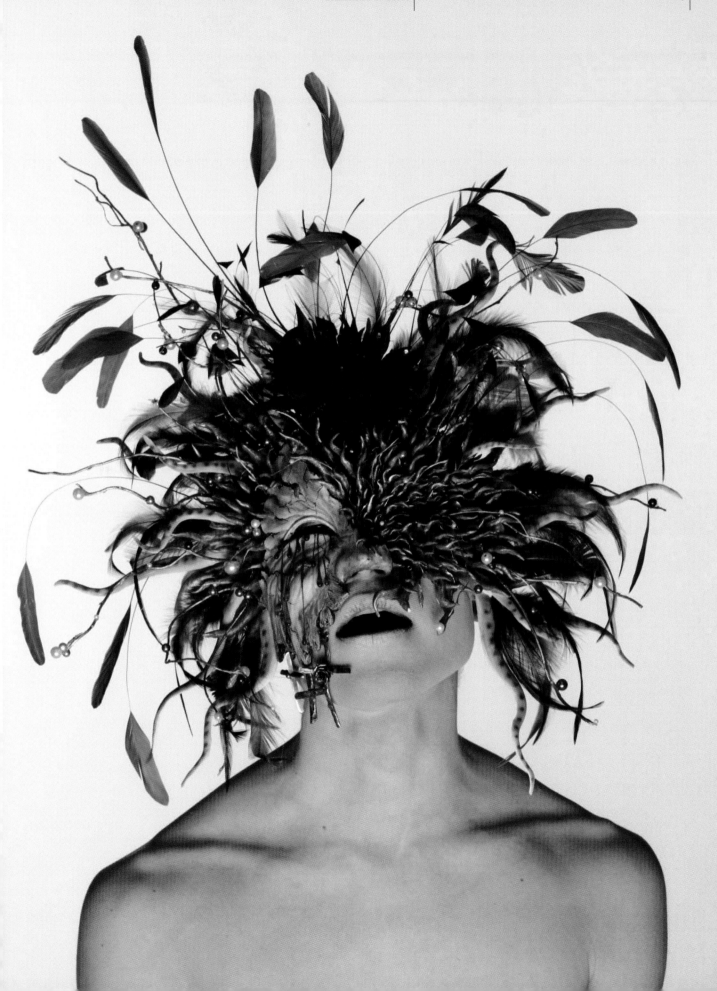

Hard, Skull-Fragment Mask

Vampire Queen Mask

Akiteru Nakada & M.E.U

The concept for this mask was to create a vampire queen. The initial design had the skull fragment worn over both eyes. However, this was altered during the production process to better suit the model's face. Concealing only half of the model's face exudes a mysterious air, which is echoed in the black, Goth clothing. This mask absolutely requires making a mold. Turn to the chapter beginning on p. 70 for more information on mold-making.

Materials: Urethane foam (film-forming), beads bracelet kit, black fabric (any thick fabric will suffice), plaster, red and gold lace trim, grease paint (red to portray bruising), colored contact lenses (blue), Roma Plastilina clay, acrylic paint, mold-making silicone, rubber bands, foundation used to portray bruising

Tools: Spatula (putty knife), brush, sewing machine, and nails

Concept

This is intended to be a mask fabricated from a portion of a vampire's skull. Adding embellishments creates the look of a queen who has been transformed into a vampire.

Process

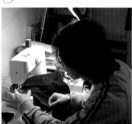

1. To make the cape, sew gold lace trim to the fabric's edges and then sew red lace on top of the gold.

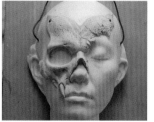

2. Apply Roma Plastilina clay on top of a lifecast of the model's face and sculpt the clay. Form the skull fragment, having it conform to the shape of the model's nose. Create an eyehole that follows the shape of the skull fragment to evoke a sense of realism. A texture stamp made from a mandarin orange peel recreated the texture of bone.

3. The key to sculpting the clay to make it look convincing is to carve fine cracks and tiny holes into the surface.

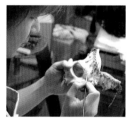

4. Once you have finished sculpting the clay, make a plaster mold and fill it with urethane foam. Using a brush, coat the inside of the mold with urethane foam to prevent air bubbles from forming, and then pour the urethane foam into the mold.

After filling the mold, let the urethane foam sit for one hour and allow it to solidify. After the urethane foam has finished solidifying, remove the cast from the mold and color it with Liquitex acrylic paint. Using black India ink to paint the interiors of grooves and the edges of bone gives the skull mask a more authentically bonelike appearance. Attach beads to the forehead with an instant adhesive, and paint the mask once more with Liquitex to finish.

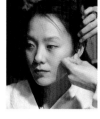

5. The model pictured here is wearing colored contact lenses that were purchased outside of Japan. Some opticians and eyewear specialists overseas will customize the contact lenses' design according to your specifications. While this might be somewhat costly, ordering colored contact lenses outside of Japan gives you access to lenses that can make dark eyes look blue.

6. The hood will cast a shadow across the model's face, so go ahead and apply the grease paint slightly on the thick side. Apply grease paint around the eyes, to the cheeks, and to other areas where the model's skin appears directly next to the mask. Add foundation used for bruising to the lips to give them depth. Drape the cape over the model to finish.

Texture Stamps

Having to carve each individual, minute crack, rough bump or pore that one finds in a skull is a horrendous task. On such occasions, one viable option would be to make a cast of an object that already has tiny cracks on its surface or a rough texture and use it as a stamp. These are called "texture stamps," and making them is as easy as pie.

How to Make a Texture Stamp from a Mandarin Orange Peel

Materials: A citrus fruit peel, silicone rubber, silicone curing agent, a release agent (lacquer spray or the like), a brush, gauze, scissors

1. The next time you eat a mandarin orange or some other citrus fruit, keep the skin and allow it to dry. Select a fruit that has a peel reminiscent of human skin with pore holes or that resembles the surface texture of bone.
2. After reading the printed instructions carefully, combine the silicone rubber and the silicone curing agent at the ratio specified in the instructions to create mold-making silicone. (Incidentally, if you are using Shin-Etsu's KE-12 silicone, then the ratio of silicone rubber to curing agent is 100:1.)
3. Apply a lacquer spray or other release agent to the fruit peel, and using a brush, lightly coat the peel with mold-making silicone.
4. Once the silicone has solidified, apply another layer on top of that, and press gauze onto the second layer before it finishes solidifying to act as reinforcement.
5. Once the silicone cast of the peel has solidified, cut it into pieces of easily manageable sizes.

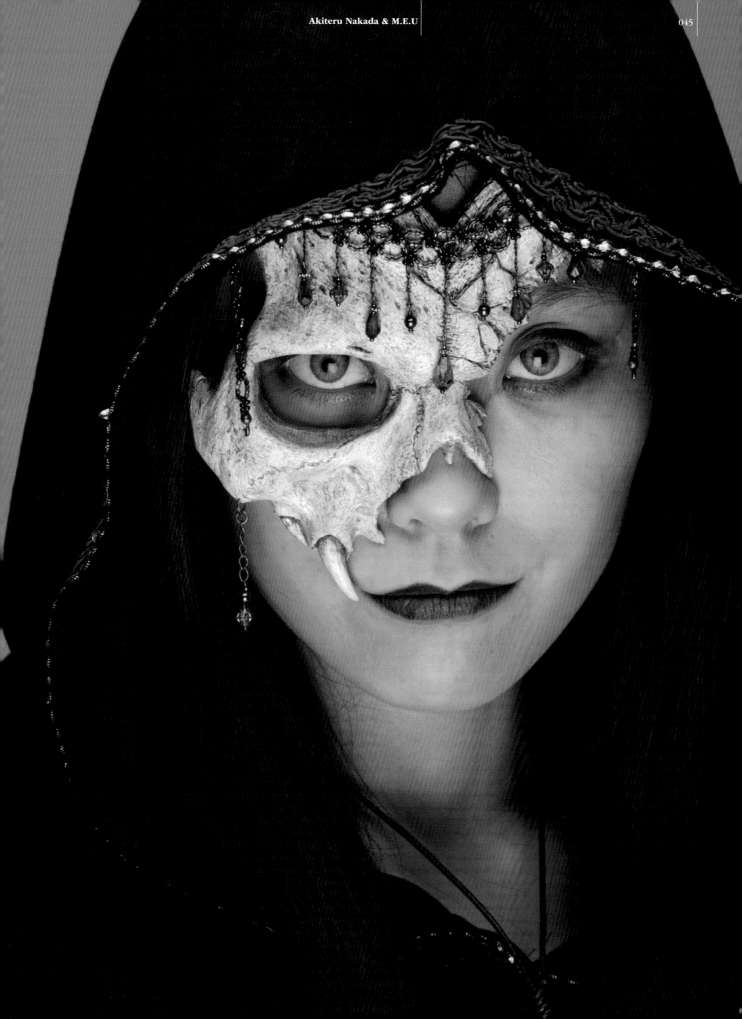

Mask Made of a Purchased Skull and Clay with a Proboscis
Incorporating toy premiums that come free with the purchase of a candy, etc. into a mask of this sort allows
you to create an infinite variety of designs.

Proboscis Man TOMO

This intermediate-level mask is perfect for parties and other events. This mask starts with a skull. The example presented here has an added nose. However, exaggerating the eyebrows, lips, or other features enables you to create a host of designs. Note that adding too much clay could result in the mask becoming too heavy.

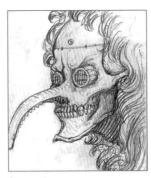

Materials: A commercially available skull, clay, instant adhesive, parts of a toy plastic model, flexible gardening wire of a large diameter, acrylic paint, Tamiya Color Acrylic Paint (Tamiya "Clear Orange" and "Clear Red"), fake fur boa, clear G-Bond, spray paint (cream)
Tools: A wire cutter, paintbrushes, tubing, and scissors

Concept
An FBI agent from Hell, who is able to catch fugitives using his keen sense of smell

Process

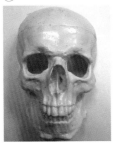

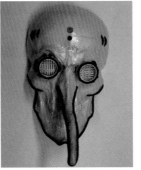
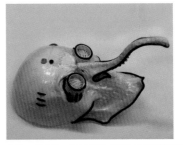

1. Make a silicone cast of a skull bought online or in a store. The purchased skull may be used as is. However, those readers who intend to play around with the weight or make multiple masks should make a mold.

2. Using ceramic clay allows you to perform intricate sculpting, and it becomes relatively lighter once it dries.

3. Use the clay to add eyebrows. Attach the toy plastic model parts to the eyes and forehead with instant adhesive. The black borders are wire that was attached using instant adhesive.

4. To make the proboscis, start by punching a hole in the mask and inserting a wire into it to create the proboscis's core. Next, use clay to build up the proboscis gradually, drying the clay as you work. Attach toy plastic model parts (a plastic toy spine or tank track, etc.) to the proboscis's underside. Using paint from a can, spray cream-colored paint over the entire mask.

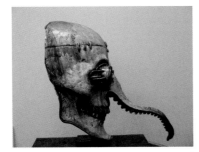
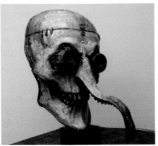
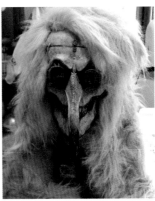

5. Paint the cranium's top using silver Tamiya Color Acrylic Paint, and paint the teeth and the proboscis's underside in "Clear Orange." Slightly dilute brown acrylic paint with water and apply to the mask so that it looks like dripped motor oil. Once the paint has dried, apply white acrylic paint lightly with a dry brush (remove excess paint and other moisture remaining on the brush with a paper towel to create a bristly effect when the paint is applied and then scrub the brush over the mask). The initial colors applied will remain in indented areas, while areas that are jutting out will become white.

6. Paint the proboscis's tip using "Clear Red" Tamiya Color Acrylic Paint, and then go over it again with "Clear Orange."

7. Cut the boa into the lengths desired and glue it to the mask using clear G-Bond to finish.

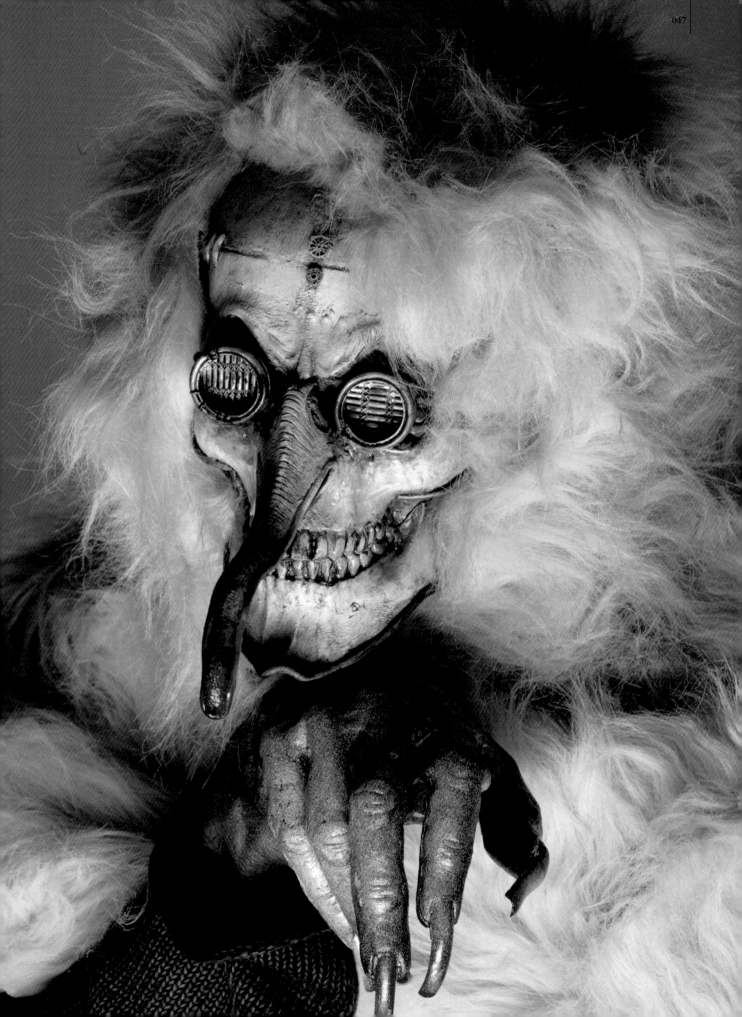

Gruesome Leather Mask Reminiscent of a Medieval Torture Device

Veronica # Manabu Namikawa

This piece involves creating a paper pattern, cutting it out, and then gluing black leather and leather cord to form the mask rather than sewing. The artist, Namikawa conceived of the strap covering the eyes during the production process. However, there was a risk that the strap would affect the contact lenses when the mask was photographed, so it was removed.

 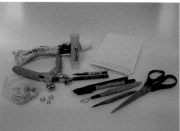

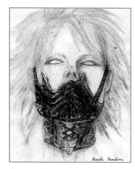

Concept

This is a mask from an alien world that might be used as a gag, as a strangulation, or as a hanging device as a means of torture or punishment.

Materials: Hide, leather strap, metal fittings, leather cord, wire, rubber tubing, epoxy putty, acrylic paint, Metallic Rust Color, plastic model tank track (to use as the band to hold the mask in place), paper for making a pattern and glue, clay, silicone spray, Mr. Color model paint (silver and copper), metal jewelry-making parts, G-Bond
Tools: A leather hole punch, eyelets, shears, a pencil, and a pen

Process

 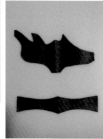

1. Make a paper pattern. Draw outlines of the target form onto a lifecast of the model's face. Then wrap a sheet of paper over the lifecast and, with a pencil, trace the outlines onto the paper to make a paper pattern. Cut out the pattern. If you are using yourself as the model, wrap aluminum foil around your head, draw the outlines on the foil in pen, and then transfer that to paper. Leave a little extra space for applying glue, as you will be attaching the pieces together. Fold the pattern for the collar in half and cut both the right and left sides at the same time to ensure they are symmetrical.

2. Lay the paper pattern over the leather and cut the leather.

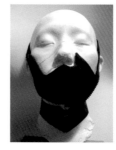

3. See how the cut leather looks by placing it on the lifecast (if you are using yourself as a model, then place the cut leather on your face and look in the mirror). Attach pieces of leather together using G-Bond. Using epoxy putty, attach the model tank tracks that you painted black to the mask, following the contours of the lifecast (or your face).

6. Completed piece

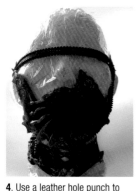 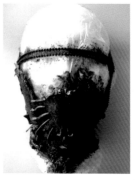

5. Apply red paint over the black. This should give depth to the color. Using a dry brush, apply copper and silver to the mask, creating a pattern. To finish, apply Metallic Rust Color to the mask overall and coat the mask with silicone spray (to prevent the rust and other pigments from flaking off).

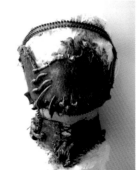

4. Use a leather hole punch to make holes in the collar and hammer in the eyelets. Pass a leather cord through the eyelets. Sculpt tiny demon figurines, claws, and other decorations in clay and attach them to the mask with G-Bond. Cover the entire mask with a heavy coat of black paint.

The mask pictured on these pages was created using a paper pattern. However, for those who have difficulty making a paper pattern, start with a three-dimensional mask sold for people with pollen allergies or the like and modify its form as needed. When selecting leather, opt for one that is thick, as that will prevent rippling and warping in the finished product.

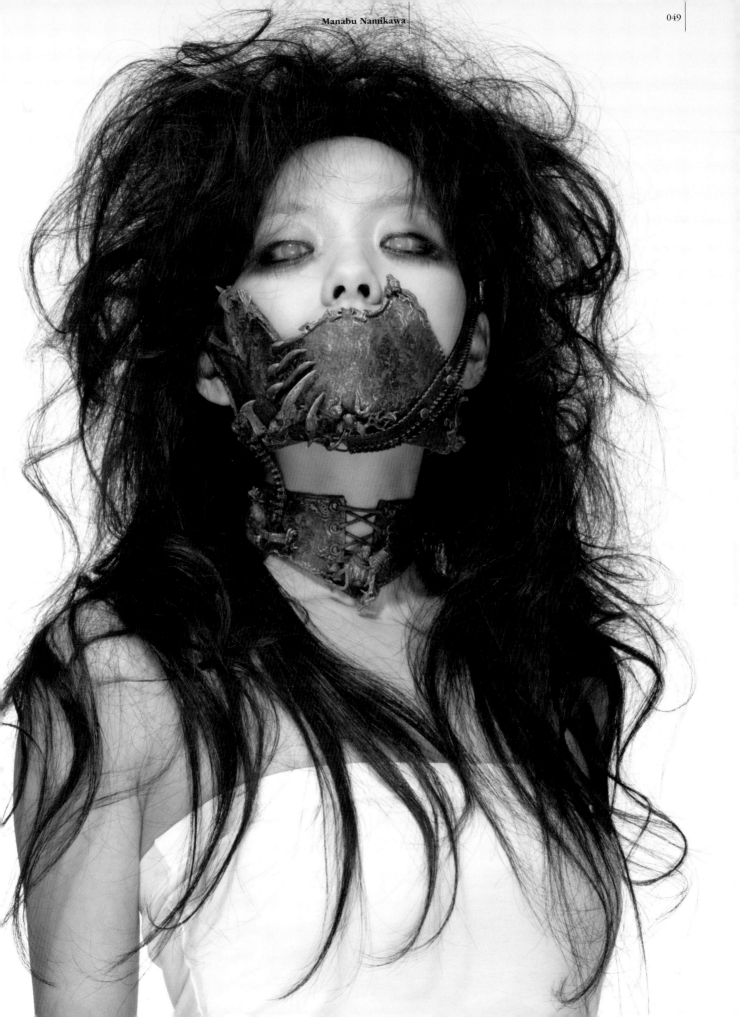

Cloth Mask of a "Little House on the Prairie" Style Girl

Miss Huggles TOMO

This is a simple, cloth mask worn over the head that may be fabricated without using a paper pattern or a sewing machine. If you push it, you could even make this mask in a single day. The wearer looks out through the mask's "mouth."

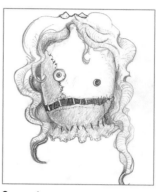

Materials: Large mesh strainer, glue gun (a tool that melts glue sticks and is often used to make artificial flowers), clear G-Bond, two terrycloth towels, urethane that is 5 mm thick (approx. .2"), a button, a doll's eye, wire (length, thickness, and volume at your discretion), gardening wire, yarn
Tools: A wire cutter, brushes, tubing, and scissors

Concept
This is a crude, handmade mask of the sort one might expect a serial killer to produce.

 Process

1. Use the wire cutters to remove the round foot of the mesh strainer. Reshape the strainer into an ellipse. Bend back down and reattach with the glue gun any mesh wires that are sticking out after the foot has been removed (indicated in black in the photo).

2. Cover the strainer with 5-mm urethane and glue it in place with clear G-Bond. The thicker the urethane, the rounder the mask's silhouette will appear, so select a thickness that best suits the mask's design.

3. Cut out a mouth in the urethane and attach a black, sheer fabric, such as from a curtain, over the mouth opening. Purchase two terrycloth towels of any fabric you prefer and cover the top of the mask with one and the bottom of the mask with the other, so that the towel's edges form the mouth. Attach the towels using clear G-Bond. Cut the wire in any length you desire and glue the wires to the towels' undersides, as if they were teeth.

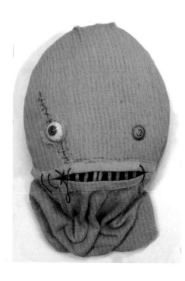

4. Attach the button to the mask as one of the eyes. For the other eye, cut the towel and apply G-Bond to glue back the frayed edges. Draw capillaries on the doll's eye and insert it into the cut towel, gluing it in place. Attach long pieces of cut wire to the eye seam, inserting the ends of the wire into both towels to make it look like an incision suture. Add wires of shorter lengths in the same manner, but have them cross over the seam.

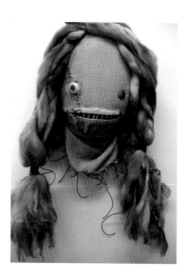

5. Add wires to the mouth seam and neck seam in a similar manner. Twist the yarn ahead of time. Attach the thickest portion to the head. Use wires to tie the yarn in pigtails, positioning the wire differently so that the two sides are uneven. To finish, attach a belt to the back of the head to hold the mask in place.

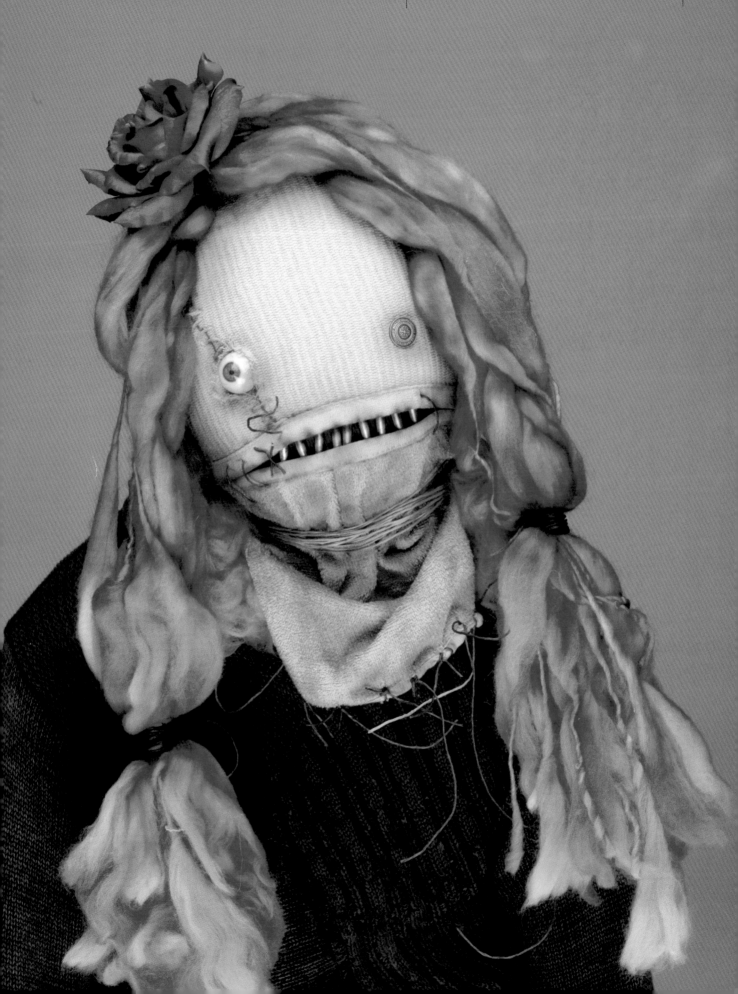

Paper Mask Reminiscent of an Elementary School Student's Arts-and-Crafts Project

Paper God # Yuya Takahashi

This is a papier-mache style mask built up over headgear made of paper. This mask uses the naturally forming crinkles and folds in the paper to portray an old man's face, so do not worry about if the paper is laying properly. Just keep building up the layers little by little. This type of mask-making also lends itself to portraying an old woman or a wizened hermit.

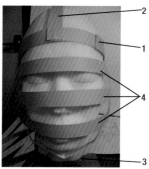

Materials:
An umbrella, newspaper, thick paper, colored paper (flesh tone), a vinyl sheet

Tools: A stapler, an airbrush, a heat gun, and glue

Concept

Using familiar, everyday objects, such as paper and an umbrella, to portray a divine being that exists on another plane

Process

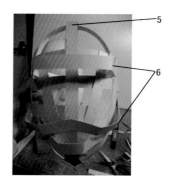

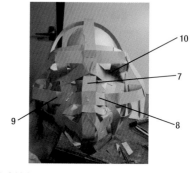

1. Wrap a strip of thick paper around a lifecast of the model and fasten the strip with a stapler.
2. Place a paper strip across the top of the head and fasten it in the front and back.
3. Attach one strap underneath the chin, just like the chin strap of a helmet.
4. Wrap strips of thick paper loosely around the face.

5. Attach more strips of thick paper to complete the understructure.
6. Build up the facial features that will jut out from the masks surface on top of the understructure.

7. Add the bridge of the nose, 8. the tip of the nose, 9. he cheeks, and 10. the eye sockets, fastening each with the stapler.

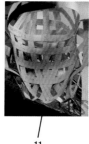

11

11. This photo shows the understructure as seen from behind. The model's face will touch the inside of the understructure, so staple each sheet from the inside.

12. Attach the each to the sides of the head.
13. Once the mask's overall shape is established, add thick paper strips to fill in the gaps. Glue flesh-tone paper to the understructure. Diluting carpenter's glue with water, and then letting the paper soak in the mixture as you glue each strip to the mask makes the process go smoothly. Let crinkles and folds in the paper represent the eyelids. To make the eye, use a heat gun to melt the vinyl sheet and shape it into a half sphere. Color the eye with an airbrush.

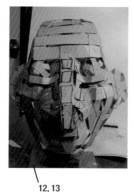

12, 13

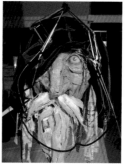

14. To make the beard, glue strips of a newspaper and wrapping paper to the mask. To make the hood, disassemble a cheap, folding umbrella. Separate the fabric cover from the ribs. Wrap the fabric around the head and then drape the ribs on top.

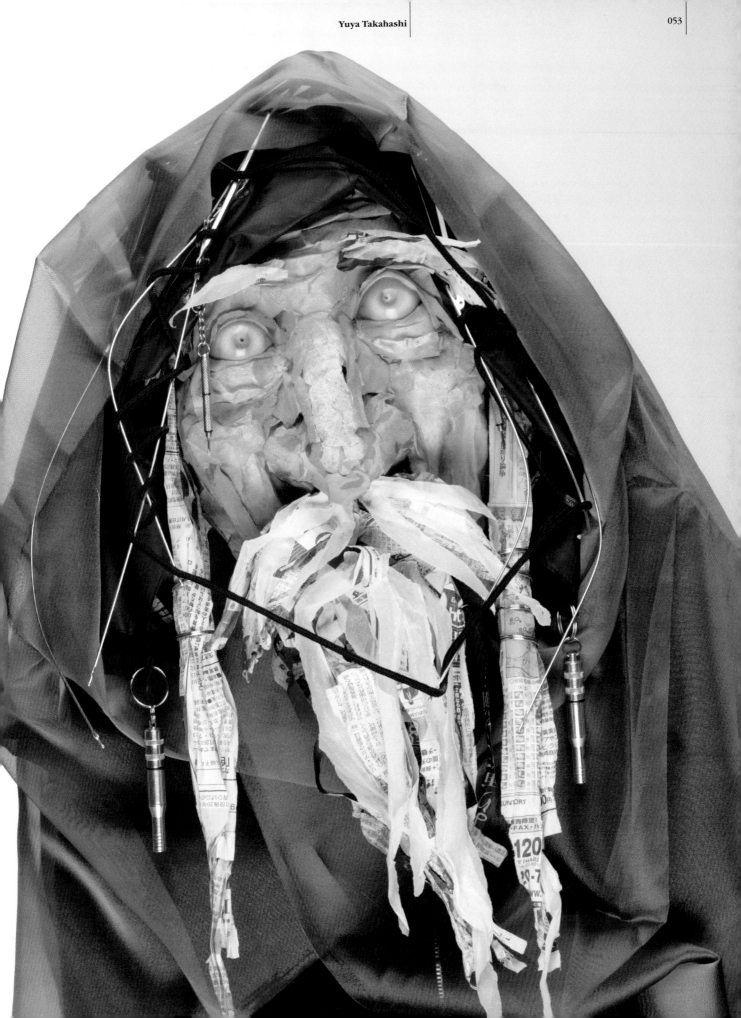

Artificial Flower Used as an Accent on a Modifiable, Easy Mask

Executioner's Mask Keizo

The artist, Keizo made this mask in a single day, using a burlap sack as the base mask. The design may be easily varied, such as substituting the flower with two adhesive bandages in the shape of a cross, using a bow or choker necklace instead of the rope around the neck, etc. The eyehole is uncovered, and the mask may be worn so that the model's eye is visible.

The accent article does not have to be a flower. Any cheap drugstore or garage-sale object will suffice.

Materials: A burlap sack (large enough to fit over the head), black fabric (of wide muslin or "sheeting"), red vinyl, a rope, lace, an artificial flower, press-on nails, packing twine

Tools: Sewing needles, scissors, cotton swabs

Concept

This is an executioner who sends with a cute, girlish flair the doomed to meet their maker. This type of mask is easily customized to project the designer's personal style.

Process

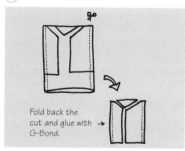

Fold back the cut and glue with → G-Bond.

1. To make the stitched cuts appearing on the head, cut the burlap sack with scissors as indicated in the diagram, and sew the seams together with twine. Fold the ends of the cuts back slightly and glue them down with G-Bond to prevent fraying.

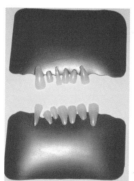

2. Determine the mouth's size and the gums' shape based on the design concept sketch. Trim the press-on nails so that they have the shapes of teeth. Attach gum-colored vinyl sheet (the sheet may be either vinyl or latex, provided that it is shiny and stiff) with an adhesive intended for use with silicone to the mask.

3. Burlap feels uncomfortable when it comes into direct contact with the skin, so make a lining for the mask. Fold the black fabric in half, and make a sack that is slightly smaller than the burlap sack. Sew lace on the sack's bottom edge. Place the lining inside the burlap sack, and make holes for the eyes and the mouth in both sacks.

4. Blind stitch the vinyl gums to the black fabric from the back where the mouth hole is located. (G-Bond may also be used to attach the gums.)

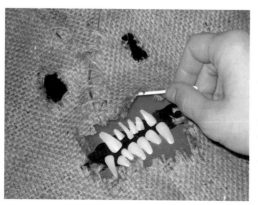

5. Turn the burlap sack inside out but not the black fabric sack. Place the black fabric sack on top of the burlap sack. (If you have already made holes for the eyes and mouth in both the burlap sack and the black fabric sack, then the rest of this step should be a snap.) Align the four corners, and sew the two sacks together. Reverse the burlap sack again, so that the sack's inside is in, and the outside is out.

6. Attach the vinyl gums to the mouth hole using the silicone adhesive. Cotton swabs make applying the adhesive easy. Insert the artificial flower into an eyehole, and sew it in place to finish.

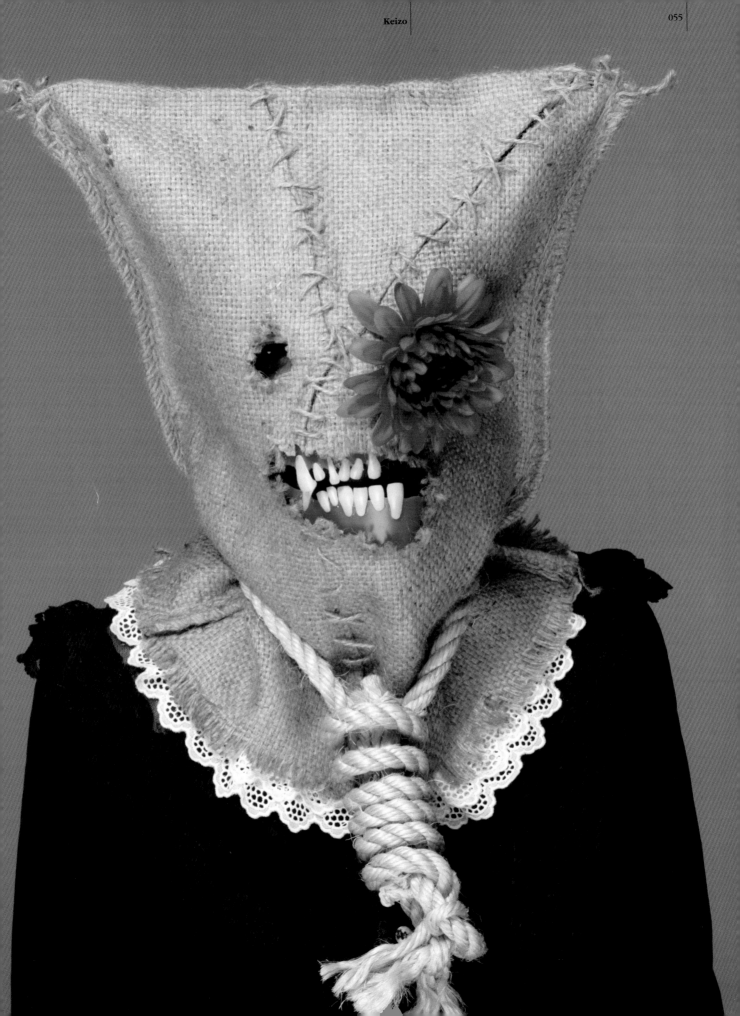

Mask of a Nun with Googly Eyes Attached Directly to Latex

Nun Mask

Keizo

This mask covers the entire head and is similar to the sort of fake heads worn with animal costumes seen at theme parks. The veil, coif, and wimple cover the mask's head and neck region, so fabricating only the head sufficiently creates a full costume effect.

A mannish nun

Concept
This nun with insane eyes is the sort that appears in nightmares and whom you hope does not exist in real-life.

Materials: Black fabric (wide muslin), white fabric (spandex), false eyelashes, latex, black wire, round end caps of a pen, etc. (3.2 mm or approx. 1/8"), gauze (to coat and reinforce the latex), acrylic paint, a belt's core, epoxy resin (super clear), modeling clay, Styrofoam and wood (to make the understructure), flexible urethane (an urethane sheet may also be used), plaster, talcum powder, instant adhesive, white spray paint, and a belt
Tools: A house paintbrush or hake-style brush, a craft knife, eyebrow scissors, sandpaper, and a round receptacle

Process

1. Fabricate an understructure in Styrofoam, and build up a face in modeling clay. Next, make a mold of the clay face. Carve a cross into the forehead.
2. Mix flesh toned acrylic paint with latex and coat the inside of the mold with a house paintbrush. Once you have coated the mold's inside with one layer, blow it dry and add a second layer. Repeat until you have added a total of 12 layers. When you apply the 13th, 14th, and 15th layer, also add gauze to reinforce the latex.
3. Pour flexible urethane foam onto the reverse side of the cast to reinforce the mask. See how the model looks when the mask is held against his or her face, and use a craft knife to cut off any excess urethane. Leave urethane on the mouth to function as gums and attach the teeth to it.
4. Remove the mask from the plaster and pat it with talcum powder. Use eyebrow scissors to trim the eye sockets and mouth.

5. To make the teeth, soften resin in hot water and form the teeth with your hands, as if you were working with clay. Keep the shapes inconsistent. Once the teeth have hardened, use sandpaper to fine tune the shapes.

6. To make the eyeballs, coil the wire to create the iris and pupil part of the eye. Attach one end of each wire to a round end cap with instant adhesive (so that the tip of the wire with the end cap becomes the coil's wiggly center).

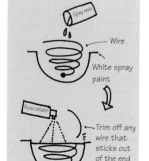

7. To make the eyeballs, insert the round end cap completed in step [6] all the way into the bottom of a round container, and fill it with epoxy resin, allowing it to solidify. Spray white paint onto the back of the hardened resin to crate the white of the eyeball.

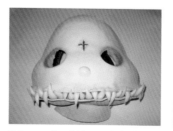

8. Use acrylic paint to create the illusion of eye shadow and blush, as well as to color the carved cross on her forehead. Insert the teeth into the urethane gums and affix with G-Bond. Color the urethane so that it will look like gums when it is seen from between gaps in the mouth. Insert the eyes from the mask's rear, and, once again, affix the eyes with G-Bond.

9. Attach the belt to the mask's rear, and use leftover fabric to make a lining for the mask.

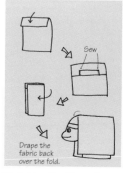

10. Put together the nun's habit with the black and white fabric and drape over the mask.

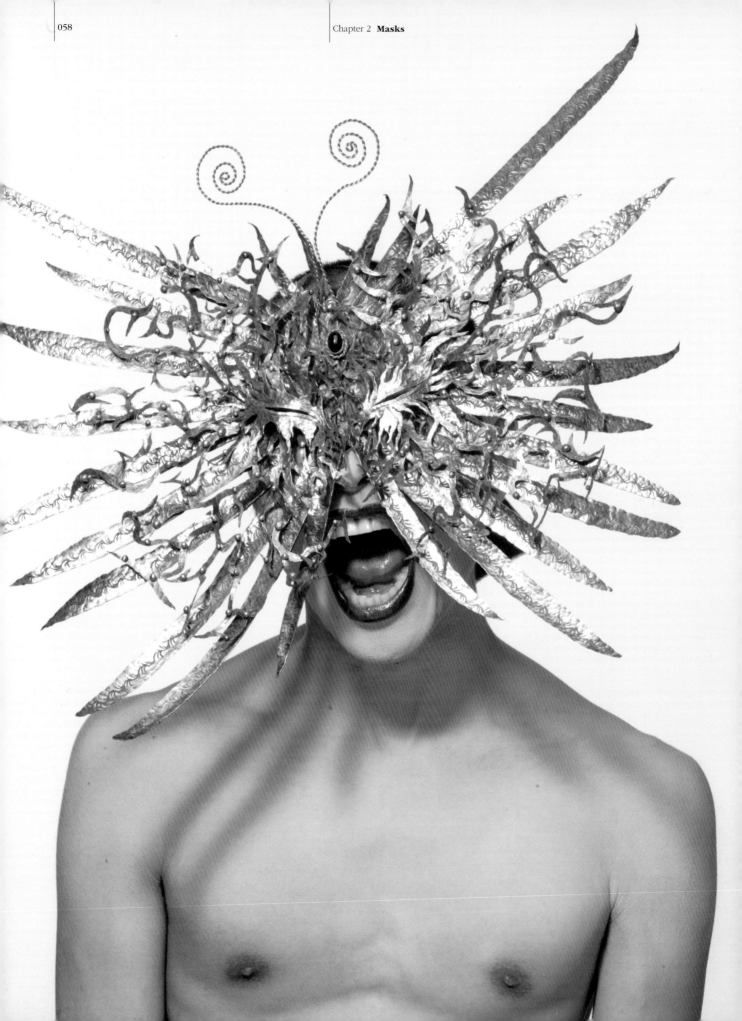

Otherworldly Mask of Sharp Metal Reflecting on White Flesh

Black Butterfly

Tomonobu Iwakura

This mask involved heating silver and brash and them hammering them to create a metal sculpture. The artist, Iwakura added textural detail to each individual sheet comprising the silver feathers. This mask requires considerable time and concentration to make, so the process is explained in detail on these pages. We encourage the reader to give it a try.

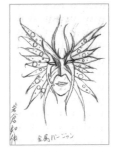

Concept

This mask portrays the world view of an ephemeral life form. The motif is a butterfly, which is forced to survive in a harsh environment. The butterfly's form is portrayed as frail and yet strong.

Materials: A brass plate (gold in tone), silver rods, silver bullions (1 kg. or approx. 2.2 lbs. total), silver plates, wire (brass and silver), an amethyst
Tools: A metal bar grinder (GTSG-150), a metal pressure roller, a router, a blow torch, a piercing saw or fretsaw, a ceramic board, homemade chisels (small, medium, and large), and a hammer (cross pein or the like)

Process

1. Place a silver bullion (of about. 50 to 60 g. or approx. 1.76 to 2.11 oz) on top of a ceramic board and heat with a blow torch (at approx. 900°C to 1000°C or 1652°F to 1832°F) for about 10 to 15 min.

2. Pound the silver bullion with a hammer while it is still red from the heat and give it an oblong shape.

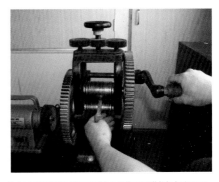

3. Lengthen the silver with a roller until it is between 1 and 2 cm in width (approx. 2/5" to .4/5"). The roller compresses the silver molecules closer together, making the silver become more brittle.

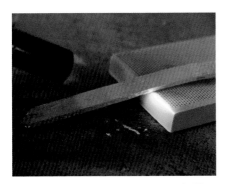

4. Heat the rolled out silver once again with the blow torch. This makes the silver more flexible. It is easier to work with the silver when it is more flexible.

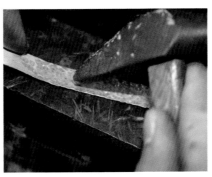

5. Use the hammer's pointed end to add detailing to the silver.

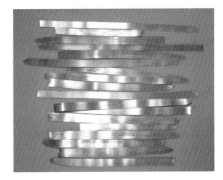

6. Repeat the same process to make the feathers.

7. Overlay two of the processed silver strips and make holes in them with a router so that they can spread in a fanned pattern.

8. Melt the end of a wire with the blow torch so that it is like a nail head. Cut the wire about 7 mm (approx. 1/4") down and pass it through the holes in the silver strips.

9. Bend the wire on the reverse side of the silver strips to hold them in place. Melt silver alloy and allow it to drip over the wire, functioning as an adhesive (silver alloy melts at a low temperature, so you cannot stop the silver brazing once you have started).

10. Continue in the same process until you have created a fan of ten silver strips.

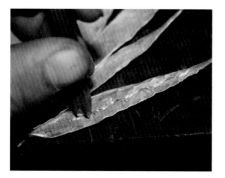

11. Use the piercing saw to shape the tips of each silver strip into a point. Take a chisel with a "C" shaped edge (the chisel pictured was handmade by filing down the edge with sandpaper) and create a random scroll pattern. Chisels may be purchased at hardware stores.

12. Lightly sketch a pattern outline in pencil on the brass sheet and cut out the pattern with a piercing saw.

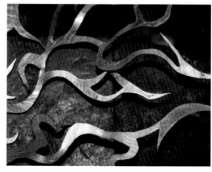

13. Have the brass pattern float over the silver feathers. The entire pattern was cut out of a single sheet of brass.

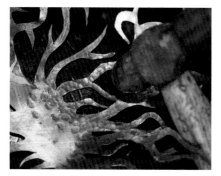

14. The surface of the brass is still too smooth, so use the hammer to give the brass's surface texture.

15. Repeat the same process to create a right and a left side of the same side. The two sides should not be mirror images.

16. Melt silver alloy to braze the brass onto the silver feathers.

17. Heat a thin silver sheet with the blow torch and then cool it down gradually.

18. Use the piercing saw to cut out the eye patterns. Hammer a piece of brass wire to flatten it, and use the flattened brass as eyeliner, silver brazing the brass to the silver eye patterns.

19. All of the metals at this point are shiny, and the overall color lacks depth. So, use liquid sulfide (an agent used to darken copper and silver) to unify the overall tone and give the metal a more somber palette.

20. Add hot water of about 70ºC to 80ºC (approx. 158ºF to 176ºF) to a large container (a storage container is pictured above), add drops of liquid sulfide to the water, and stir.

21. Placing the entire pair of wings into the liquid sulfide solution causes the water to change into the color pictured above.

22. The wings appear blackened and scorched when they are removed.

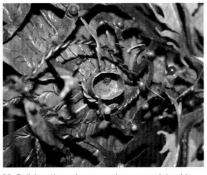

23. Polish patterned areas and areas you intend to highlight. This will remove the black and give the mask color. The main portion of the mask is now finished.

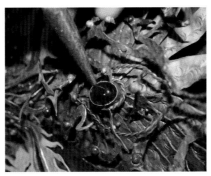

24. Make a round ring in the mask's center and inlay the amethyst.

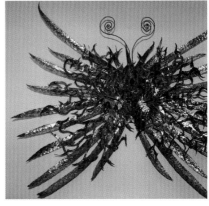

25. This shows the completed mask. To make the butterfly's antennae, fold a piece of brass wire in half. The folded wire should be on the long side. Hook the fold around a nail (the fold may be hooked around any object, provided that the object is secured firmly in place). Put the loose wire tips into the opening of a drill, and activate the drill so that it rotates the wire. This results in a single, elegantly twisted wire.

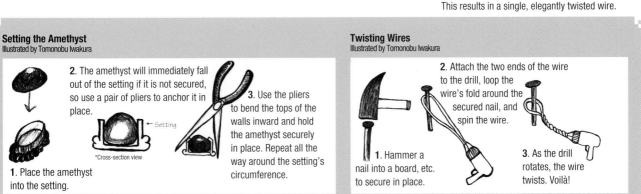

Setting the Amethyst
Illustrated by Tomonobu Iwakura

1. Place the amethyst into the setting.

2. The amethyst will immediately fall out of the setting if it is not secured, so use a pair of pliers to anchor it in place.

← Setting

*Cross-section view

3. Use the pliers to bend the tops of the walls inward and hold the amethyst securely in place. Repeat all the way around the setting's circumference.

Twisting Wires
Illustrated by Tomonobu Iwakura

1. Hammer a nail into a board, etc. to secure in place.

2. Attach the two ends of the wire to the drill, loop the wire's fold around the secured nail, and spin the wire.

3. As the drill rotates, the wire twists. Voilà!

An Advanced-Level Mask with Unlimited Variations! How to Make a Mask Using Vacuforming

Funky-Monkey Grandpa Takechio

Akihito

As with the metallic mask presented previously, this mask again is a little difficult to produce. "Vacuforming" involves applying heat to soften a plastic, vinyl, or other resin sheet, and then putting it into contact with the sides of a mold to create a cast.

Materials: Plastic sheet (0.2 to 0.5 mm thick), lifecast of the mask's target face, acrylic and lacquer-based paints, a wig, a false beard, and other items to dress up the mask
Tools: A vacuform, scissors, house paintbrushes or hake-styles brushes, a paintbrush

Concept
To elicit a physical reaction from the viewer that could be verbalized as, "How did he get so old so fast?"
Inspiration
To create an instant disguise and have fun, just like in a Lupin III animated film.

Model:
Kazuyuki Okada

Process

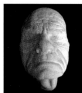

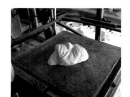
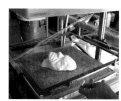
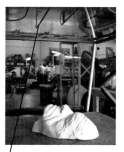

1. Find a mold of a face that you intend to turn into a mask. The "mold" can be the head of a mannequin, a doll, or half of a watermelon, provided that it is stiff, does not lose its shape when heated, and can fit over the model's head. If you intend to turn the face of a friend into a mask, then turn to the chapter beginning on p. 70 for more information on mold-making. In this case, the artist, Akihito selected the face of an elderly gentleman of a different ethnicity than the Japanese model.

2. Place the face mold on the center of the base board. The face must lie flat against the base board, or the cast will not come out properly. Make sure that it is lying flat against the base board and facing up.
*If needed, use a drill to make little air holes in deep depressions in those facial features that dramatically project out from or dip into the face (such as the corners of the eyes in the case of this face). These will allow air to escape. Akihito did not feel the need to drill air holes into this particular mold, so he did not use the technique to make this mask.

3. Set a plastic sheet into place and slowly heat the sheet electrically.

4. The black bars visible above the mold are heating elements. When they become hot, the plastic sheet softens.

5. Once the plastic sheet has softened, place it on top of the face mold, and turn on the vacuum switch.

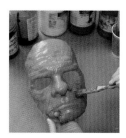
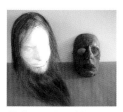

6. The metal base board, on which the mold rests, contains tiny holes. Extremely hot air is sucked through these holes. The plastic sheet becomes sucked down along with the air, causing it to fit snugly against the mold.

7. Remove the plastic cast from the mold once the plastic sheet has cooled.

8. Cut out the inside of the eyes, the mouth, and the nostrils, and trim the outside of the face with scissors.

9. Color the mask and tie a cord to the back.

10. Have a wig, a fake beard, false eyelashes, and other items to dress up the mask on hand. Akihito borrowed the items shown from KNB EFX Group's Hair Department.

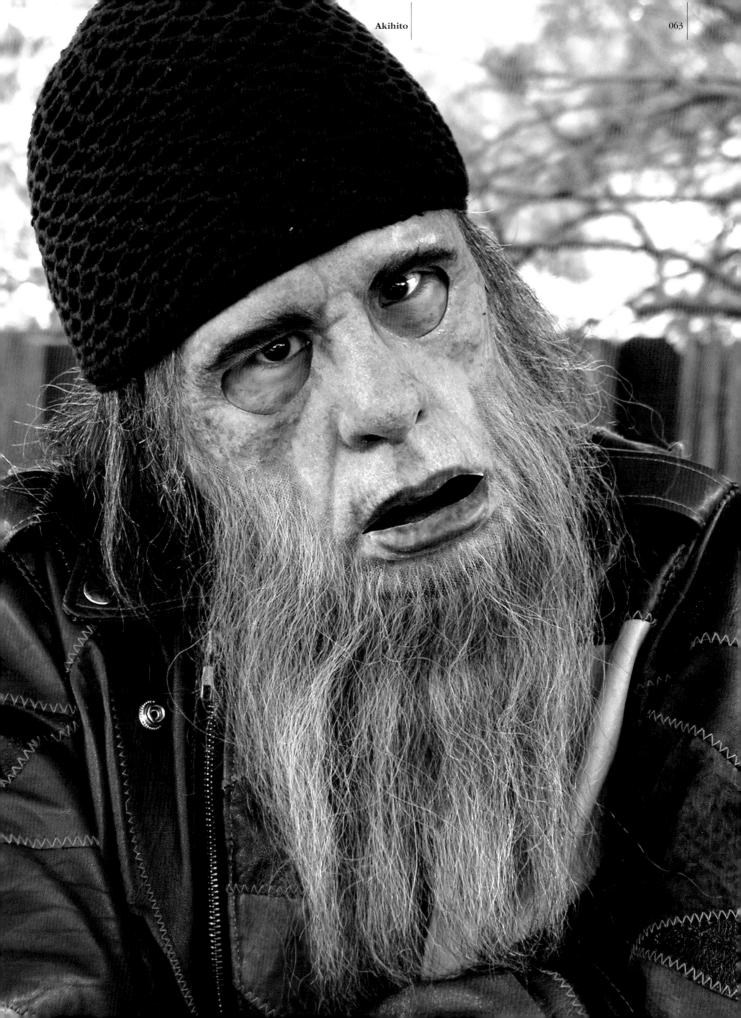

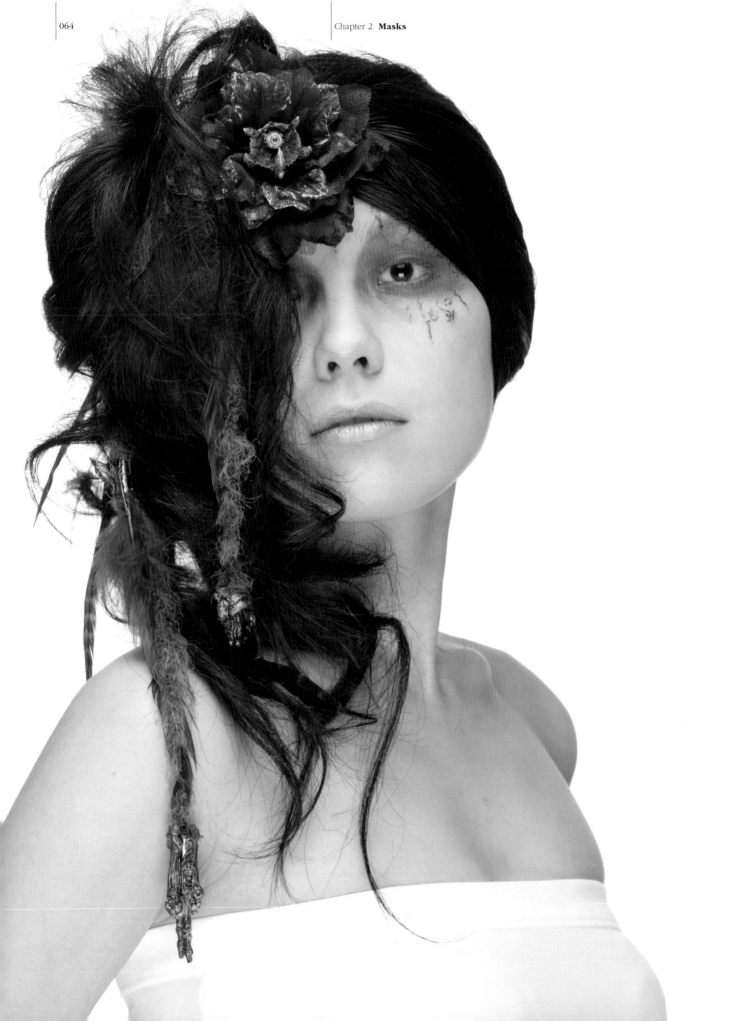

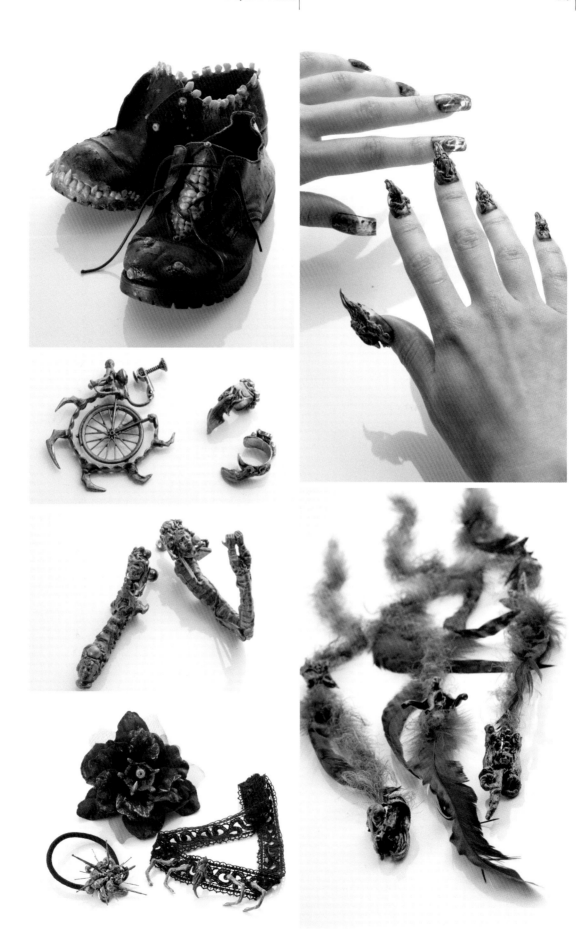

Silene # Manabu Namikawa

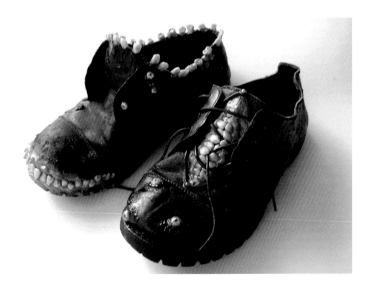

This section moves beyond masks and presents methods of remodeling shoes, jewelry, and other accessories to portray a complete look. Remodeling a worn-out pair of shoes allows you to create a totally unique, original pair, unlike any other on the planet. Once you have established what the design will be, glue on decorative elements to reinforce the concept and use Super Sculpey clay to make the decorative elements seem like organic parts of the shoes. Thick soled leather shoes are probably the easiest to remodel.

Materials: An old pair of shoes, doll eyes, Super Sculpey clay, instant adhesive, epoxy putty, Tamiya Color Acrylic Paint, clear coat lacquer spray, acrylic paint, gloss finish for use with latex

Concept
A people-eating, demonically possessed, mischievous pair of shoes that has gobbled its owner in a Lupin III animated film.

Process

1. Create teeth and gums with Super Sculpey clay and use acrylic paint to color them. Cutting the toe of the shoe or the vamp would make the shoe difficult to wear. Instead, add a structural base (i.e. "gums") and attach the teeth with instant adhesive.

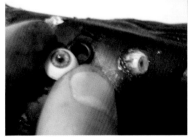

2. Insert doll eyes into small holes, such as the shoelace eyelets, etc., and attach the eyes with instant adhesive. Apply Super Sculpey around the eyes to hold them securely in place.

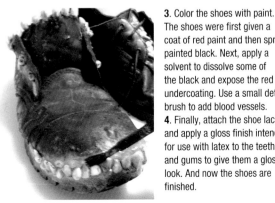

3. Color the shoes with paint. The shoes were first given a coat of red paint and then spray painted black. Next, apply a solvent to dissolve some of the black and expose the red undercoating. Use a small detail brush to add blood vessels.
4. Finally, attach the shoe laces and apply a gloss finish intended for use with latex to the teeth and gums to give them a glossy look. And now the shoes are finished.

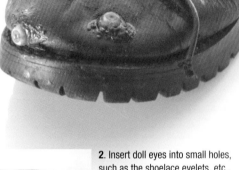

ManabuNamikawa
Original Accessories

Special effects artists now only make masks, but they also create earrings, press-on nails, extensions, and other accessories that complete the unique world they are portraying. This section covers how to make demonic-looking accessories out of familiar materials.

Materials:
To make demonic fingernails: Clear press-on nails

To make trinkets and accessories: Pencil caps, a pipe cutter, feathers, aluminum foil, yarn, jewelry-making parts, wheels from a plastic model set, Mr. Color model paint

To make hair accessories: Hair accessories and seashells

To make a choker: Black lace, Velcro, and plastic model parts

To make earrings: Jewelry-making parts

For all of the above: Instant adhesive, epoxy putty, Tamiya Color Acrylic Paint, clear coat lacquer spray, and acrylic paint

Demonic Fingernails

Process

1. Divide up the clear press-on nails into the different fingers. Make decorations for the top of each nail. Remove the decorations and create a duplicate, backup set. Instant adhesive is used to glue the decorations onto the press-on nails, so you will need a clean, backup set of nails.

2. Use dual-sided tape to hold the nails in place on top of a base. Make sure the base is something that you do not mind getting messy. Use epoxy putty to form the nail decorations.

3. Color the decorations with Tamiya Color Acrylic Paint.

4. Remove the colored decorations from the first set of press-on nails, and glue them to the second, backup set of nails with instant adhesive.

5. Color both sets of nails first with red Tamiya Color Acrylic Paint and then with blue Tamiya Color Acrylic Paint. Apply a clear coat of lacquer spray to finish. Irregularity in the paint coat enhances the desired mood. If you intend to add decorations to the nails on both hands, repeat the same process for the second set of backup nails. Use dual-sided tape to attach the completed, decorated press-on nails to the model's own nails.

ManabuNamikawa
Unique Accessories

Trinkets and Extensions

Process

1. The trinkets' bases consist of metal pencil caps cut with a pip cutter into roughly 1 cm (approx. 2/5").

2. Use epoxy putty to fabricate the trinkets and add them to the tops of the caps. The trinket to the farthest right consists of rubber tubing and a wheel from a toy plastic model set, attached to the pencil cap with instant adhesive Add a drop of instant adhesive between the epoxy putty and the pencil cap to set the trinkets in place.

3. Glue the trinkets to the metal caps, while double-checking the overall balance, and paint with Tamiya Color Acrylic Paint.

4. Apply red and purple Mr. Color model paint over the Tamiya Color Acrylic Paint and add a clear coat of lacquer spray to finish.

5. To make extensions, braid some yarn and then interweave feathers into the yarn, fixing it them place with thread. Wrap aluminum foil around those areas on the extension where trinkets will be added, and then thread the aluminum through the trinkets to finish.

Hair Accessories

Process

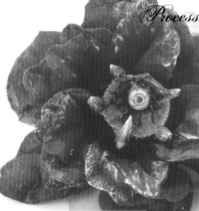

1. Cheap, black hair accessories purchased at a drugstore form the base components.

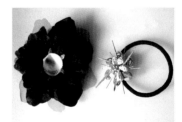

2. Cut the petals off the flower pictured to the right (or a similar hair accessory) and glue shells to the flower using instant adhesive. Attach pins sold as jewelry-making parts to the flower.

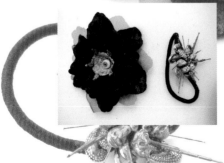

3. Using Tamiya Color Acrylic Paint, add black spots to the shells and jewelry pins. (Apply the spots so that they can be made to look like irregularity in paint application when you color the flowers later.) Glue a doll eye to the left flower's center with instant adhesive. Add epoxy putty on top of the balls on the hair accessory to the right. This creates a sense of texture.

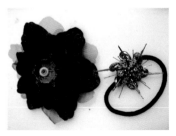

4. Add a final coat of red Tamiya Color Acrylic Paint and apply a clear coat of lacquer spray to finish.

ManabuNamikawa
Unique Accessories

Choker

Process

1. Cut the lace into a length that is long enough so that it will not choke the model, and then add another 3 cm (approx. 1 1/5"). Attach 3 cm of Velcro to each of the additional 3 cm of lace and to the opposite end of the lace.

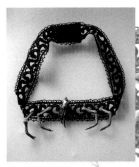

2. Fabricate insect legs and a tiny skeletal hand using epoxy putty and attach to the end of each metal rings used for attaching charms and trinkets. Pass thread through each metal ring and sew your handmade trinkets to the lace.

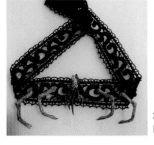

3. Color with Tamiya Color Acrylic Paint.

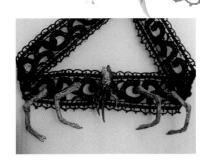

4. Apply a clear coat of lacquer spray to finish.

Earrings

Process

1. Use commercially available jewelry-making parts as the understructure.

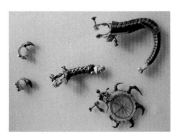

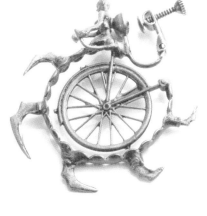

2. The artist, Namikawa produced insect-inspired earrings for this book. The wheel earring pictured to the lower right consists of a wheel from a toy plastic model set around which was wrapped a large, metal ring intended to be used as a jewelry part. Sticks from a toy plastic model set were attached to the wheel in two locations with instant adhesive. A human form fabricated in epoxy putty sits on the seat, while claws reminiscent of insect legs made of epoxy putty surround the wheel. Polishing the metal with sandpaper before adding epoxy putty makes the epoxy stick more readily.

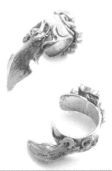

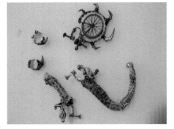

3. After painting the earrings with Tamiya Color Acrylic Paint, apply a coat of white overall so as to achieve a subdued tone.

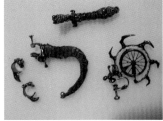

4. Finally, paint the earrings with copper-colored Mr. Color model paint and apply a clear coat of lacquer spray to finish.

Chapter 03

Making Molds

Up to this page, we primarily discussed wounds that could be produced using only paint, masks that could be fabricated from paper, and the like. However, more convincing special effects makeup requires something with an understructure that fits closely against the wearer's face. Mold-making constitutes the most critical element of special effects makeup. Once you are able to make molds, you will be able to produce arresting special effects makeup that fits snugly against the wearer's skin, and includes fingers, teeth, feet, and torso parts as well as faces.

Why is mold-making necessary?

The biggest characteristic of special effects makeup is that a prosthetic, unlike a mask, adheres to the contours of the wearer's face and allows to come through the wearer's facial expressions. Consequently, the interior of a prosthetic (the side that attaches to the wearer's face) mirrors the contours of the wearer's face, while the exterior (the visible side) is a sculpted design. A prosthetic must have an exterior that is different from the interior.

1. Wearer's face

2. The above is a concept design, drawn without any consideration for the wearer's actual face. The final product may not look precisely like this.

3. If the prosthetic's interior does not correspond to the wearer's face, then the positioning of the prosthetic's and the wearer's eyes, mouth, and nose will not match, and gaps may form. The wearer will not be able to see, talk, or even breathe. The prosthetic will have no use from either a photography or performance perspective.

4. However, if you make a cast from a mold, so that the interior matches the wearer's facial contours, then the eyes, nose, and mouth will fit perfectly to those of the wearer, and the wearer can change facial expressions at will. The area indicated in blue is the special effects makeup prosthetic.

Mold-Making Process

Before we show you actual examples of mold-making, we will first cover the entire process using easy-to-follow illustrations. This page strictly covers the process in general terms to make it comprehensible. For more detailed information regarding temperature settings and volumes, please peruse the actual mold-making examples that we provide, complete with photographs, beginning on page 72.

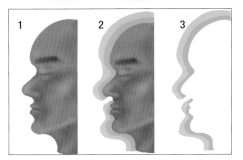

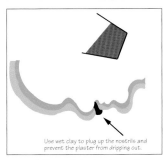

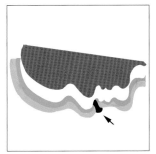

1. Model's natural face

2. Coat the face with alginate (a pink or light green gum that dentists use when making a tooth mold; alginate appears as the green area in the diagram above). Cover the face with plaster bandages and allow to them harden (the plaster bandages are indicated in blue in the diagram above and are the sort used to make orthopedic casts). Make sure that the model's eyes are closed and that you have opened up holes for the nostrils so that the model can breathe.

3. Once the alginate and the plaster bandages have hardened, remove the cast from the face. The alginate should come off easily.

4. Use wet clay to plug up the nostrils and pour plaster (denoted in grey in the diagram) into the alginate.

5. Once the plaster has hardened, remove it from the mold. You have now made the positive mold. Smear on a light layer of Vaseline to make the clay go on more easily.

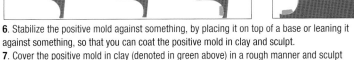

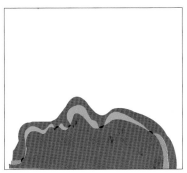

6. Stabilize the positive mold against something, by placing it on top of a base or leaning it against something, so that you can coat the positive mold in clay and sculpt.

7. Cover the positive mold in clay (denoted in green above) in a rough manner and sculpt details into the clay. Use Roma Plastilina, modeling clay, or another clay.

8. Once you have finished sculpting the clay, make a mold following the same guidelines as in step [5]. Add wet clay around the sculpted clay to create a border (denoted in yellow in the diagram) to prevent a plaster flash from forming when the plaster is poured. You may also use a key. Please refer to pp. 72 and on for more information.

9. Lay the plaster lifecast with the sculpted clay down and coat with a clear lacquer spray. This will make it easier to remove the plaster from the clay. Pour the plaster over the cast. Mix in sisal strips to reinforce the plaster.

10. The eyes, mouth, nose and other areas with open holes are part of the negative mold. These holes are helpful when matching up the positive and negative molds.

11. Pour the plaster and smooth out the surface. Set it aside, allowing it to harden.

12. Once the plaster has hardened, remove the plaster lifecast and the sculpted clay. You have now finished the negative mold.

13. Pour mixed foam latex, in liquid form (appearing in red in the diagram), over the plaster positive mold (the original lifecast). Brush foam latex on the detailed interior of the negative mold (the mold created from the sculpted clay).

14. Bring the positive and negative molds together so that they align and place a weight on top of the molds to hold them in place.

15. Fire in an oven for three hours at 90°C (approx. 194°F). Next, separate the positive and negative molds, sprinkling talcum powder on the latex as you work. The finished product is a prosthetic whose inside matches the model's face and whose exterior reflects the designed special effects makeup piece. Now you may color the piece.

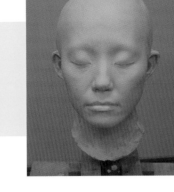

Making a Mold of a Face

Now that you understand the mold-making process, let's look at how to make an actual lifecast. Here, we show you how to make a mold of the model's entire head, but if the prosthetic is only supposed to cover the model's face, then making a mold of just the front of the head is plenty.

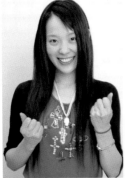

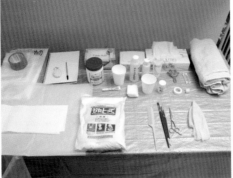

Materials & Tools

Materials: Pros-Aide, isopropyl alcohol, alginate, plaster bandages, Vaseline, release agent (mixed with water at a 1:1 ratio), warm water, plaster, and clay (to plug up the nostrils and other openings when pouring the plaster)

Tools: A comb, scissors; a red pencil (a pen with water-based ink is also acceptable); gauze, facial tissue; something to cover up clothes and keep them clean (bath towels and plastic garbage bags both work well); gummed tape; cotton swabs; a container for dissolving the alginate

Model: Marie

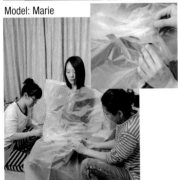

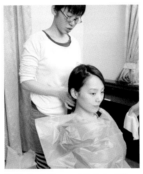

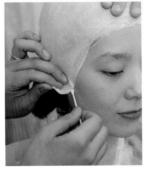

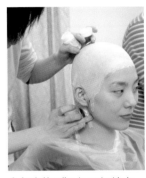

1. Cover the model's entire body (excluding the head) with a sheet to prevent his or her clothes from becoming dirty. Anything large enough to cover the model completely will suffice, including plastic sheets or translucent trash bags. Have the plastic covering the model's upper body lie over the plastic covering the bottom half to prevent alginate from leaking through the two layers of plastic onto the model's clothes.

2. Tie back the model's hair. If the model has short hair, use bobby pins to pin the hair close to the head rather than having the model wear a head band so that the lifecast will match the model's face as accurately as possible.

3. Cover the model's head with a latex bald cap and glue it in place with Pros-Aide to prevent wrinkles from forming. If you do not have access to a bald cap, use Saran Wrap and apply surgical tape around the edges. Alternatively, have the model wear a thin bathing cap.

4. Apply Vaseline to protect hair at the sides of the ears. This will prevent the alginate or plaster from sticking.

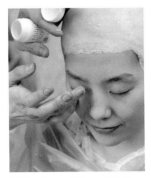

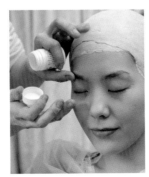

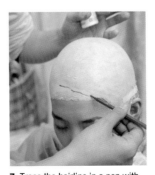

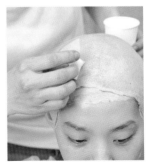

5. Likewise, coat the eyelashes with Vaseline. Have the model remove contact lenses to get a more accurate cast.

6. Coat the eyebrows in Vaseline as well.

7. Trace the hairline in a pen with water-based ink. Use a color that stands out, like red or orange. The water-based ink will end up staining the inside of the alginate, reflecting the model's hairline, when it is applied on top of the ink.

8. Apply soapy water to the bald cap to prevent the alginate from sticking. The soapy water functions as a mold release agent.

9. Begin the mold-making process for the back of the head. Soak plaster bandages in warm water that is about the same temperature as your skin and allow them to soften.

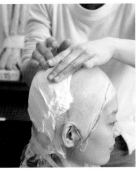

10. Apply the plaster bandages to the back of the model's head so that they adhere to the head's contours.

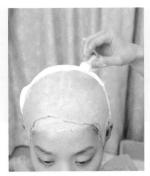

11. Once you have finished applying the plaster bandages to the back half of the model's head, pat the surface to smooth it out and completely remove any air pockets so that the plaster fits closely against the head. Apply soap to the edge of the plaster bandages, where the back half will overlap with the front. This will make it easier to remove the two halves.

12. Dissolve the alginate in lukewarm water that is about the same temperature as your earlobe, until the alginate has a gooey consistency. Take careful note that if the water is too hot, the alginate will solidify too soon. Alginate tends to solidify quickly on skin, so make sure that you have absolutely completed all other preparations and that all you have left to do is apply the alginate first, and then mix the alginate all at once.

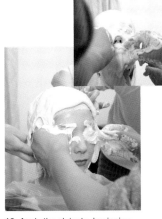

13. Apply the alginate, beginning with the top of the head and smoothing it down the sides. Start with the eyes, nose, and mouth. Cover the entire back of the model's head, while smoothing out any alginate that comes dripping down and ensuring that the nostrils remain clear for breathing.

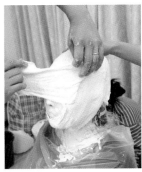

14. Once the alginate has solidified (this should take no more than five minutes), repeat the same process for the front of the head. Cover the rest of the face with plaster bandages that have been soaked in warm water.

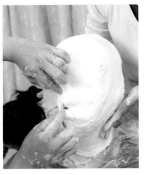

15. Cut a plaster bandage so that it is small enough to fit on the nose between the nostrils and apply it to the nose.

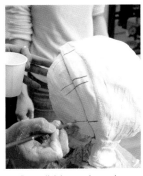

16. Draw division markers where the front and back meet to help you match up the two halves of the mold after it is removed.

How to Make a Bald Cap

Use the back of a model's head to make a bald cap. Remember that once you have a mold of the model's head, you can make as many bald caps as you like.
1. Apply latex to a sponge and pat a thin layer of the latex onto a lifecast of a head.
2. Once the latex in step [1] has dried, pat down a second layer.
3. Repeat the above process eight times. Once the latex has finished drying, the bald cap is complete.

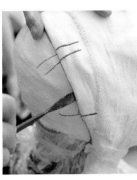

17. Use a spatula or putty knife to separate the molds once the plaster bandages have hardened.

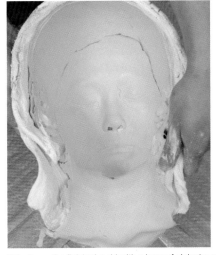

This shows the finished mold with a layer of alginate and a layer of plaster bandages visible. The red line inside the alginate is the hairline drawn in red ink on the bald cap (see previous page). Once plaster is poured into this mold, it will become the positive mold and will serve as the understructure for sculpted clay.

Making a Mold of a Hand

Compared with making a mold of a head, making a mold of a hand is relatively easy and does not require much space. You can use hand molds to make hands with unnaturally elongated fingers or that have raised wounds, etc.

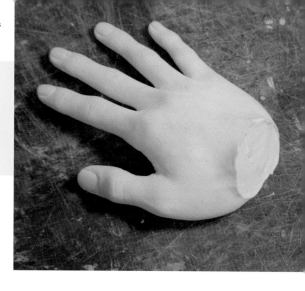

Materials & Tools

These are the same as when making a mold of the head. However, plaster bandages are not necessary to make molds of small areas. Filling shallow container that will cover the entire hand with alginate works perfectly well.

1. Have the model place his or her hand into a box. The hand should be in natural position with the fingers spread.

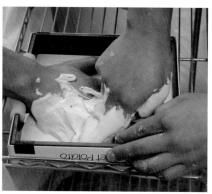

2. Dissolve alginate in lukewarm water and spread the alginate underneath and between the fingers.

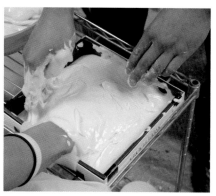

3. Cover the entire hand in alginate.

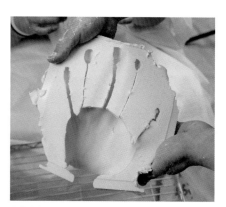

4. Pull the alginate off the hand, once it has solidified. No alginate was applied to the palm, so it should come off easily.

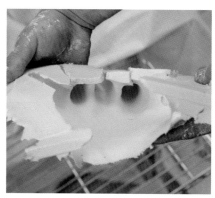

5. This photo shows the finger holes. Pour plaster into this mold to finish a cast of the fingers.

How to Make a Mold of the Thumbs

The thumb has a greater range of motion than the other four digits. If you intend to create a mold that has intricate variation in how the fingers are held apart, first make a mold of the hands and then make a mold of the thumbs by themselves. Have the model put his or her thumbs inside a paper cup and then pour in alginate. Ensure that the remaining fingers are stabilized and held motionless while making a mold of the thumbs.

Making a Mold of Teeth

Teeth molds are indispensable for creating fangs or jagged teeth. The process is essentially the same as that dentists' use.

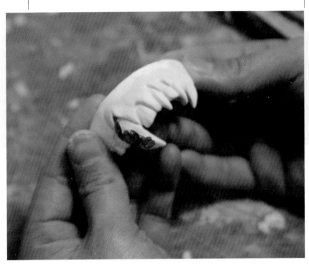

Materials & Tools

A dental tray, a paper cup, disposable chopsticks, and a vinyl apron

1. Dissolve alginate in a clean paper cup. The paper cup should only be half full.

2. Fill the dental tray with alginate.

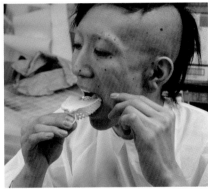

3. Have the model insert the tray all the way into his or her mouth and clamp it firmly between the teeth. This will create a dental impression.

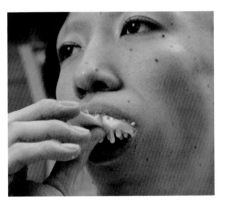

4. Have the model hold the alginate and dental tray in his or her mouth for three to four minutes. Hiro is the name of the model pictured above.

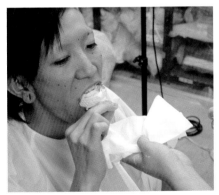

5. Remove the dental tray once the alginate has solidified. Clean out any alginate remaining in the mouth to finish.

6. This shows the impression of the teeth. Rinse it out and fill it with plaster to finish.

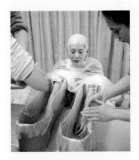

Word of Advice on Making Molds of the Arms

Construct two long boxes out of cardboard, as shown in the photo, and line the interiors with plastic sheets to prevent the alginate from leaking out. This eliminates any need for the model to hold his or her arms up in the air, making the mold-making process easier on the model. Molds can be made of the legs in the same manner. You can make a mold of any body part, provided that you have some type of container that will prevent the alginate from leaking out.

The Process from Sculpting to Completing the Foam Latex Prosthetic

Materials & Tools

Foam Latex Materials: Latex base, curing agent, foaming agent, gelling agent, and wax (as a release agent)

Mixing Tools: Hand mixer (a cheap seven-speed power mixer), a scale (if possible, one that gives accurate measurements in 0.1 g units), a spoon, a spatula, and a paper cup

Oven: The oven appearing in the photograph is a professional model. A regular kitchen oven or the dish-drying setting of a dishwasher may be used instead.

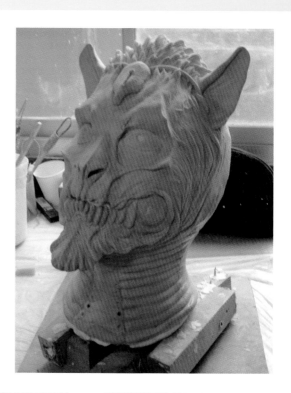

1. Model: Atsushi

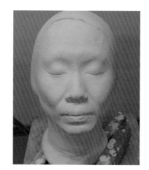

2. Plaster lifecast of Atsushi (positive mold)

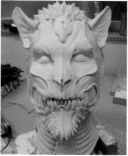

3. Sculpt the target design in modeling clay over the positive mold.

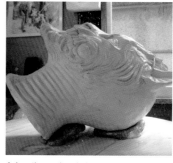

4. Lay the sculpted clay design down on top of patties of wet clay in Saran Wrap, using the wet clay as cushions.

5. Fabricate a key out of clay. This is inserted into the base, and when the face and the rear of the head are brought together, the two sides of the key align perfectly.

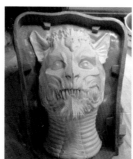

6. Use wet clay to build a wall around the clay form, so that the plaster will not spill out.

Once you have a lifecast of the target model, you may sculpt in clay over the lifecast to create any design desired. To make a prosthetic, pour foam latex between the negative mold fabricated from the clay design and the original lifecast (i.e. the positive mold). A prosthetic is a latex prosthetic applied to the model's face (such as a protruding forehead or pointy ears or a nose, etc.)

7. Spread plaster over the detailed areas first and then pour the plaster over the entire mold.

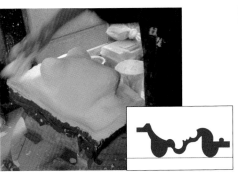

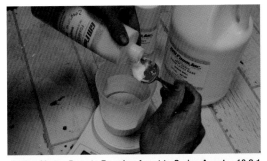

8. After pouring the plaster, construct three projections to serve as support in laying down the mold horizontally when pouring foam latex onto the mold's inside.

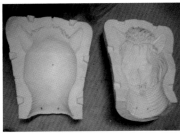

9. Once the plaster has dried, remove it from the clay form (do not worry if the clay form breaks). Make a plaster mold of the rear of the head, using the same process. The plaster face mold appears in the right side of the photo, while the plaster mold of the back of the head appears in the left. Bisque-fire the plaster molds to try them completely.

10. Preheat the oven to 90°C (approx. 194°F).

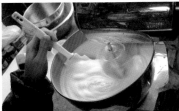

Ratio of Latex Base to Foaming Agent to Curing Agent = 10:2:1
The amounts needed to make a single foam latex prosthetic are 150 g. (5.29 oz.) of latex base, 30 g. (1.06 oz.) of foaming agent, and 15 g. (0.53 oz.) of curing agent.

11. Pour the latex base into a bowl and add the foaming agent and the curing agent. Stir.

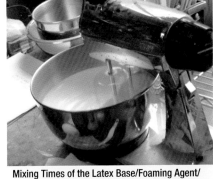

Mixing Times of the Latex Base/Foaming Agent/ Curing Agent Mixture
1. Electric mixer speed 1 setting: 1 min.
2. Electric mixer speed 7 setting: 3 min.
 (The mixture should become foamy at this stage.)
3. Electric mixer speed 4 setting: 2 min.
4. Electric mixer speed 1 setting: 3 min.

12. Mix the three liquids with a hand electric mixer until all of the bubbles disappear.

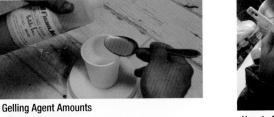

Gelling Agent Amounts
The amount of gelling agent required changes according to where you live and what season it is. However, the following are the standard amounts of gelling agent combined with 150 g. of latex base.
Summer: 2 to 3 g.
Winter: 6 to 8 g.

13. Coat the inside of a paper cup with wax and measure out the correct amount of gelling agent. The gelling agent causes the latex base to solidify. During hot weather, the gelling agent causes the latex base to solidify faster, so the amount differs in the summer from that in the winter. Measure out the correct amount of gelling agent ahead of time.

How to Mix the Gelling Agent
Once you have added all of the gelling agent to the bowl, hold the mixer in one hand while it is switched on, while slowly turning the bowl with the other. Turn the bowl in the opposite direction as the beaters for 30 sec. Turn the bowl in the same direction as the beaters for 30 sec.
Mix well with a spatula to finish.

14. After mixing the latex base, etc. in step [12] for the final three minutes on speed 1, continue on speed 1 for another 30 seconds while adding the gelling mixture to the bowl.

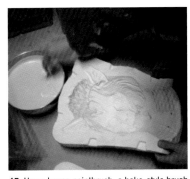

15. Use a house paintbrush, a hake-style brush, or a sponge to apply the mixed liquids to the negative mold (the interior of the clay form).

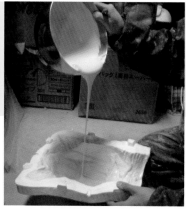

16. Spread the latex onto the detailed areas first and then pour the latex into the mold so that it distributes evenly. Work quickly before the latex has a chance to solidify.

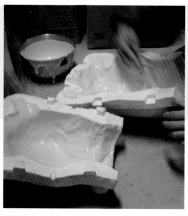

17. Carry out the same process with the head's rear. Spread the latex onto the detailed areas and then pour the latex into the mold.

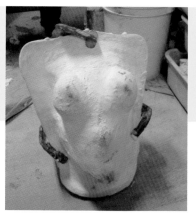

18. Press the positive and negative molds together (the model's lifecast is sandwiched in the center). First place the negative mold of the face, containing the foam latex onto the original lifecast (the positive mold) and press. Next, press the negative mold of the head's rear, containing the foam latex onto the back of the lifecast. Use the key to match up the front and back molds. Hold the molds together with clamps. Allow the molds to sit for 20 minutes so that the foam latex has sufficient time to solidify.

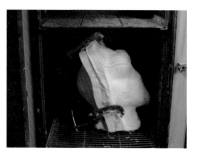

19. Place the mold into a preheated oven.

20. Fire the mold at 90ºC (approx. 194ºF) for approximately three hours. Once the three hours have expired, remove the mold from the oven and remove the cast from the mold while sprinkling talcum powder on the cast and taking care that it does not break.

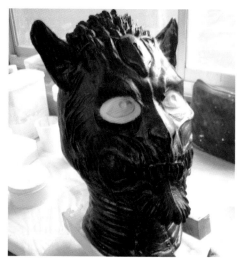

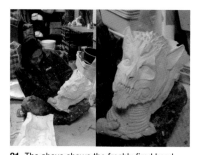

21. The above shows the freshly fired head prosthetic.

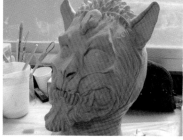

22. Remove the model's lifecast that is still inside after you have finished painting the prosthetic.

23. This shows the prosthetic after it has been painted with PAX paint. Mix acrylic paint with Pros-Aide and then paint the prosthetic as desired. Remove the lifecast from inside, and glue the prosthetic to the model's own head with Pros-Aide to finish.

Alternatives to Using a Professional Oven

- When using a regular kitchen oven: Fire at approx. 100ºC (approx. 212ºF) for three hours.
- When using a dish dryer: Firing at 90ºC (approx. 194ºF) for three to four hours is preferable. On a note of caution, the heat in dish dryers tends to be significantly unevenly distributed, so the time that the piece should be left in the dish dryer depends greatly on the environment. Furthermore, small, detailed parts could end up too hard or under-fired, so divide the prosthetic into smaller pieces and change their positions in the dish dryer regularly.
- When air drying: If it is summertime, and you are allowing the piece to dry naturally, place the piece in a sunny, indoor area and allow it to sit for one month.

Hollywood-Style Mold-making

So, what is the mold-making process used in Hollywood, the place that gave birth to special effects makeup? We approached Akihito, a professional special effects artist working at KNB EFX Group, a special effects studio that has participated in the making of numerous Hollywood feature films, including The Chronicles of Narnia: The Lion, the Witch and the Wardrobe, and asked him to show us how it's done.

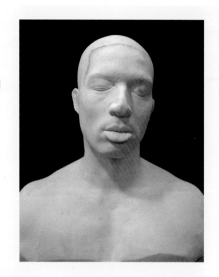

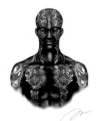

Concept
The title of this piece is "Ara-Han."

Materials & Tools
KNB uses essentially the same tools as are used in Japan. However, people of many different ethnic backgrounds work in Hollywood, so there is the added process of checking the actor or model's skin tone.

1. Selecting the appropriate model is crucial. Choose a model who best suits the image you pictured. The model Akihito chose was Ralph J. Hooper III, who visits the gym every day to workout, and who has an excellently developed physique.

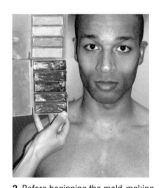

2. Before beginning the mold-making process, Akihito first takes Ralph's measurements (this is done when covering the entire body in makeup). Akihito also checks Ralph's skin tone. The model's skin tone plays a tremendous role on the day that the makeup is actually applied. Akihito also photographs the front, side, and top of Ralph's head.

3. Now a mold will be made of the model's head. The photo above shows the KNB studio. Making head molds creates an unexpectedly big mess, so make sure you do sufficient prep work to protect the space.

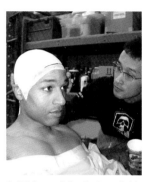

4. Akihito carefully attaches a bald cap with Pros-Aide (an adhesive) to Ralph's head to protect his hair and then traces Ralph's hairline on top of the bald head.

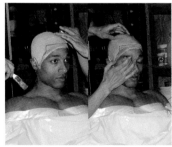

5. Always cover the model's eyelashes, eyebrows, and beard, and any other facial hair with Vaseline as protection.

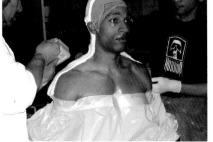

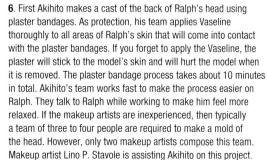

6. First Akihito makes a cast of the back of Ralph's head using plaster bandages. As protection, his team applies Vaseline thoroughly to all areas of Ralph's skin that will come into contact with the plaster bandages. If you forget to apply the Vaseline, the plaster will stick to the model's skin and will hurt the model when it is removed. The plaster bandage process takes about 10 minutes in total. Akihito's team works fast to make the process easier on Ralph. They talk to Ralph while working to make him feel more relaxed. If the makeup artists are inexperienced, then typically a team of three to four people are required to make a mold of the head. However, only two makeup artists compose this team. Makeup artist Lino P. Stavole is assisting Akihito on this project.

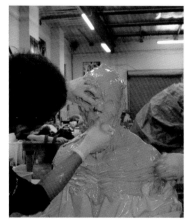

7. Once Akihito and Lino have finished applying the plaster bandages, they quickly remove excess that has stuck to Ralph's front (including his shoulders and his ears) and use alginate to make a mold of his head. Always make sure that the model's nostrils are clear so he or she can breathe.

Hollywood-Style Mold-making

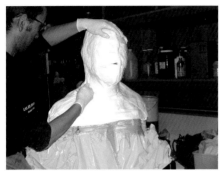

8. After the alginate has solidified, Akihito and Lino reinforce it with plaster bandages. Before applying plaster bandages to the front of Ralph's head, they smear Vaseline on the plaster bandages of the head's rear so that the bandages of the head's front and the bandages of the head's rear do not stick together.

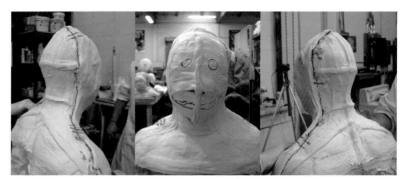

9. They draw lines in colored pencil, showing where the plaster bandages divide. These lines will play a key role in realigning the mold later, after it has been removed from Ralph.

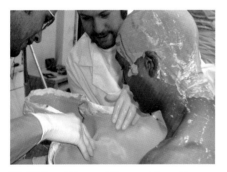

10. Akihito and Lino carefully remove the mold from Ralph. They clean him up, and thereby complete the mold-making process.

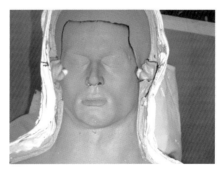

11. This photo shows the inside of the mold.

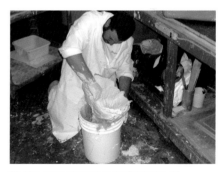

12. Lino pours plaster into the finished mold.

13. The freshly poured plaster is heated. Once it is finished baking, the team cools it down thoroughly and carefully removes the plaster bandages and the alginate. They make any adjustments needed, and Ralph's lifecast is finished!

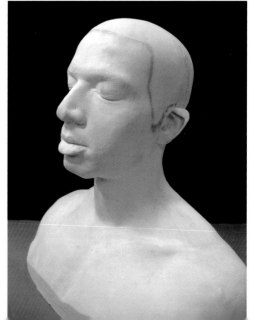

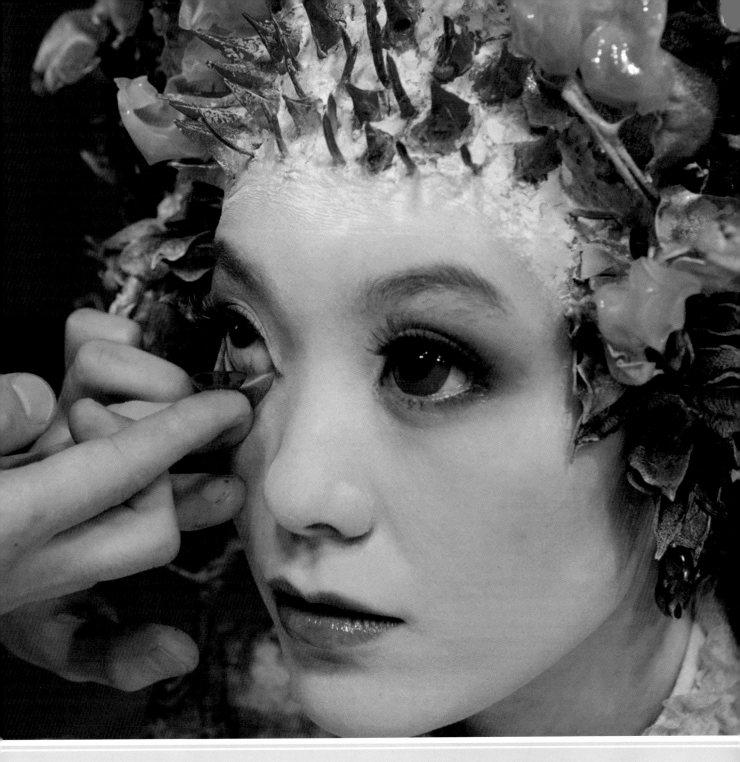

Practical
Applications

Chapter
04

Catlike Hands

These catlike hands may be worn like gloves and are easily constructed of papier-mache and a pair of gloves. Have fun playing around with the design by changing the color of the fur boa used or of the paint, etc. If you do not already have a mold of the hands, use urethane and vinyl gloves instead.

by Tomonobu Iwakura

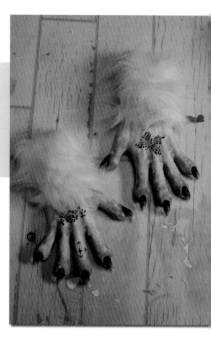

Materials & Tools

Materials: A mold of the model's hands, papier-mache, urethane sponge, latex, G-Bond, white gloves (any cheap pair of while gloves will suffice), acrylic paint, PAX paint (a mixture of Pros-Aide and acrylic paint combined at a ratio of 1:1), and cotton

Tools: A paper cup, a spatula (putty knife), an airbrush, a brush, and a blow dryer

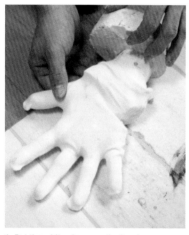

1. Put the white gloves on the hand casts. Divide the hands into two parts at approximately where the life lines (lowermost of the three main creases on the palm) lie, one part consisting of the thumb and the other of the remaining fingers. This will make the mold-making process easier.

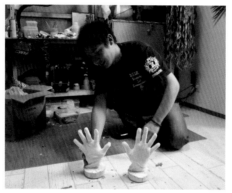

2. This shows the two hands wearing the gloves. If you do not have hand casts available, fill vinyl gloves with urethane sponge until all creases and wrinkles have completely disappeared. These may be used instead of hand casts.

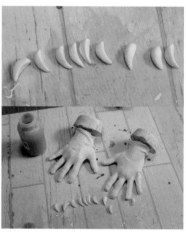

3. Fabricate the claws out of papier-mache. These are cats claws, so they should have a certain degree of thickness to them. Hold them against the gloves repeatedly as you work and adjust the forms as needed.

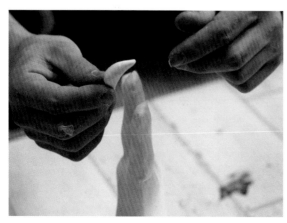

4. Glue on the claws one at a time with G-Bond.

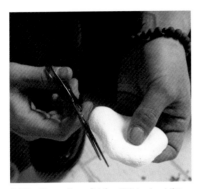

5. Trim the papier-mâché until it is about the size of a fingertip.

6. Press the papier-mâché fingertip onto your own fingertip to achieve an appropriately rounded form.

7. Push the papier-mache fingertip down onto your finger with a brush to create a texture impression.

8. Use G-Bond to glue the papier-mache fingertip to the white gloves. Repeat for each finger. These form the toe pads.

9. Attach the palm pad with G-Bond as you did the toe pads.

10. Make the toe pad for the thumb slightly larger than you did for the other digits and attach it with G-Bond.

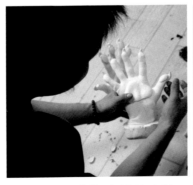

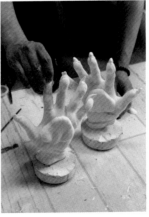

11. The makeup artist has just finished gluing all of the pads onto both hands.

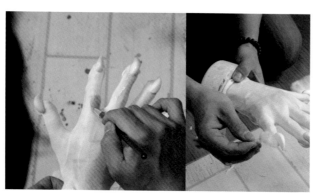

12. Once you have achieved the target shape, use a brush to coat both hands with G-Bond. The hands should become stiff after the G-Bond has hardened.

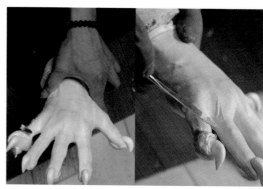

13. After the G-Bond has hardened, shape the flesh around the claws (from which the claws protrude) so that it has a bulging form. Apply latex around the claws and glue on cotton, taking care not to flatten the cotton.

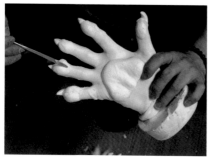

14. Use a spatula to cover the cotton with latex. Apply the latex so that it creates a smooth coat over the cotton's surface and not so that it soaks into the cotton. This will give the fingertips the desired adorable, plump shape.

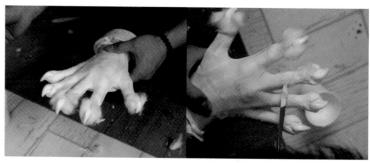

15. Glue cotton to the remaining fingers in similar fashion.

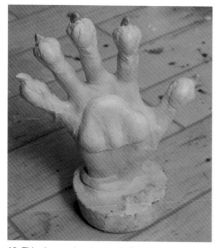

16. This shows a hand once the latex-coated cotton has been added to all of the fingertips.

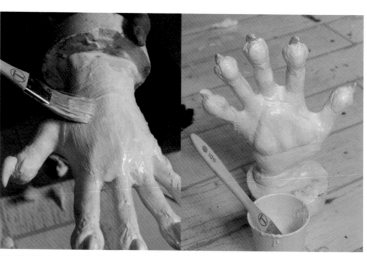

17. After you have finished, cover the entire hand in latex as reinforcement. Latex is flexible and allows the hand freedom of movement.

Catlike Hands

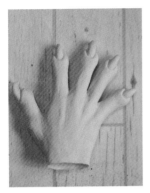

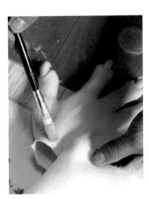

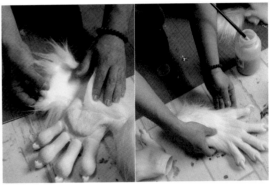

18. After the latex has dried, remove the gloves from inside the cast.

19. Brush G-Bond onto the wrist.

20. Wrap a piece of a boa around the wrist and glue it down with G-Bond. Cut the fur trim so that it is the same length on both hands.

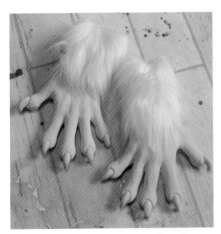

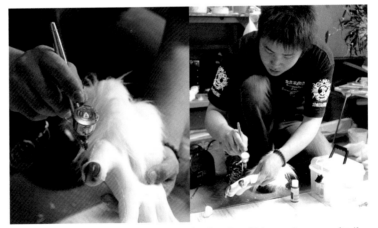

21. Once you have finished gluing the fur to the hands, brush PAX paint on the flesh and nails as the base color.

22. Use an airbrush to apply acrylic paint to the hands, using whichever colors you prefer. If you do not have access to an airbrush, you may use regular paintbrushes instead.

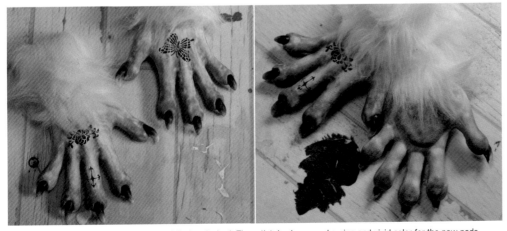

23. To finish, apply tattoos of any color and design desired. The artist, Iwakura used a nice and vivid color for the paw pads to make them more visible.

Catlike Ears

You can make these catlike ears out of materials that are relatively easy
to purchase, such as urethane and an adhesive. Adjust the shape to make
bunny ears, squirrel ears or the ears of any other animal.

by Tomonobu Iwakura

Materials & Tools

Materials: An urethane sheet, latex, G-Bond, acrylic paint, PAX
paint, a flexible headband, gummed tape, and a wig (optional)

Tools: A craft knife, scissors, a paper cup, a spatula (putty
knife), an airbrush, a paintbrush, and a blow dryer

1. Cut the urethane sheet into two triangles about the
target size of the ears. The triangles should not look
like geometric shapes but rather be curved on two
sides and pointed at the top.

2. Trim both sides of the triangles
until they appear sufficiently
rounded.

3. Brush G-Bond on the ears' inside surfaces and give
them the round form of cat's ears using both hands.

4. Once you have achieved the target shape,
brush G-Bond over the outside of the ears.

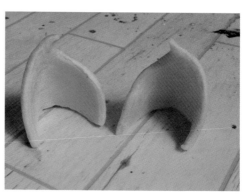

5. Blow dry the ears until they are no longer
sticky.

6. The ears will stiffen in this form, making it the final shape.

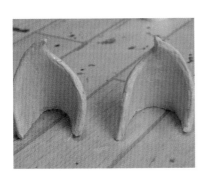

7. Brush PAX paint over both ears.

8. Brush G-Bond onto the ears' bases.

9. Apply G-Bond onto the flexible headband on the positions where you intend to attach the ears. (The headband functions solely to hold the ears in place.)

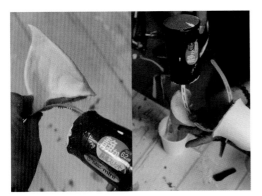

10. Glue the ears to the headband and blow them dry.

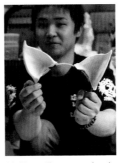

11. Try on the ears and make minor adjustments to their positions as needed.

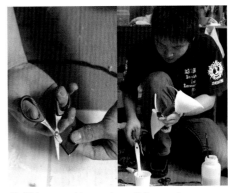

12. Stick gummed tape underneath the ears to secure them further.

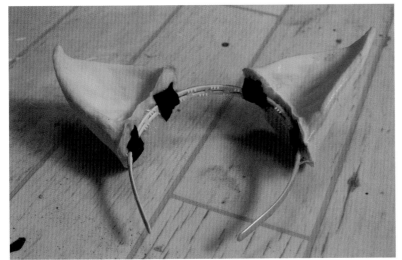

13. The ears' positions are now set. Paint the ears any color you desire and wear them. For those who are concerned that the headband might be visible, attach a wig, yarn or the like to the headband for a more natural look.

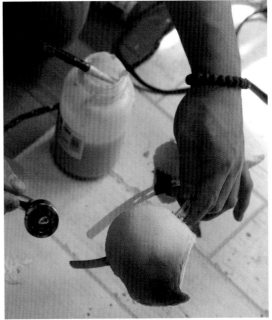

Fangs

Try making a mold of your teeth and fabricating fangs for yourself. The fangs presented on these pages are vampire fangs. However, they can be adapted to a variety of purposes. Make them a little longer and pointier for animal fangs. Elongate only the canines for a more attractive look.

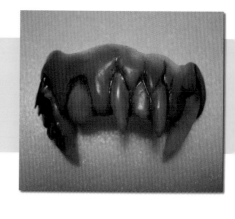

by Yuya Takahashi

Materials & Tools

Materials: Dental cast (see p. 75), Roma Plastilina clay, lacquer spray, acrylic model paint (translucent colors), silicone, plaster, dental acrylic resin (Tokuso Curefast), and Vaseline

Tools: A scale, paper cups (small and large), disposable chopsticks, electric polisher, sandpaper, spatula (putty knife), and gummed tape

Concept: To achieve an asymmetrical design so that when the character's mouth was closed, a single tooth would peek out. Dramatizing the differences in appearance from when the character has his mouth closed and when he has it open heightens the effect.

1. Place the cast of the teeth that you made on page 75 on top of a flat base. Stick dual-sided tape on the base (to hold the cast in place). Cut a paper cup a few centimeters (or a few inches) down from the rim so that it is deep enough to cover the cast completely. Place the cut portion of the cup rim-side down, and place the cast inside. Secure the cast in place.

2. Cover the cup's rim completely in gummed tape to hold it securely in place and to prevent liquid from leaking out. You will be making an additional mold of the model's teeth. (This is for use as a backup, in case you intend to use dental acrylic resin, which sticks to plaster, making it easy for a plaster dental cast to break.)

3. This photo marks the start of making the second mold of the teeth. Have the silicone, a silicone curing agent, disposable chopsticks, and a paper cup on hand.

5. Squeeze approximately 1 g. of silicone curing agent into the silicone and use the chopsticks to stir the liquids until they are well mixed. The standard ratio given on instruction sheets is 100 g. of silicone to 1 g. of curing agent. However, once you become accustomed to making silicone molds, you may use 2 to 5 g. of curing agent to speed up the process. This will make the silicone solidify faster.

4. Measure out precisely 100 g. of silicone.

6. Use the chopsticks to drizzle the silicone onto the mold, while making sure that bubbles do not form.

7. Allow the mold to sit on a level surface and let it rest until the silicone solidifies.

8. Once the silicone solidifies, remove the gummed tape and take out the plaster cast. If the silicone has solidified properly, the plaster cast should pop right out.

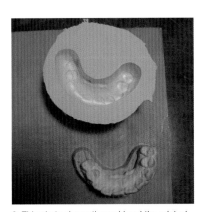

9. This photo shows the mold and the original plaster cast.

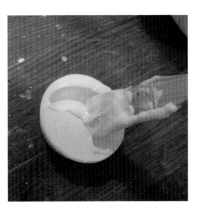

10. Pour plaster into the silicone mold to make multiple sets of dental casts.

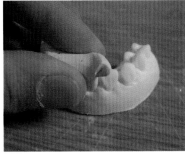

11. Remove the plaster cast from the silicone mold once the plaster has finished hardening. Add Roma Plastilina clay to the plaster cast and begin sculpting. Create whatever design you intend without being concerned about the positioning and size of the model's own teeth. Please note, however, that adding too much clay to the gum region prevent the model from being able to close his or her mouth fully when wearing the prosthetic.

12. Apply clay to and sculpt the back of the teeth as well, if you intend to create fangs that appear to be inserted into the gums. Limit the amount of clay you use on the back of the teeth so that it just rounds over the tops of the teeth and toward the back by only a few millimeters. Otherwise, the back of the teeth will become overly thick, which will impede the model's ability to talk.

13. This photo shows the Roma Plastilina covering the gums. Round the clay so that it adheres to the natural curve of the model's gums.

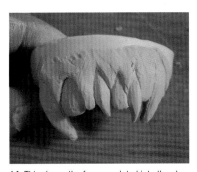

14. This shows the fangs sculpted into the clay.

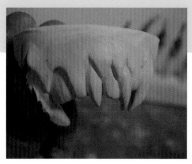

15. Add in the details to finish the sculpting process.

16. Make a second silicone mold following the same process as previously. This silicone mold will become the negative mold, while the backup plaster cast of the model's teeth will become the positive mold. You will apply dental acrylic resin between the positive and negative molds.

17. The above shows Tokuso Curefast's entire dental acrylic resin set. The photo shows the pink powder, the liquid, and the ivory powder (from left to right). This is a clear, hard resin that dentists use when making bridges or dentures. You will start by painting the cast. Use ivory for the teeth and pink for the gums.

18. Mix the liquid and a powder at a ration of 1:2. The combination should achieve a gooey consistency (if it seems too smooth and liquid, add more powder). Dental acrylic resin hardens in approximately one minute, so work quickly. Start by filling the tooth (crown) portion of the silicone mold with ivory acrylic resin. As you add the acrylic resin, you must occasionally try inserting the plaster cast to make sure that the acrylic resin will not bulge up when the plaster cast is inserted into the negative mold. This is important. (Otherwise, the acrylic resin could end up preventing the plaster cast from fitting into the mold.) Coat the plaster mold thoroughly with Vaseline as a release agent. Quickly pour the pink acrylic resin (which will represent the gums) into the mold, once the teeth have hardened. Push the plaster cast (positive mold) firmly down into the negative mold. (It is all right if some of the acrylic resin seeps out over the top.) Allow the mold to set for 10 minutes. Remove the plaster cast from the silicone mold.

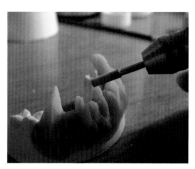

19. This photo shows the finished teeth cast. Use an electric polisher and sandpaper to burnish and reshape.

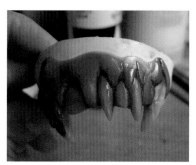

20. Paint the gums with translucent yellow acrylic model paint to create the impression of stains and add translucent red to create the illusion of blood. Apply the paint so as to darken the junction where the gums and teeth meet and create a suggestion of shadow. Use instant adhesive to glue seashells to one fang. Give the entire piece a clear lacquer spray finish.

21. The piece is now complete. Since this prosthetic is meant to be popped in like dentures rather than glued into the mouth, it can be reused any number of times.

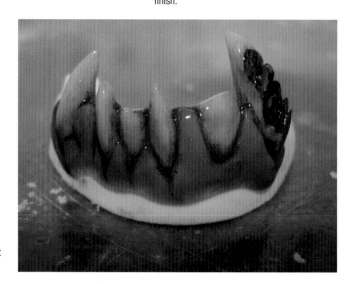

Elongated Fingers

These elongated fingers made of foam latex slip on the finger like a fingerstall and only need to be glued at the base. Add press-on nails and paint them for a manicured look or thicken the joints. Adjust the fingers to any design you like.

by Yuya Takahashi

The artist, Takahashi intended this design to look like the elongated fingers of a demon. He selected long, sharp seashell shards to make the nails to incorporate natural forms and patterns into the design.

Materials & Tools

Materials: Lifecasts of the model's hands, Roma Plastilina clay, clear lacquer spray, wet clay, plaster, latex (base), curing agent, foaming agent, gelling agent, release agent, Pros-Aide (or other medical adhesive), PAX paint (a mixture of Pros-Aide and acrylic paint), seashells, G-Bond, Pros-Aid/Cabosil (a paste mixture of Pros-Aide and Cabosil, which is made from silica fiber), and Vaseline

Tools: Sculpting tools, a house paintbrush or hake-style brush, hand mixer (a cheap seven-speed power mixer), a scale (if possible, one that gives accurate measurements in 0.1 g units), a spoon, a spatula (putty knife), paper cups, a brush, and an airbrush

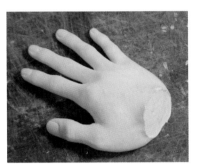

1. Use lifecasts of the model's hands. See p. 74 for information on the mold-making process.

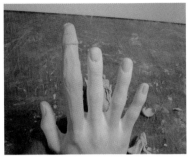

2. Add Roma Plastilina clay to the fingers. Use clay to construct the nails. Insert the shells and then quickly pull them out. The remaining gaps will become the openings in which you will later reinsert the shells.

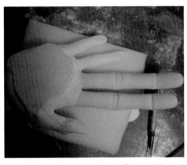

3. Use sculpting tools to create fingerprints and skin creases. Sculpt the joints, while double-checking the distance between the actual joints on the model's hands to ensure that they are positioned relatively the same.

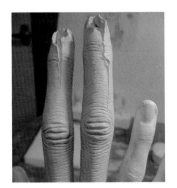

4. Sculpt torn or wrenched-looking gashes into the fingers, staring from the openings for the shells.

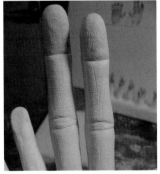

5. This shows a close-up of the fingerprints. Sculpt the fingers and then use a texture stamp at the very end to add skin details. Sprinkle the fingers overall with paint thinner.

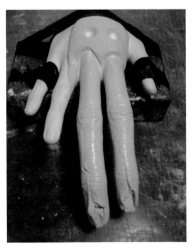

6. Make holes in the back of the hand to insert keys. Add walls of Roma Plastilina clay (to keep the flash that forms as thin as possible) about 5 mm out from the end of the sculpted clay, while avoiding the area surrounding the keyholes. The fingers' forms will become distorted if they are placed directly onto a flat surface, so rest them on a brick or the like to keep them slightly elevated. This will hold them securely in place as you make the molds. The keys are necessary, because the molds must be made in two parts. The walls are added to keep the plaster from seeping out and forming flash. Coat the fingers with clear lacquer spray. Turn the fingers over onto the reverse side once the plaster has hardened, remove the wet clay, and coat with Vaseline. Repeat the same process with the reverse side.

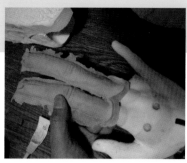

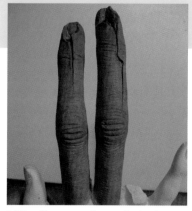

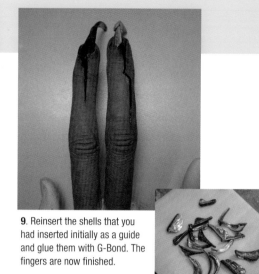

7. Using a hand mixer, blend the latex base, the foaming agent, and the curing agent at a ratio of 10:2:1, respectively, for about nine minutes. (See p. 77 for more information on mixing the chemicals.) Add the gelling agent last and blend to finish the foam latex liquid. Pour the foam latex liquid into the plaster mold made of the sculpted clay, press the lifecast of the model's hand into the foam latex liquid, and hold the mold in place with clips. Fire the mold in an oven preheated to 90°C (approx. 194°F) for about three hours. The foam latex piece is now finished.

8. Trim off any excess foam and paint the fingers with flesh-tone colored PAX paint. Pat the fingers with talcum powder once they have dried completely. Dab red PAX paint onto the fingers with a urethane sponge after brushing off any excess powder. This will create the look of real skin. (Pinch the wide surface of the sponge between your fingers to accentuate the indentations in the sponge so that it creates a texture similar to a rock.) Use the airbrush to create blood vessels, fill the inside of the torn gashes with blood red, and add create the illusion of dirt and soiling.

9. Reinsert the shells that you had inserted initially as a guide and glue them with G-Bond. The fingers are now finished.

Putting the Fingers on the Model

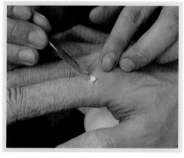

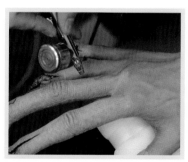

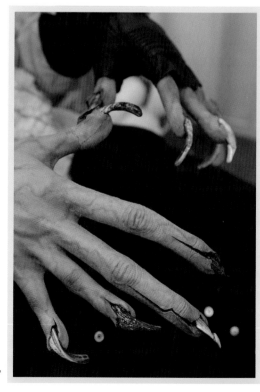

1. Brush skin toner onto the base of the model's fingers and slip the fingers into the prosthetic fingers. Apply Pros-Aide to the base of the model's fingers to glue the prosthetics in place. Use Pros-Aide/Cabosil to conceal any visible edging. Brush on PAX paint, dry the PAX, and pat with talcum powder.

2. Airbrush flesh-tone paint onto the fingers, starting with the model's skin and gradating as you apply the paint along the prosthetic. This will conceal where the prosthetic and the model's actual finger meet. Use the airbrush to add blood vessels.

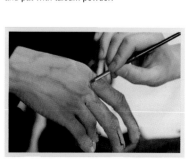

3. Apply foundation to adjust the coloring.

4. Repeat the process for all of the fingers, until the hands are finished.

Artificial Eyes

The artificial eye presented here is made of polyester resin. The artificial eye is not placed directly on the eyeball like a contact lens, so feel free to play around with the size and colors. Clear polyester resin is added at the end of the process to give the glass portion of the eye a glossy finish.

by **Yuya Takahashi**

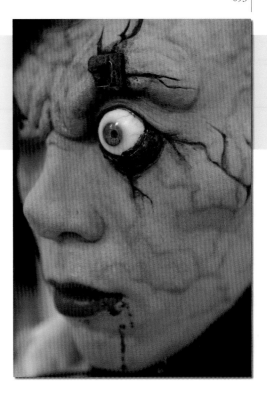

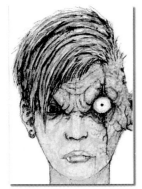

Concept:
A demonic eye with a constricted pupil, exposing a large portion of the white of the eyeb

Materials & Tools
Materials: Lacquer spray, acrylic model paint (translucent shades and white), silicone, silicone curing agent, plaster, polyester resin, and Vaseline

Tools: A scale, a paper cup (small and large), disposable chopsticks, sandpaper, a ruler, gummed tape, a plastic half sphere, and a brush

1. Have ready a plastic half sphere that is approximately the target size for the artificial eye (you should be able to find assorted sizes in a craft store or art supplies store). Brush a light layer of Vaseline inside the plastic half sphere to serve as a release agent, and pour plaster into it. The plaster constitutes the base mold.

2. The plaster will take about 10 to 15 minutes to harden. Remove it once it is hard. The base mold may really be of any material, such as clay, provided that you are able to create unevenness in the surface texture and use it later to make a silicone mold.

3. Use sandpaper to smooth down the surface.

4. After you have achieved a moderate smoothness, soak the plaster in water and then burnish it again with sandpaper. This should result in a nice, slick surface.

5. Use a ruler to locate the center. This will help you establish where to position the pupil and its size. The center then becomes the eye's pupil.

6. Tape the plaster mold to a base to hold it in place. Make a small dent with a drill bit to where the pupil will be.

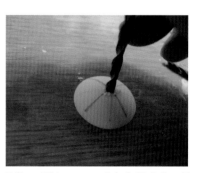

7. Use a drill to open up a hole that is that pupil's target size.

8. Once you have made a hole, burnish down any rough areas with sandpaper until the surface is nice and smooth. Smooth the inside of the pupil so that it forms a concave half sphere. The size of this hole determines the pupil's diameter.

9. Use the plaster mold to make a silicone mold. Following the same process used to make a mold of teeth, cut off the top of a paper cup a few centimeters (or inches) down from the rim so that it is deep enough to cover the plaster eye completely. Place the cut portion of the cup rim-side down, and place the plaster eye inside.

10. Cover the cup's rim completely in gummed tape to hold it securely in place and to prevent liquid from leaking out. Have the silicone, silicone curing agent, disposable chopsticks, and a paper cup on hand.

11. Coat the plaster mold with lacquer spray as a release agent.

12. Measure out exactly 100 g. of silicone.

13. Add about 1 to 5 g. of silicone curing agent to the silicone and stir thoroughly with the disposable chopsticks. Use the chopsticks to drizzle the silicone onto the mold.

14. Allow the mold to continue resting on the flat base until it has solidified. Once the silicone has solidified, remove the gummed tape and the paper cup, and remove the silicone mold from the plaster mold.

15. This shows the now empty silicone mold. Fill the portion of the mold that you intend to be the white of the eye with polyester resin. Add one to two drops of white acrylic model paint to the polyester resin. (This gives the eye a satisfying translucency rather than making it completely opaque.) Mix the paint and the resin thoroughly, and pour it into the mold.

16. Once the resin has solidified, remove it from the mold. Use Liquitex acrylic paint to color the pupil jet black and paint the iris.

The Iris
1. Once the Liquitex has hardened, fill the pupil depression with polyester resin, so that it creates a mound. This becomes the lens-like iris.
2. Coat the entire eyeball with white polyester resin so that it covers the iris.
3. Once the white polyester resin has hardened, use sandpaper to burnish the iris, applying water to the iris as you work.
4. The iris should slowly emerge from beneath the white polyester resin, while producing a gradation at the boundary where the iris and the white of the eye meet. This gives the iris a realistic look.
5. Dry off the eye thoroughly and apply clear lacquer spray to finish.

Putting the Eye on the Model

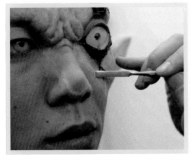

1. The eye will be inserted between the eyelids of a foam latex prosthetic that is attached to the model's face, so mark down ahead of time where the pupil should end up located before adding the eye.

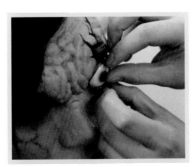

2. Insert the artificial eye into the prosthetic while aligning the pupil's center.

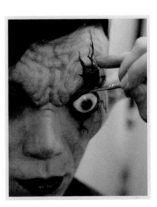

3. Glue the artificial eye to the eyelids with G-Bond to finish.

Demonic Ears

This prosthetic ear presses onto the model's ears. Tinted silicone gives the flesh a translucent look (rather than applying pigment on top of the silicone, pigment is actually mixed into the silicone). Each strand of hair is applied individually to evoke a sense of realism.

by Yuya Takahashi

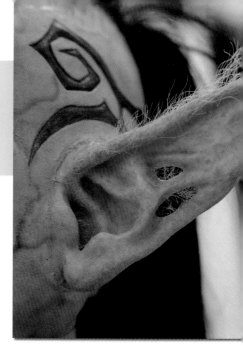

Concept: To elicit a demonic look, Takahashi made the ear pointed and opened holes all the way through the auricle. The key points lie in how much to extend the prosthetic ear beyond the model's actual ear and what elements to incorporate into the design.

Materials & Tools

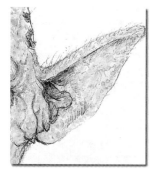

Materials: Lifecast of the model's head, Roma Plastilina clay, wet clay, wire (thick), clear lacquer spray, Vaseline, plaster, silicone (Takahashi used silicone caulk and bath caulk; this is normal caulk used to prevent water damage around the bathroom, so it may be purchased at a hardware store), oil paints, benzene, artificial hair, and medical adhesive

Tools: A scale, paper cups (small and large), disposable chopsticks, a spatula (putty knife), a sewing needle, a craft knife, an airbrush, a drill, and a paintbrush

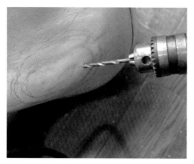

1. The weight of the clay base form that you will sculpt will cause it to fall off the lifecast, so create an escape hole to serve as support. Using a pencil, sketch a guide on the lifecast of where the ear will attach. Drill a hole at one point and insert a thick wire.

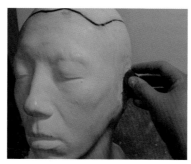

2. Apply Roma Plastilina clay to the area.

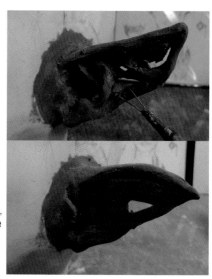

3. Once you have sufficiently built up the clay, sculpt the ear using sculpting tools. If you use the Number 2 (Medium) Roma Plastilina clay, you should be able to create holes, like those in the photo, without the clay collapsing.

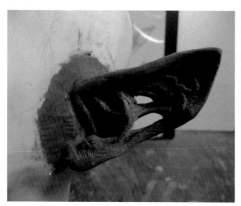

4. Lightly build up the clay around the ear. This creates a margin or buffer zone to use when attaching the prosthetic ear to the head. Add details like holes in the ears and swollen veins.

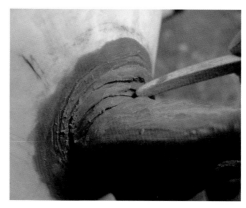

5. Sculpt wrinkles behind the ear. This will make any creasing that occurs when the prosthetic is worn appear more natural.

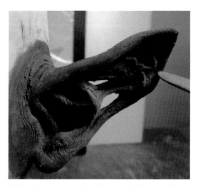

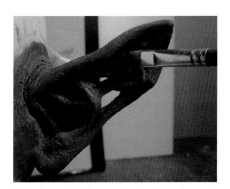

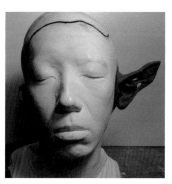

6. Use the wooden handle a sculpting tool to smooth out the surface.

7. Brush on paint thinner to dissolve the surface and make it smoother. This will remove traces of the spatula and give the skin a nice, silky texture.

8. Take a couple of steps back and do a visual check of the overall balance.

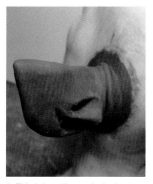

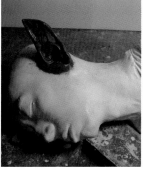

9. This is how the ear looks from behind. Special effects makeup needs to look realistic from all angles.

10. This is the beginning of the plaster mold-making process. Coat the ear with a clear lacquer spray and lay the lifecast down in a horizontal position.

11. It is impossible to make a one-piece mold for the ear, so using the ear's tip as the demarcation point, divide the ear into two parts to make the mold. You will need to create a wall to do this. Cut the wet clay and build a wall around the entire ear.

12. Build an additional block outside of the wall to create a key when the plaster is formed. The two parts of the mold have to be matched up, so make a trapezoidal key that will allow the two parts to align.

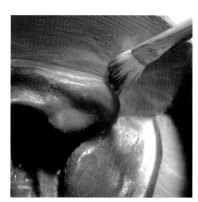

13. Brush water onto the clay's surface to make it smooth.

14. Make a mold of the front first. Pour the plaster, making sure that air pockets do not form.

15. Once the front has hardened, make a plaster mold of the back using the same process.

16. Once the plaster mold has hardened, coat the inside with a clear lacquer spray. This will act as a release agent for the silicone.

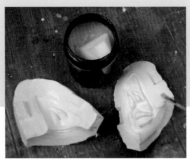

17. Coat the mold with Vaseline. Again, this is to act as a release agent and prevent the silicone from sticking to the plaster mold.

18. Give the silicone a flesh-tone beforehand, which you will use later to paint the ear. Add a small amount of oil paint (Holbein's Jaune Brilliant No. 1) to a paper cup. You can adjust the tone later, so do not worry about adding too much. Just do a visual estimate on how much looks sufficient. You are not making a finely tuned color mix at this point.

19. Add a small amount of the tinted silicone from step [18] to a paper cup, Add colorless, clear silicone to the tinted silicone. Use about 1/5 of the paper cup's contents to paint the ear with a single coat of tinted silicone.

21. Mix in benzene to function as paint thinner. Add enough benzene to give the silicone the texture of a lotion and is sufficiently soft to spread easily over the plaster.

20. Mix the tinted silicone with the clear silicone. The resulting silicone mixture should not be clear but rather translucent. Adjust the degree of transparency as needed.

22. Paint a single coat of silicone on each of the mold of the ear's front and the mold of the ear's back and allow the silicone to solidify thoroughly. Repeat this process two or three times. Allow the molds to rest for a few days in between coatings.

23. This photo shows the solidified silicone. At this point, the ear's coloring is closer to that of a doll's ear. It still needs to be painted to give it a more convincingly demonic appearance.

23. This photo shows the solidified silicone. At this point, the ear's coloring is closer to that of a doll's ear. It still needs to be painted to give it a more convincingly demonic appearance.

25. Apply ear hair, one at a time.

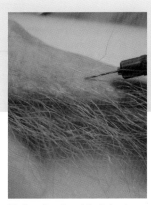

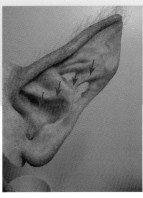

26. Use pliers to cut the hole of a sewing needle. Insert the needle into a pin vice, so that the side that will hook onto the hairs is facing down(?). You will use this as a tool for applying the hairs to the ear. Hook artificial hair strands onto the needle and push the tool into the ear. You should be able to insert two hairs at a time.

27. Insert the hairs following the direction that the arrows indicate. Be forewarned that if you do not plan ahead how the hairs should appear to grow, then the hairs will not look convincingly natural.

28. Following the same process, use the margin of latex around the ear to build up a latex membrane. Match the membrane up with the margin behind the ear. This marks the end of the preliminary preparations.

Putting the Eye on the Model

1. These steps outline the process of attaching the ear to the model. The tools you will use are Pros-Aide, scissors, a paintbrush, talcum powder, a powder puff, and surgical tape (Surgical tape is highly sticky. Nichiban brand surgical tape that was sold in a local pharmacy was used here.)

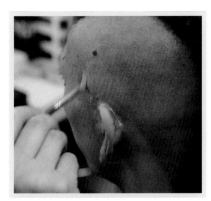

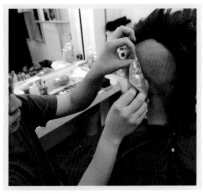

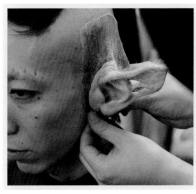

2. Brush skin toner onto where you intend to attach the ear. This will remove oil from the model's skin. Brush on a light coat of Pros-Aide.

3. Glue the membrane to the model, pressing the prosthetic ear so that it fits perfectly over the model's ear. Press the prosthetic down to smooth out any creases and ripples and so that the model's ear cannot be detected sticking out from underneath the prosthetic.

4. Glue the membrane underneath the ear, stretching the membrane to prevent creases and ripples from forming.

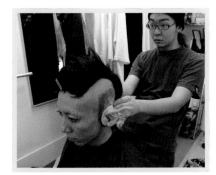

5. Do a visual check to make sure that the prosthetic ear is level with the model's own ear on the other side of the head.

6. Secure the membrane in place with surgical tape until the membrane has finished drying and is firmly stuck to the model. Leave surgical tape on any areas that will not be visible once the model is fully made up.

7. Pat the membrane with talcum powder once it has completely dried. This will make the latex less sticky. Now the ear is finished.

Zombies

This is the section everyone has been waiting for: authentic-looking zombie makeup. Akiteru Nakada and M.E.U. created sophisticated zombie looks using gelatin to achieve a heightened sense of realism. There are numerous makeup techniques used to make zombies. While you might think that you have to go all out to make an authentic-lookng zombie, really painting on a few splotches to suggest livor mortis is sufficient for achieving a convincing effect. Play around with different techniques.

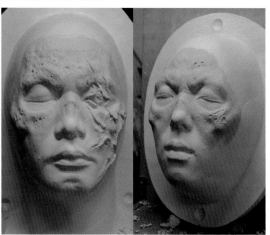

by AKITERU NAKADA & M.E.U

Concept: Nakada and the M.E.U. team intended to create zombies inspired by Goth and Lolita-style fashion, resulting in this pair of "Goth and Lolita-Style Zombies."

Materials & Tools

Materials: Lifecasts of the models' heads, technical gelatin, glycerine, sorbit (Nakada purchased the technical gelatin, glycerine, and sorbit online through Live House Zokei Big Site), epoxy putty, silicone spray (as a gelatin release agent), wet clay, alginate, plaster bandages, modeling clay, Al-Cote (fabric starch may be used instead), grease paint, PVA (polyvinyl alcohol), fabric starch, and oil paints

Tools: Sculpting tools, a house paintbrush or a hake-style brush, a scale, a spoon, a spatula (putty knife), a paper cup, a paintbrush, and a microwave oven

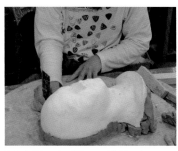

1. Only lifecasts of the models' heads are needed this time around. The first step is to take the life casts and fill in the entire backs of the heads, from the ears all the way around, with a flat base.

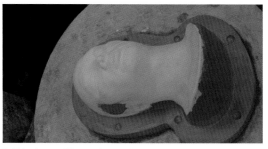

2. This shows a lifecast after the base has completely filled the back. The objective is to be as exacting as possible, so use wet clay to fill in the underside of the chin on the female model's lifecast and any other areas that might get stuck when the mold is removed. (This is referred to as "filling in undercuts," and it makes the model appear to have a chin waddle when fully made up). Make a mold using alginate and plaster bandages, and then make a second cast of the models' faces by pouring plaster into the mold. These second, undercut casts are then used as the base forms.

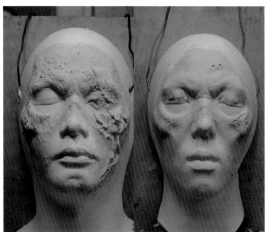

3. Begin sculpting while the molds set. Apply Al-Cote or alternative material to the original lifecasts to act as a release agent. Add clay to the lifecasts and sculpt the clay while double-checking the overall proportioning of the models' facial features. Zombies are corpses, so (since it is not as if you can cut away the model's skin to reveal the bone) building up the nasal bones with clay and then making them appear to be exposed is an important trick in making the zombies' appear bony.

4. Transfer the sculpted clay to the undercut casts made in step [2]. Pour water into a bathtub or other large receptacle, gently lay the original lifecasts bearing the sculpted clay into the water. Allow the clay to soak for one full day. The clay will come off the lifecasts once they are removed from the water. Then you may carefully transfer them to the undercut casts.

How to Make Gelatin
1. Thoroughly mix glycerin, technical gelatin, and sorbit at a ratio of 2:1:2, respectively.
2. Allow the mixture to rest for one day in a bowl.
3. Heat the mixture in a microwave to obtain clear gelatin.
4. Add flesh-toned oil paint to the gelatin ahead of time to tint it. Purchasing a gelatin kit, sold at some art supplies and craft supplies stores might be helpful.

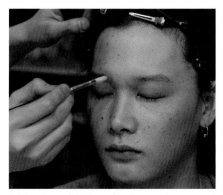

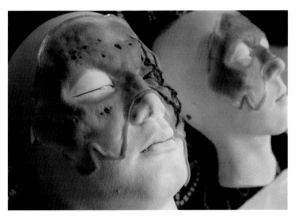

6. Melt the gelatin in a microwave oven and pour it into the molds made in step [5] and press the undercut casts on top. Allow the gelatin to cool for two hours, and then carefully open the molds.

4. Spray a release agent on the undercut casts with the sculpted clay. You will be pouring gelatin into the molds this time, so you will need to make the following preparations:
Brush PVA onto the undercut casts to serve as a release agent.
Brush epoxy putty onto the casts and make molds.
Make backups using plaster, Ultracal 30, or the like.

Making up the Goth Zombie

Now that the preparatory work is finished, it is time to put the prosthetic onto the model's face. Painting skills play a crucial role at this stage. Pay attention to how blood vessels and livor mortis appear as you work.

Tools: Pros-Aide, ethanol, plastic sealer, grease paint, makeup sponges, paintbrushes, Pros-Aide paste, makeup brushes, urethane sponges, and colored contact lenses

The Goth zombie model is Degu Zombie, owner of the famous Trick or Treat pub located in Roppongi and introduced on p. 135.

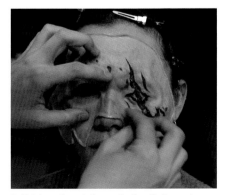

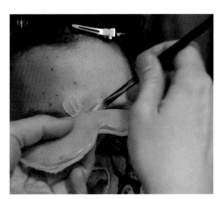

1. Wipe the model's face with skin toner to remove oil.

2. Match up the gelatin prosthetic with the spot where the bridge of the nose meets the brow. This establishes how the prosthetic will be positioned.

3. Glue the prosthetic to the face with Pros-Aide, starting from the brow.

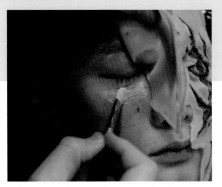

4. Glue the prosthetic to the eyelid and underneath the eye.

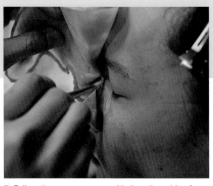

5. Follow the same process with the other side of the face. Glue the prosthetic to the brow with Pros-Aide to set it in place and then continue gluing it to the model's face, while stretching the prosthetic to prevent rippling and creasing.

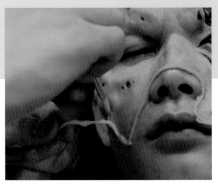

6. After the prosthetic is glued to the model's face, remove excess gelatin around the prosthetic's border (flash). Slowly grasp the flash between your fingers, melt the border with ethanol, and make the prosthetic's border blend in with the model's skin.

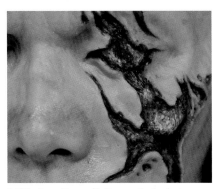

7. This shows the prosthetic once the border is blended in with the model's skin.

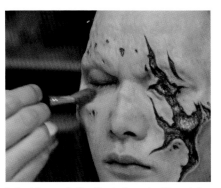

8. Coat the prosthetic with plastic sealer. The painting process now begins.

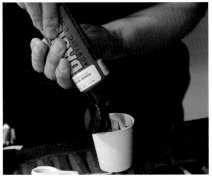

9. Separate the black from the red acrylic paint and add black indigo paint.

10. Trim a urethane sponge into a rectangle and carve one side so that it may be used like a stamp to create livor mortis splotches. Dip the sponge in grease paint and dab livor mortis splotches all over the face.

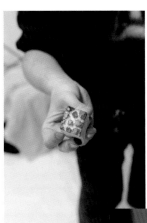

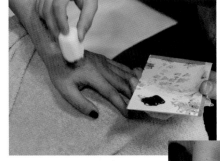

11. Add livor mortis splotches to the hands as well.

Zombies

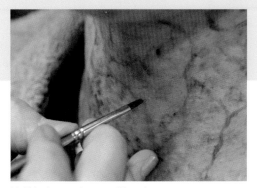

12. After adding the livor mortis splotches, use blue grease paint and a small detail brush to paint veins.

13. This shows a close-up of the veins.

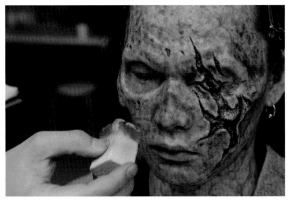

14. Dab more livor mortis splotches over the freshly painted veins and blend the makeup on the entire face.

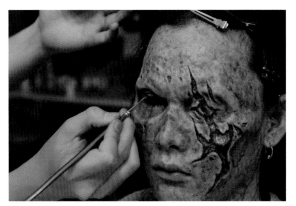

15. Brush black grease paint just underneath the eyebrow to create a shadow. This gives the eye a sunken look. Add black shadows to the upper and lower eyelids.

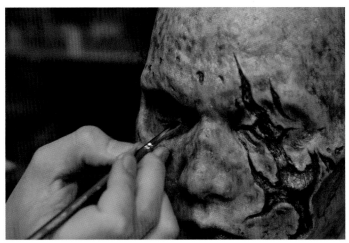

16. The foundation makeup process is now complete.

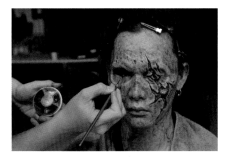

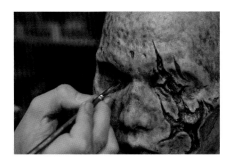

Zombies

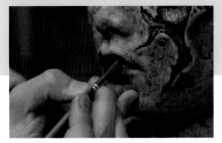

17. Apply black grease paint to the lips.

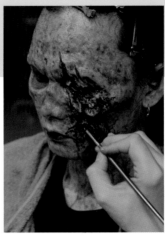

18. Apply a combination of red and black grease paint to sunken areas sculpted into the gelatin prosthetic.

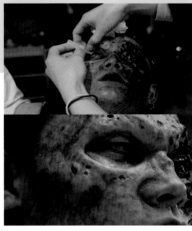

19. Apply the colored contact lenses. The lenses are multicolored and have a red outer rim. As the colors progress toward the center, the red is followed by yellow, white, and then the natural color of the model's own eyes.

20. Dress the zombie in his costume to finish.

Making up the Lolita Zombie

We now show you how the female model transforms into a zombie, just as we did with the male model.

Tools: Pros-Aide, ethanol, plastic sealer, grease paint, makeup sponges, makeup brushes, Pros-Aide paste, paint brushes, urethane sponges, and colored contact lenses

Mari is the model for the Lolita zombie. The extent of her transformation is amazing.

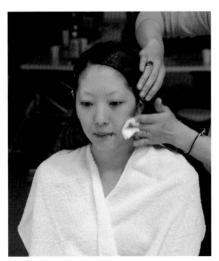

1. Nakada wipes Mari's face with skin toner to remove oil and ties her hair back.

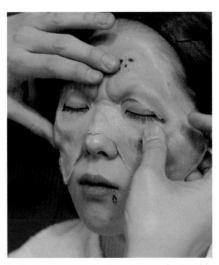

2. The next step is to align the prosthetic with the model's face. Mari has a thin face, so Nakada has to work carefully to ensure that gaps do not form between Mari's face and the prosthetic.

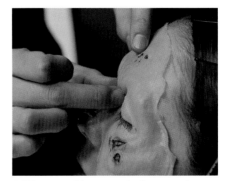

3. When attaching a prosthetic, press down firmly at the top of the nose bridge and pull. Pull the cheeks are of the prosthetic to ensure that rippling and creases do not form.

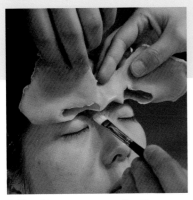

4. Glue the areas surrounding the eyes securely in place, while pressing down firmly on the prosthetic to prevent it from shifting.

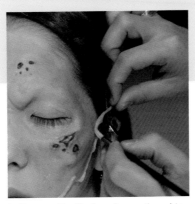

5. Remove the flash and use ethanol to smooth out the border.

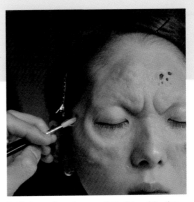

6. Using a brush, carefully blend in the prosthetic's border with the model's skin.

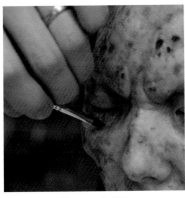

7. Add a small amount of blue grease paint to some red grease paint and apply the combination to the lower eyelid. Brush on the grease paint starting from where the prosthetic and skin meet to just inside the prosthetic. The objective is to conceal the prosthetic's border.

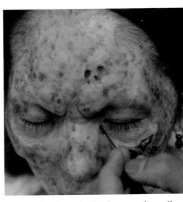

8. Add shadows to the brow, where the nasal bone, sculpted into the prosthetic, juts out.

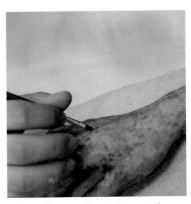

9. Apply livor mortis splotches to the hands and then paint veins onto the hand using a mixture of red and black grease paint and a small detail brush.

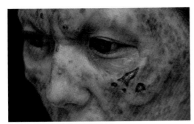

10. The foundation makeup process is now complete.

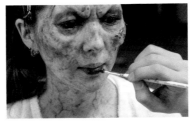

11. Color the lips with bruise-colored grease paint instead of lipstick.

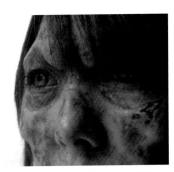

12. Apply blue contact lenses to finish.

Cat

The cat depicted here is a combination of a foam latex prosthetic, a commercially available wig of artificial hair that has been modified and handmade clothing and shoes. In this section, we recount the process, starting with the actual application of the foam latex prosthetic to painting the prosthetic and the completion of the makeup. Please refer to the section starting on p. 82 for more information on how to make hands and ears.

The model is Hiroaki Murakami. Colored contact lenses are applied first to facilitate coordinating the rest of the color palette.

Concept: The title of this piece is "Cat Girl," and the idea was to portray a young, cat girl with a rock-music soul burning inside her, who chases after her dreams with everything she is worth.

Materials & Tools

Materials: Skin toner, a foam latex prosthetic, Pros-Aide, a hair net, grease paint, PAX paint, false eyelashes, and cat eye contact lenses
Tools: Brushes, sponges, scissors, cotton swabs, an airbrush, and a blow dryer

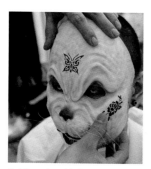

1. After using skin toner to remove oil from the model's skin, place the prosthetic on the model's face and visually check the positioning.

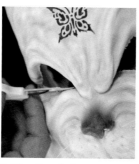

2. Trim off any flash.

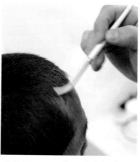

3. In this case, the artist, Iwakura glues the model's hair to his head with Pros-Aide. This allows the prosthetic to fit snugly against the model's head.

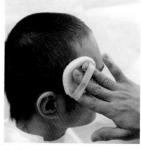

4. Likewise, Iwakura makes the model's sideburns lie flat against his temples.

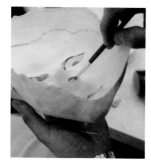

5. The next step is to brush Pros-Aide onto the inside of the prosthetic.

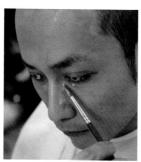

6. Brush Pros-Aide onto the bridge of the nose and underneath the eyes as well.

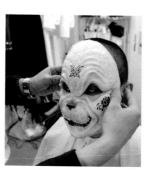

7. Match up the bridge of the model's nose with the bridge of the prosthetic's nose and attach the nose while pulling it at the cheeks.

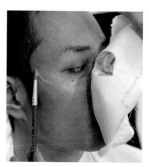

8. Brush on the Pros-Aide, starting from the bridge of the nose and moving toward the temples, using arcing strokes.

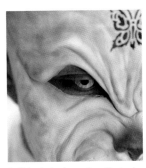

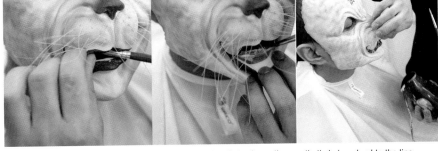

9. This photo shows the attached prosthetic. The butterfly on the forehead was made from a tattoo stencil.

10. The prosthetic extends all the way to the lips, so the photo shows the prosthetic being glued to the lips. (Prosthetics do not typically cover the lips.) Brush Pros-Aide onto the upper and lower lips, including the insides of the lips, attach the prosthetic, and blow dry the Pros-Aide.

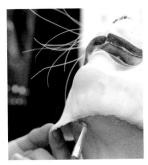

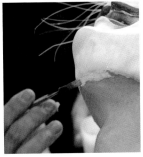

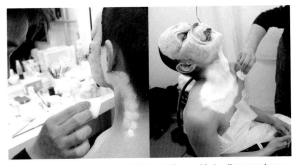

11. Pull the prosthetic down to where a depression forms underneath the jaw and glue it in place. Basically, designing the prosthetic so that its borders lie in depressions or sunken areas that are not typically visible allows you to conceal artfully where the prosthetic's borders and the model's own skin meet.

12. Brush white PAX paint over the glued areas. To ensure there is no difference between the PAX paint on the model's skin and the prosthetic, use the density of the white on the prosthetic as a means of determining how dense the PAX paint that you apply to the model's skin should be. Apply PAX paint all over the model.

13. Using a sponge, apply white PAX paint thoroughly to all areas where a gap in the costume might reveal a bit of skin.

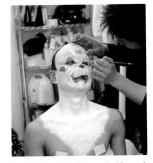

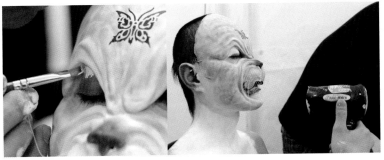

14. The PAX paint is applied in such a thick layer that it dries slowly. Consequently, it is blown dry.

15. PAX paint is also applied to the upper eyelids and blown dry.

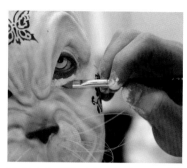

16. Apply the PAX paint as closely as possible to the lower eyelid rim and blow it dry.

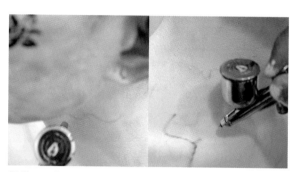

17. Use acrylic paint and an airbrush to create veins. This is a punk rock kitty, so use bright green and purple for the veins. The trick to drawing blood vessels lies in using gentle, fluid forms with no discernible angles. Try looking at your own palm to see how the blood vessels form patterns. Incidentally, the makeup artist used a 0.3 mm airbrush to make the veins.

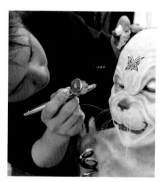

18. Use the airbrush to create shadows on the eyes as well.

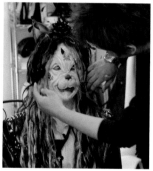

19. Now comes the donning of the wig. To make this original wig, first Iwakura fabricated the understructure using a lifecast of the model's head, and then he glued artificial hair to the understructure.

How to Make a Wig

This explains how to make an original wig that fits snugly against the wearer's head. Flashy, extravagant wigs can be expensive. However, making your own wig allows you to design a wig any way you wish and at only the cost of the materials.

1. Prepare a plaster lifecast of the model's head.
2. Coat the top of the head with Vaseline to function as a release agent.
3. Use a house paintbrush or a hake-style brush to apply polyester resin containing a curing agent (hereinafter called, "resin").
4. Cut a fiberglass mat into playing card-sized pieces and attach them to the still sticky resin.
5. Allow more resin to soak in over the fiberglass and pat with a hake-style brush.
6. The fiberglass and resin will harden if they are left alone, so wedge a stiff spatula, regular screwdriver or the like between the resin and the plaster to remove the resin.
7. Once the resin understructure has been removed, it should have the appearance of a 1 mm-thick helmet. Use G-Bond to glue cats' ears to the understructure.
8. Glue artificial hair to the understructure with G-Bond, while thinking about how hair grows naturally on the head. Finally, use G-Bond to glue artificial flowers and birds' feathers to the wig to finish.

20. False eyelashes are applied.

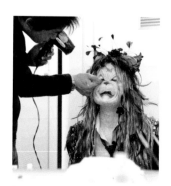

21. The entire piece is blown dry to finish.

Fantastic Creatures

The creation of fantastic creatures involves making a foam latex prosthetic and fabricating props and a costume that matches the prosthetic in atmosphere to portray the creature's world. To create the nymph shown, the face only necessitated straight makeup. The makeup artist, Tomo then fabricated the headpiece, the thorns, and the other makeup effects to portray the fey beings.

by TOMO

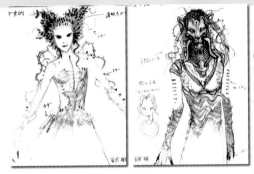

Concept: Beauty and the Beast did provide some inspiration for these designs. The rose nymph reflects freedom and innocence. In contrast, the lion man's face is totally covered, creating a closed, isolated atmosphere.

Making the Skirt

The first part of this section shows how to fabricate the props, while the part beginning on p. 112 shows how to assemble all of the components and dress the models. To start, we show the reader how to construct the lion man's skirt, which requires making a paper pattern.

Materials & Tools
Materials: Black imitation leather (thin), black thread, metal clasps, elastic drawstring, and acrylic paint (red and black)
Tools: Scissors, a large sewing needle, a yarn needle, pins, and an airbrush

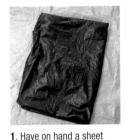

1. Have on hand a sheet of imitation leather, just under two meters or two yards in width. Purchase a sheet whose length is 1.5 to 2 times the girth of the model's waist.

2. Fold over the waist and stitch it down so that elastic can be threaded through the waist. Wrap the imitation leather around the model's waist and fasten it in a temporary manner. Cut the end on a bias. While the imitation leather is still fastened in place, grab loose, excess material around the hips and pin it.

3. Without sewing the waistband, make diagonal cuts approximately 10 cm or 4" from the waist and sew them closed. From the reverse side of the material, sew the pinned excess fabric to make tucks. Now the skirt should fit closely to the model's body without appearing loose or baggy.

4. Thread the elastic drawstring through a yarn needle and pass it through the waistband. After having finished threading the waistband, check the size of the model's waist and tie the drawstring so that the waist will have a good fit. Hide the drawstring's knot inside the waistband.

5. Use clasps that are normally hidden inside clothing as decorative accents. Place the clasps over the side that was cut on a bias, checking the overall balance.

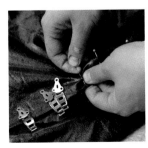

6. Once you have established where to position the clasps, insert pins to mark where to sew the clasps.

7. Sew the clasps to the skirt.

8. Sew on all of the clasps, making sure that a single ripple will form when the clasps are locked in place.

9. Once the clasps are attached, dress the model, add touches of red and black acrylic paint to create the appearance of soiling, and dry the paint to finish.

Making Rose Ornamentations for the Head

This involves fabricating individual rose petals, stems, and thorns and attaching them to the top of a bald cap. You will need to adjust the ornaments' weights and how they are attached to ensure that they are not so heavy that they come off. Glue sticks for use with glue guns constituted the base materials for the tiny thorns, so they do not hurt when touched.

01 Petals

Materials & Tools
Materials: Plastic sheet and acrylic paint
Tools: A heat gun, scissors, and pliers

1. Look over rose-related reference materials and coordinate the overall design.

2. Take a thin plastic sheet and cut out scalloped, ruffle shapes. Cut the shapes so that when they are heated with a heat gun, the edges will curl and ruffle. Size the shapes, taking into consideration that they will shrink when they are heated.

3. Grasp the cut-out shapes with pliers so that your hand will be safe while heating the shapes.

4. Hold the heat gun up to the cut-out shape and shrink the perimeter.

5. This shows a finished petal. The petal is then painted with red acrylic paint and dried. Make slightly more petals than needed, just in case.

Fantastic Creatures

02 Branches and Thorns

Materials & Tools
Materials: Jiyujizai brand colored craft wire, glue gun, Liquitex Texture Gel (Ceramic Stucco Texture Gel)

*Liquitex Texture Gel is mixed with Liquitex Color Gesso and then used on canvases and other painting surfaces as primer. Liquitex makes a Ceramic Stucco Texture Gel, a dynamic primer.

Tools: A paintbrush, pliers, and acrylic paint

1. Use pliers to twist together two to three strands of colored craft wire.

2. Use a glue gun to add bits of melted glue randomly along the twisted wire. Extend out the bits of glue into short strands to turn them into thorns.

3. Once you have finished twisting the wire, adjust the shape until it looks like a branch.

4. The wire has a smooth texture. So, to give it a texture closer to that of a rose stalk, brush Liquitex Ceramic Texture Gel all over the wire.

5. Allow the Liquitex Ceramic Texture Gel to dry naturally in a shaded location.

6. This shows a completed branch. Color the branch with acrylic paint. Now it is ready for use.

03 Head and Arm Thorns

Materials & Tools
Materials: Wire, papier-mâché, acrylic paint, latex, and plastic sheet
Tools: A paintbrush

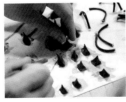
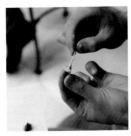
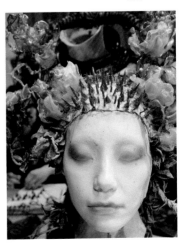

1. Twist and shape the papier-mâché into the forms shown in the photo. Make only the number of thorns you intend actually to attach.

2. Color the thorns with acrylic paint and attach them to a plastic sheet coated with latex.

3. Once the paint has dried, brush Pros-Aide on the bottom of each thorn, and attach the thorns to finish. Leave the headpiece on top of the model's lifecast to maintain the proper shape until the day you intend to make up the model.

This photo shows the completed headpiece.

Fantastic Creatures

Making up the Model: Rose Nymph

Materials & Tools

Materials: Skin toner, a foam latex prosthetic, a zipper, rubber tubing, Pros-Aide, a bald cap, white grease paint, red grease paint, press-on nails, lipstick, foundation, eye shadow, eyeliner, false eyelashes, and red contact lenses

Tools: Makeup and paint brushes, sponges, scissors, and cotton swabs

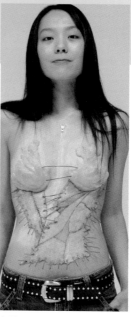

 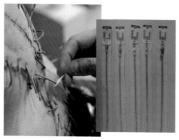

1. Make a lifecast of the model's torso, following the steps outlined on p. 70 and sculpt the desired design. Prepare a foam latex mold of the sculpted lifecast.

2. After wiping Mari's upper body with skin toner to remove oil, the makeup artist attaches the prosthetic made in step [1] with Pros-Aide. The artist, Tomo glues red rubber tubes, one at a time, to the prosthetic's perimeter, creating the illusion of seams. Tomo glues a zipper to Mari's chest, dabs talcum powder over the entire prosthetic, and allows it to dry.

3. Tomo ties back Mari's hair and puts on the bald cap.

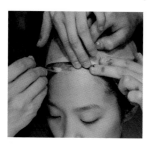 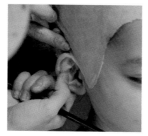 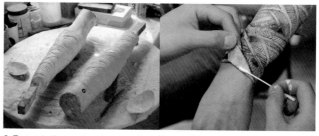

4. Pros-Aide is then applied along the hairline to glue on the bald cap.

5. When duplicating the process, cut out the area covering the ears to expose them. Apply Pros-Aide to the hair along the temples and attach the bald cap.

6. To create the arm bandages, make a lifecast of the model's arms, sculpt a bandaged pattern in clay on the lifecast, and then make a mold. Pour foam latex into the mold and fire it to make the arm prosthetic. Color the grooves over the entire arm piece with red acrylic paint, and then apply white acrylic paint on top of the red acrylic paint with a dry brush. Paint should now remain only in the sculpted grooves. Apply red acrylic paint with an airbrush to finish. Put the prosthetic on the model's arm and glue the base of the arm with Pros-Aide.

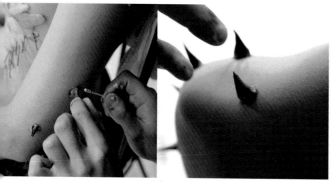 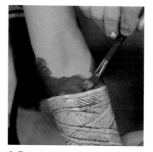 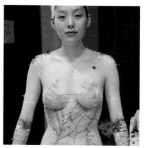

7. Apply Pros-Aide to the bottoms of the thorns made at the same time as the headpiece and attach them to the arms and shoulders.

8. Tomo intended to create the appearance of red tissue visible from underneath white skin, so he applied a base coat of red grease paint.

9. The next step is to apply water-based grease paint to the model's entire upper body. The upper body is now finished.

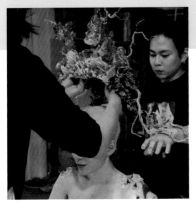

10. Remove the headpiece from the lifecast and place it over the bald cap.

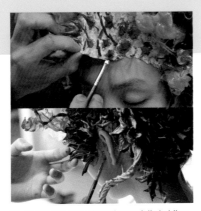

11. Apply Pros-Aide along the model's hairline to glue down the headpiece. Glue the headpiece behind the ears as well.

12. Paint a set of press-on nails red and stick them on the model's hand.

13. Color the hands white with grease paint.

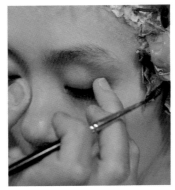

14. Apply red eye shadow from the far corners of the eyes to just below the eyebrows and blend to produce a gradation. Trace the bases of the eyelids with black eye shadow to define the eyes' contours, applying the black eye shadow over the red. Blend the black and red eye shadows.

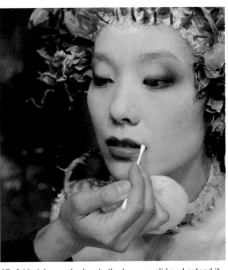

15. Add pink eye shadow to the lower eyelid and extend it beyond the corner of the eye. Apply pink lipstick to the lips.

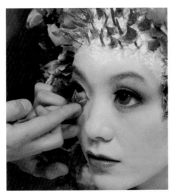

16. Apply red contact lenses.

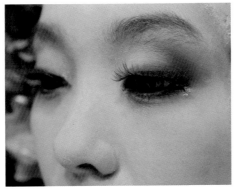

17. Color a set of white false eyelashes red and attach them to the upper and lower eyelids.

18. This shows the finished look being photographed.

Making up the Model: Lion Man

Materials & Tools

Materials: Skin toner, a foam latex prosthetic, an imitation leather skirt, gloves with press-on nails attached, poster paint, black rubber tubing, Pros-Aide, a bald cap, black grease paint, and white contact lenses

Tools: Makeup and paint brushes, sponges, scissors, cotton swabs, and a blow dryer

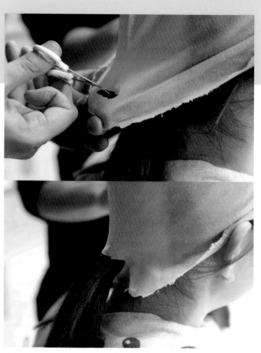

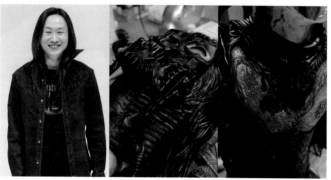

1. Atsushi is the lion man model. As with the nymph, the lion man's armor, head prosthetic, and arm bandages require lifecasts of the model's body parts, to which a sculpted design is then applied. A foam latex mold is made of the torso and then painted with PAX paint.

2. The next step is to tie back the hair and place a bald cap on the model. If the model has long hair, make a hole in the back of the cap pull the hair through the hole.

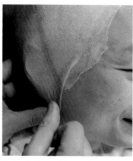

3. Apply Pros-Aide to the model's hairline and glue down the bald cap, ensuring that no wrinkles or creases form. The model's ears are not part of the makeup, so the bald cap covers them completely.

4. Wipe the model's upper body with skin toner to remove oil and place the armor on the model to determine the proper positioning.

5. Once the armor's position is set, apply Pros-Aide to the torso and stick on the armor while pulling it and smoothing out any ripples or creases.

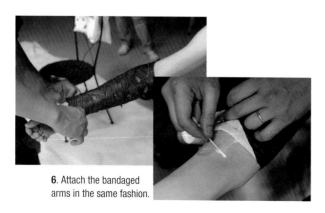

6. Attach the bandaged arms in the same fashion.

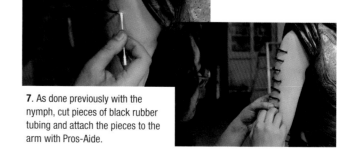

7. As done previously with the nymph, cut pieces of black rubber tubing and attach the pieces to the arm with Pros-Aide.

Fantastic Creatures

8. Apply black grease paint to the model's skin.

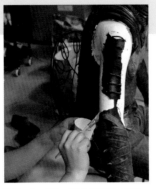

9. Brush white poster paint over the grease paint.

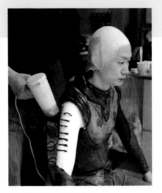

10. Blow dry the paint.

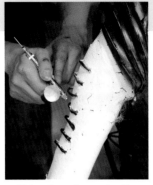

11. Make minor adjustments with a dry brush.

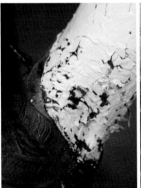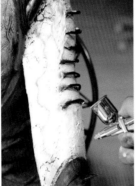

12. Once the white poster paint is dry, the black grease paint base coat will be visible from underneath, while a crackled effect will result in the white paint. With an airbrush, create blood vessels using brown acrylic paint.

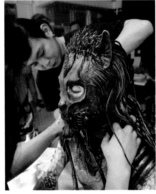

13. Place the foam latex head prosthetic on the model and glue it in place with Pros-Aide.

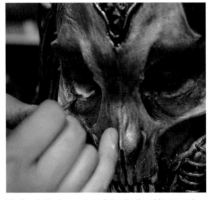

14. Brush black grease paint onto the skin around the prosthetic's eye holes.

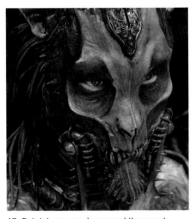

15. Dab talcum powder around the eyes to eliminate stickiness.

16. Put on the gloves. Paint a set of press-on nails black and attach them to the gloves with instant adhesive ahead of time.

17. Apply the white contact lenses. Once the contact lenses are in, the model is unable to see anything, so for this shoot, Tomo put them in right before the model was photographed. Now the makeup is finished and is ready to be photographed.

Body Carvings

This section presents exquisite body carvings that incorporate fashion trend elements, which were designed by Akihito of the Hollywood special effects studio, KNB EFX Group. Akihito used Pros-Aide, a medical adhesive primarily used to attach prosthetics, to make the body carvings. This marks a new experiment in the field of special effects makeup. We trace the Akihito's process from sculpting the body carvings all the way to completing and photographing the special effects makeup.

01　Sculpting and Making Silicone Molds

by AKIHITO

Normally, when a mold is made of sculpted clay, plaster is used as the base material for the mold, as outlined on p. 76. However, in this case the body carvings will ultimately be made of Pros-Aide, so silicone will be used to make the molds instead, which will allow for more intricate detailing. Pros-Aide and plaster stick to each other, so they cannot be used together.

1. Apply clay to a lifecast of the model and use a house paintbrush or hake-style brush to add acrylic paint of a similar color to the clay. You may use the clay without the paint. However, it is easier to ensure that the clay is uniform in color with the paint, which makes it easier to visualize the target design.

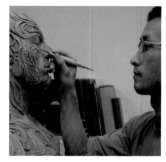

2. Akihito warms up the clay in an oven to soften it. He applies the clay to the lifecast and begins sculpting. He is using Chavant Hard Clay.

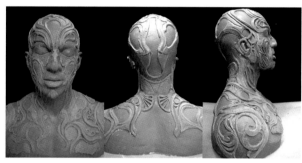

3. The lifecast only functions as a temporary understructure during this process. Sculpted work made in step [5] will be transferred to a flat base to perform further, more detailed sculpting. Consequently, detailed work is not performed on the lifecast. It is just to check the overall balance and flow of the sculpted work, and to see how well fleshed out the face and shoulders appear. The sculpture is approximately 70% complete at this stage.

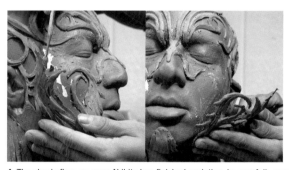

4. The clay is firm, so once Akihito has finished sculpting, he carefully removes the clay using his sculpting tool. When doing this yourself, if you are using soft clay, then the clay will not come off using solely a sculpting tool, and you will have to apply Al-Cote (a liquid that dissolves in water and that functions as a release agent for preventing the clay from sticking to the lifecast) before starting to sculpt. Once you finished sculpting the clay on the lifecast, you would then have to soak the lifecast for a full day in water with the clay still on the lifecast. If you do not have access to Al-Cote, then you may use a quick-drying woodworking glue instead.

5. Akihito transfers the removed clay to a flat board.

6. All of the body carvings are transferred to seven different boards and are divided up according to where on the model they will be attached. Akihito lightly presses them onto the board to ensure that the clay forms retain their shapes. When doing this yourself, if you find that the clay is not sticking properly to the board, then you could lightly burn the reverse sides of the clay with a culinary torch to soften them and then press them onto the board.

7. Akihito now begins to perform detailed sculpting adhering to the design depicted in the concept sketch. He can occasionally be heard complaining to himself, "Why on earth did I choose this design?" But he does not give up and forges ahead with sculpting. Akihito finds himself audibly sighing just looking back and thinking about this part of the process.

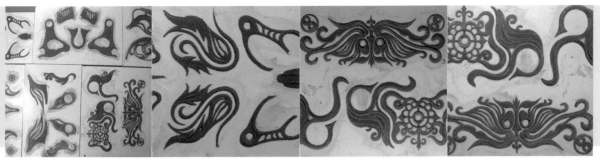

8. These photos show the sculpted body carvings.

9. Akihito then adds Clean Clay (a soft, oil-based clay) to build up walls around the body carvings. When doing this yourself, try to leave a distance of approximately 3 to 5 mm. between the walls and the body carvings and give the walls a thickness of about 3 mm.

10. The next step is to use a glue gun to attach paint sticks around the white board. This is to prepare for pouring the silicone. Akihito's coworker, Lino P. Stavole is making the mold.

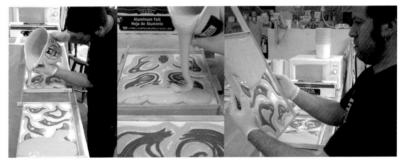

11. Lino coats the sculpted body carvings entirely in clear spray and a silicone release agent.

12. Lino then adds a curing agent to the silicone and mixes them thoroughly.

13. Lino uses a deaerator to remove air pockets in the silicone before pouring it into the molds. If you do not have access to a deaerator, then carefully read the handling instructions and draw out the solidification process by slowly pouring the silicone and/or using other techniques at your disposal.

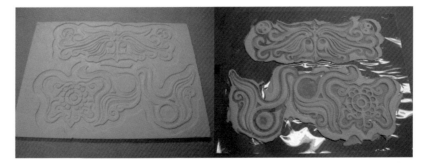

14. Lino allows the silicone to solidify for six hours.

15. After six hours have elapsed, Lino carefully removes the silicone from the molds. He then clean the molds to finish the process (this marks the completion of the negative molds). Lino now pours Pros-Aide (i.e. a combination of Pros-Aide and Cabosil*) into the negative molds. The Pros-Aide has a toothpaste-like consistency. Lino then lays a plastic sheet over the mold and allows it to sit in the freezer for one hour (the pieces' sizes affect the time spent in the freezer). After the Pros-Aide has frozen, Lino places the pieces into a dehumidifier and dries them. He allows them to dry until they reach the desired degree of transparency. You may also allow the pieces to dry naturally. *Cabosil is a silica powder.

02 Applying Color

Once the sculpting process is complete, gold and pearl dust is applied painstakingly to each piece with an airbrush. Laying one color over the other creates layers of gold and silver-toned sparkles.

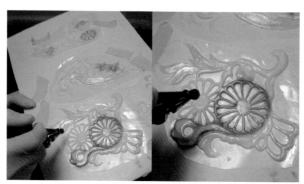

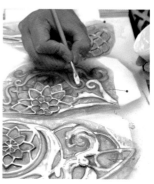

1. The first step is to apply makeup sealer to the body carvings' surfaces. This will help the paint stick. (If no makeup sealer is available, then Pros-Aide may be used instead.)

2. The base colors are carefully airbrushed onto the skin carvings. Here, Akihito's team is using alcohol-based paints.

3. The team applies another layer of alcohol-based paint over the first.

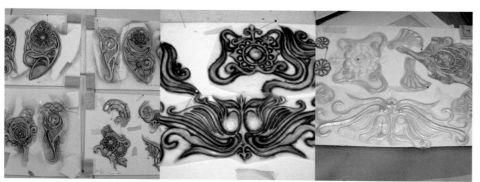

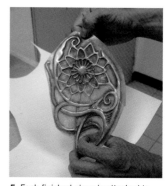

4. Now the painting process is finished. The male model will be wearing 43 pieces, while the female model will be wearing 14 pieces. The total number of pieces is significant.

5. Each finished piece is attached to tattoo paper.

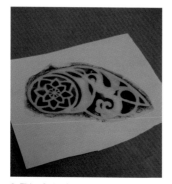

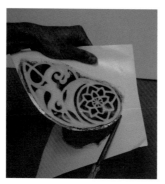

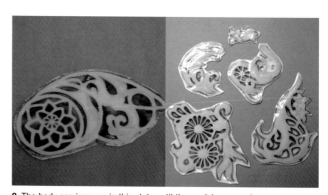

6. This photo shows the reverse side of one of the pieces.

7. The next step is to trim off excess tattoo paper.

8. The body carvings are in this state until the models are made up.

03 Test Makeup

Since this was the first time Akihito's team used Pros-Aide in this fashion, the team made up each of the male character, Ara-Han and the female character, Himico twice for testing purposes. The team was pressed for time and was therefore unable to color all of the models' exposed skin. However, making up the models went more smoothly on the official photography date.

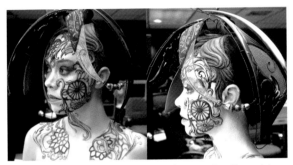

1. The above shows the first Himico test makeup session. The model appearing above is Tara Platt, who the team also used during the official photography session. Akihito improvised the skin color the day before making up Tara. The skin color ended up too harsh, and the body carvings appeared more like flat tattoos.

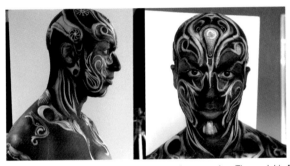

3. The above shows the first Ara-Han test makeup session. The model is Ralph J. Hopper III, who, again the team also used during the official photography session. Significant problems in attaching the pieces and in the coloring became apparent. Akihito had difficulty getting the large, rear head piece to stick on properly, and the makeup overall has no sense of three-dimensionality. Soiling and discoloration on the prosthetics' perimeters are visible.

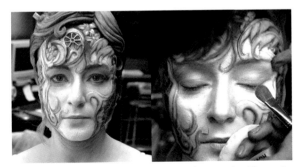

5. The above shows the second Himico test makeup session. The previous model, Tara, had another engagement, so KNB EFX Group member Patricia Urias stepped in instead. Akihito used a smaller variation of colors for the skin and used more subdued tones. He decided to blacken the very edges of Patricia's face, which gave the skin carvings a three-dimensional look that was close to what he had imagined.

2. Kathy Sully, who was in charge of wardrobe production, experienced no difficulties devising costumes for the characters.

4. Akihito made up his own arm to play around with what skin coloring would give the skin carvings a three-dimensional look.

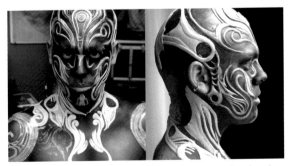

6. The above shows the second Ara-Han test makeup session. Joseph Giles is the model pictured. Akihito added silver to the paints originally used on the torso, which created a lustrous shin that accentuated Joseph's muscles. Since Akihito had completed all of the preparatory work up to attaching the tattoo paper to Joseph's skin and then trimming the perimeters with scissors, even applying the pieces went smoothly. However, the large, rear head piece still posed problems. Consequently, Akihito substituted the piece for one that had been intended for Himico.

04 Making up Ara-Han for the Official Photography Shoot

On the day of the photography shoot, the team made up the male character first. Pieces made from Pros-Aide are quick and simple to produce, which makes it well-suited for beginners. Pros-Aide is frequently used to make small pieces in movies, such as cuts, burns, or gun-shot wounds. It was also used in the Hollywood feature film, The Ring Two.

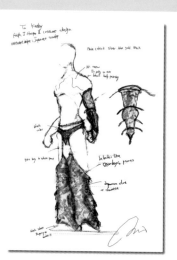

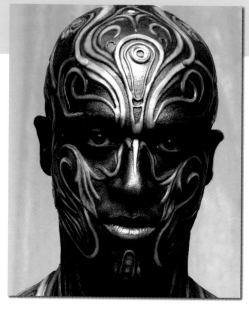

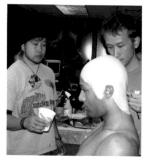

1. Akihito's team first puts on the bald cap to protect Ralph's hair. The team applies Derma Shield (a skin-protection cream) directly to Ralph's skin, followed by dark steel-colored PAX paint (PAX paint is a mixture of medical adhesive and acrylic paint).

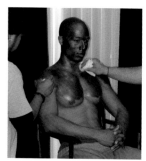

2. The team continues to coat Ralph's chest and face with the same dark steel-colored Pax paint. The team uses Illustrator body paint for the rest of the body. The team leaves Ralph's eyes, mouth, and ears for last, but applies an even coat over everywhere else.

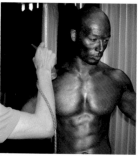

3. The team then airbrushes black pigment onto depressions on Ralph's body. This creates the illusion of shadows, which accentuates his muscles.

4. This photo shows the pieces, still waiting to be applied.

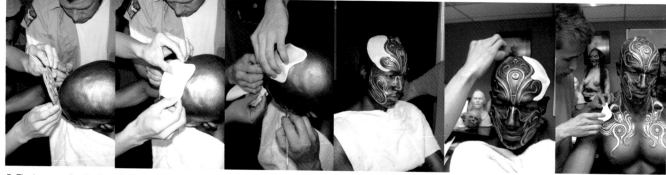

5. The team applies the Pros-Aide pieces first to Ralph's head, then to his face, and finally to his body. Lino P. Stavole and Kazuyuki Okada are assisting Akihito.

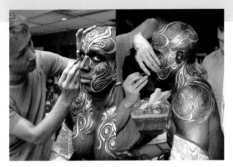

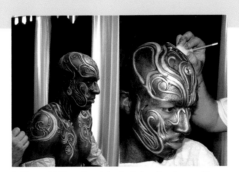

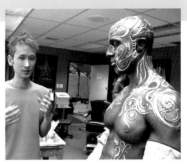

1. Kazuyuki colors the skin surrounding the eyes, the mouth, and the ears. Because the eyes move frequently so that if they were made up, they would have to be retouched often before the photography shoot, they are the last body part colored. Likewise, keep in mind that the model needs to eat and makeup the mouth afterwards.

2. Kazuyuki dips a brush in alcohol and, using small strokes on the perimeters of the Pros-Aide pieces, blends the pieces with the Ralph's skin.

3. Next, the team offers to Ralph clear and direct explanations on how to dramatize the character, including the character's personality and what photos will be taken.

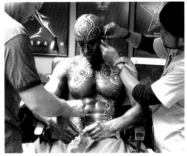

4. Behind the camera lens is Kazuhiro Tsuji, Japan's most recognized special effects makeup artist, who is currently a member of special effects master, Rick Baker's Cinovation Studios. Kazuhiro Tsuji has participated in a number of Hollywood blockbusters, including Planet of the Apes, How the Grinch Stole Christmas, Men in Black II, The Ring, and Hellboy.

5. The team removes the makeup to finish.

Review of the Pros-Aide Skin Carvings Application

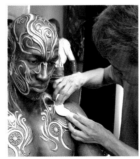

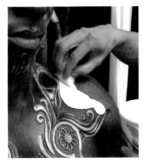

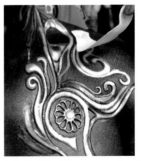

1. This first step is preparatory work. The skin carving is attached to tattoo paper, and then excess paper is trimmed. The tattoo plastic sheet backing is carefully removed. Be aware that sloppily peeling off the backing could warp the skin carving's edge.

2. Turn the skin carving so that the side where the plastic sheet backing was just removed is facing the model's skin and stick on the skin carving.

3. Soak a sponge in water and moisten the tattoo paper's upper surface. Wait one to two minutes for the water to soak in fully.

4. Peel off the tattoo paper and gently apply alcohol to the skin carving's perimeter, blending it with the model's skin. Alcohol-based paints are recommended in the case that you intend to apply additional color on top of the skin carvings. Rubber mask grease paint and regular grease paint can destroy the Pros-Aide skin carvings' beautiful translucence

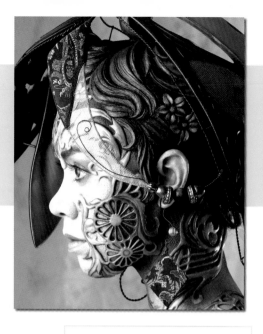

05 Making up Himico for the Official Photography Shoot

Akihito's team now makes up the female character as they did the male. The key point in making up Himico is that her look should have a Japanese flavor that emphasizes femininity and beauty.

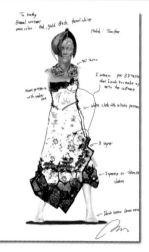

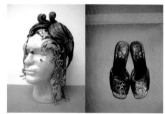

These photos show Himico's headpiece and mules. Akihito made the mules, earrings, bracelet, and press-on nails all by hand.

How to Make the Red Headpiece
Start by producing a concept sketch. The red headpiece (dubbed, "the parasol") was inspired by a lacquered tray. Sculpt the concept sketch image in clay, building the four pieces that compose the parasol. Apply a coat of clear lacquer spray to the sculpted pieces, allow the pieces to dry, and then make silicone molds. Pour casting plastic (casting plastic is made by mixing two liquids of equal portions together and then allowed to solidify until the mixture forms a plastic) into the mold. Thoroughly wash the casting plastic once you have removed it from the mold and paint the pieces. Decorate the finished parasol with aluminum netting, small ornaments and trinkets, and wire.

1. The above shows Tara without any makeup and wearing a bald cap. The bald cap protects her hair.

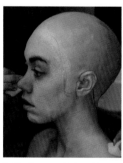

2. The team coats her skin with Derma Shield to protect it and then applies pearl white-colored PAX paint.

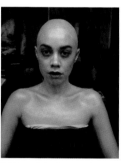

3. The paint colors used on Tara's body are pearl white, white, gold, and black. The team applied the paints carefully and thoroughly so as to prevent unevenness.

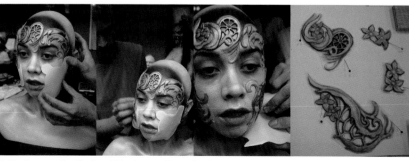

4. The team applies the Pros-Aide pieces to Tara's forehead, cheeks, neck, and around her mouth, in that order. Applying pieces first to areas that do not move much allows you to avoid doing touchups later.

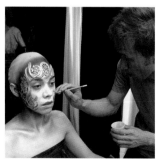

5. Kazuyuki uses a brush to blend the skin carvings' perimeters with Tara's skin.

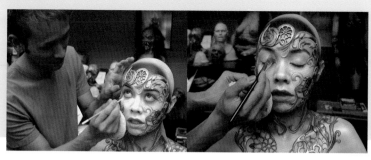

6. Kazuyuki first applies gold and then blends in a gold/purple to the broad area extending over and across the upper eyelid to the eyebrow. Next, he applies brown to the entire upper eyelid and black to the far corner of the eye, blending the colors to create a gradation. He then adds black eyeliner and applies light silver to where the inner corner of the upper eyelid curves. This gives the eye depth. He applies black mascara so as to fill in the gaps between each eyelash with black. Finally, he adds gold, silver, and brown around the eye, ensuring that it blends in well with the surrounding skin carvings, while checking the overall balance.

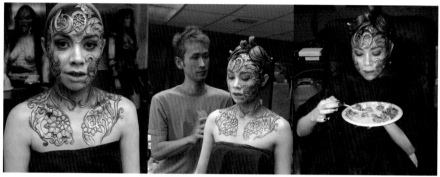

7. This shows how Tara looks after step [6] during the break period. Kazuyuki did not yet make up her mouth so that she could eat. The team put on the hair prosthetic and tentatively added the ornamentation.

8. Akihito acquired commercially available press-on nails and painted them gold and black. He painted the tips white and trimmed them in a straight line. Akihito used acrylic paint and a detail brush to create the floral pattern.

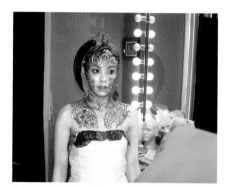

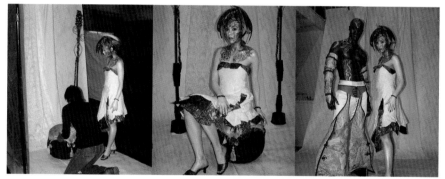

9. Akihito only created the costume design. Kathy Sully is responsible for the actual fabrication. The team attaches the parasol to Tara's head and applies the colored contact lenses to finish the makeup job.

10. These photos show scenes from the photography session.

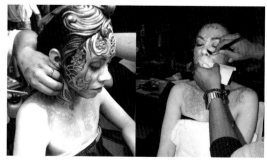

11. The team quickly removes Tara's makeup to end the session.

Studio Assistance	KNB EFXGroup,Inc.
Art director	Akihito
Photo	Kazuhiro Tuji
Model	Tara Platt
	Ralph J. Hooper
Test model	Patricia Urias
	Joseph Giles
Main assistant	Lino P. Stavole
	Kazuyuki Okada
assistant	Steven Munson
	Bruce Mitchell
	Mari Okumura
	Derek B. krout
	Lino P.Nicoletta
	Atsuko Ikeda

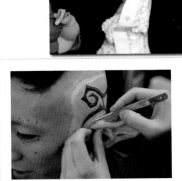

Vampire

This is a comprehensive vampire makeover, which includes a foam latex head prosthetic, silicone ears, acrylic teeth, and a polyester resin artificial eye. For more information on how to make each, refer to the section dedicated to that part. This section explains how to put all of these parts together and make up the model.

by Yuya Takahashi

Making up the Model

Materials & Tools

Materials: Skin toner, a foam latex head prosthetic, fingers, an ear, acrylic teeth, Pros-Aide, Pros-Aide/Cabosil, PAX paint, talcum powder, grease paint, castor oil, colored contact lenses (personal property of the artist), tattoo paint, artificial hair, hairspray, and blood paste

Tools: Makeup and paint brushes, sponges, a powder puff, scissors, a spatula (putty knife), cotton swabs, an airbrush, a blow dryer, and a comb

Takahashi attaches the ear first. (See p. 99 for more information on the ear.) Yuya then glues on the membrane, which he made separately, over the ear. The membrane is a foam latex prosthetic. Takahashi sculpted a tattoo-like design into this membrane. The membrane is constructed following the standard steps for making a foam latex prosthetic.

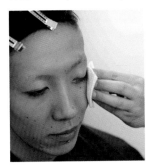

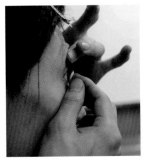

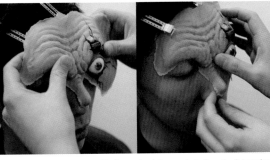

1. Tie up the model's hair and use the skin toner to remove oil.

2. Insert the contact lenses before applying the prosthetic. If Takahashi had inserted the lenses last, it would have made it difficult for him to apply the rest of the makeup and would have ruined the final look.

3. Rest the foam latex prosthetic against the model's face to determine its placement.

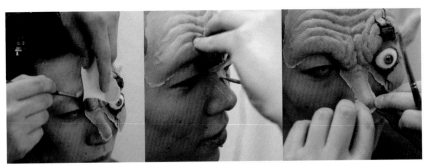

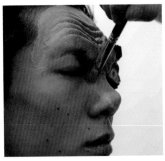

4. Next, brush Pros-Aide onto the forehead, between the eyebrows, and on the nose bridge, respectively, and attach the prosthetic.

4. Once you have finished attaching the prosthetic, allow the Pros-Aide to dry and brush on talcum powder.

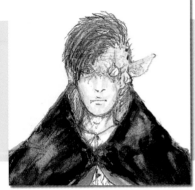

Concept: Sorrowful solitude

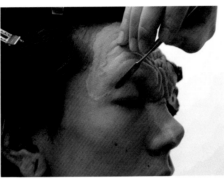
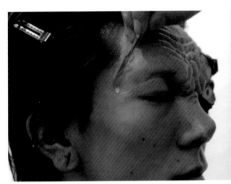
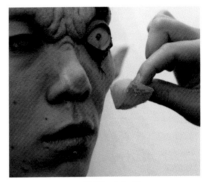

6. Using a spatula, apply Pros-Aide/Cabosil over the prosthetic's perimeter to conceal the edge of the prosthetic, whose surface is higher than the model's skin.

7. Apply flesh-toned PAX paint with a spoange.

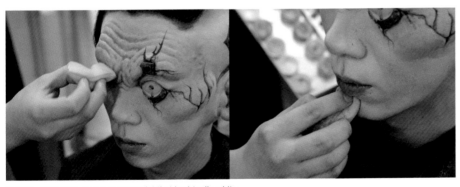
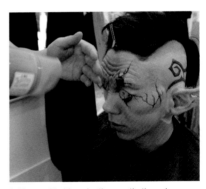

8. Next, apply flesh-toned grease paint that is virtually white.

9. Thoroughly blow dry the prosthetic and dabs it with talcum powder to remove any stickiness.

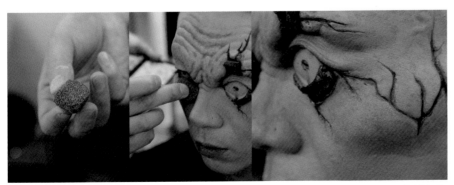

10. Here, Takahashi applied red grease paint to a urethane sponge whose surface he carved earlier so that it had a rough, stony texture and used it to create the look of skin. Castor oil is an excellent material to use to thin out the red grease paint.

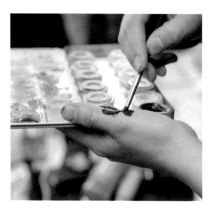

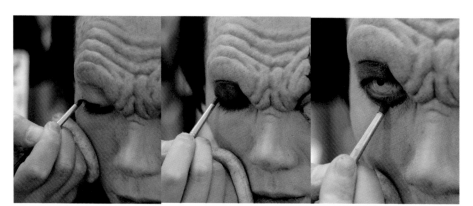

11. The next step is to dilute black grease paint with castor oil until you achieve the desired thickness.

12. Apply the black grease paint to the rims of the upper and lower eyelids with a brush, using the grease paint like eyeliner. Next color in the upper eyelid, taking care to create a gradation.

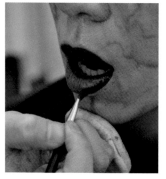

13. Use an airbrush to create blood vessels using red tattoo paint.

14. Apply black lipstick to the lips, taking care that the lipstick does not end up on the surrounding skin.

15. Takahashi prepared a woven hairpiece, which he created, himself, by weaving in artificial strands of hair, one by one. Another option would be to glue the hair directly to the prosthetic with Pros-Aide.

16. Glue the hairpiece with Pros-Aide directly to the prosthetic and over the prosthetic's perimeter. These photos show close-ups of the hair.

Body

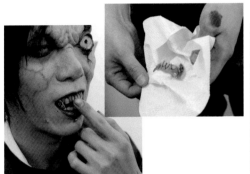
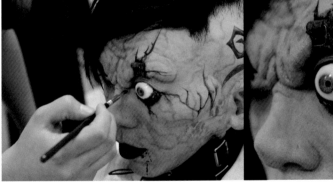
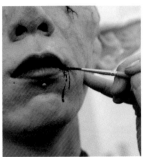

17. Now insert the teeth created on p. 88. Takahashi made them so that they would be easy to put in and take out. This enables them to be used over and over again.

18. Use brush to drip blood paste from the corner of the mouth and eye.

19. Takahashi made himself all of the costume pieces that were not available commercially.

20. Apply black to deep cuts and grooves in the face to make them stand out. The makeup is now finished.

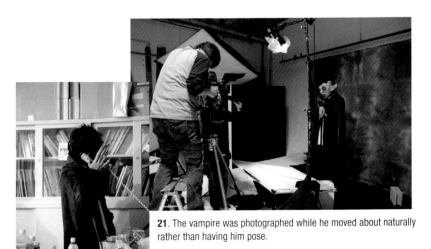

21. The vampire was photographed while he moved about naturally rather than having him pose.

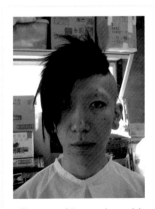

The name of the vampire model is Hiro.

Making Sculpting Tools

You can make your own wire-loop sculpting tools using guitar strings and brass pipes. Use them when sculpting clay forms to make molds. When you find that the tools commercially available are difficult to use (in other words, the stores just do not sell tools that match your vision) or when your budget prevents you from buying the tools you need, you can easily make tools on your own that are virtually like what professional special effect makeup artists use. Try making several to see what size feels most comfortable in your hand.

1. Wire-loop tool for detailed work (circle)
2. Wire-loop tool for detailed work (oval)
3. Wire-loop tool for faceting (This is used when initially sculpting the clay and removing wide swaths of clay.)

Materials & Tools

Materials: Brass piping (the piping depicted in the photo is 4 mm in diameter; however the reader should select the size that feels most comfortable) and guitar strings (any type will suffice, including inexpensive strings)

Tools: A craft saw with a thin blade (the one pictured above is a Tamiya craft saw for use with toy plastic models), pliers, a ruler, a metal file (sandpaper with a rough grit may also be used)

All three are essentially the same tool. The smaller the loop, the more the tool is capable of finely detailed work. Thin-gauge guitar strings used to produce higher notes are used for smaller loops, while thick-gauge strings used to produce lower notes are used for larger loops. Brass piping is used to hold the loops. Typically, loops of thick-gauge strings are used for sculpting, while loops of thin-gauge strings are used to smooth out sculpted surfaces. Play around and find what style of use works best for you.

1. Measure out the brass pipe. If you intend to make several different tools, make them all the same length, so they will be more comfortable to use. Eyeing the length works fine.

2. Set the brass pipe down on a flat surface. Hold a thin-bladed craft saw against where you intend to cut the pipe and saw through (Do not move the saw. Move the pipe instead.) Craft saws with thin blades are frequently used to put together toy plastic models, so the blades are extremely thin, making them perfectly suited to detailed work.

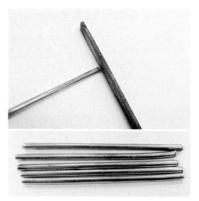

3. Burnish both sides of the pipe with a metal file. You may also use sandpaper with a rough grit instead. The handle is now finished.

4. Have on hand thin and thick-gauge guitar strings. (They should be sold together in the same package.) Cut off the strings' round tips.

5. Try bending the strings into loops. Estimate how long the string should be to make a given loop and cut the string. If the portion of the string inserted into the brass pipe is too short, the loop will come out, so ensure that the portion to insert into the brass pipe is no shorter than 1.5 cm (approx. 9/16"). A wire that is 6 cm (approx. 2 7/16") in length will yield tool number (1).

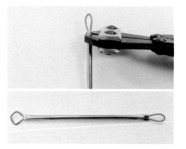

6. Insert the guitar wire into the brass pipe. Fine-tune the loop's size while squeezing the end of the brass pipe with a pair of pliers. Voila! Make a few in your spare time for use later.

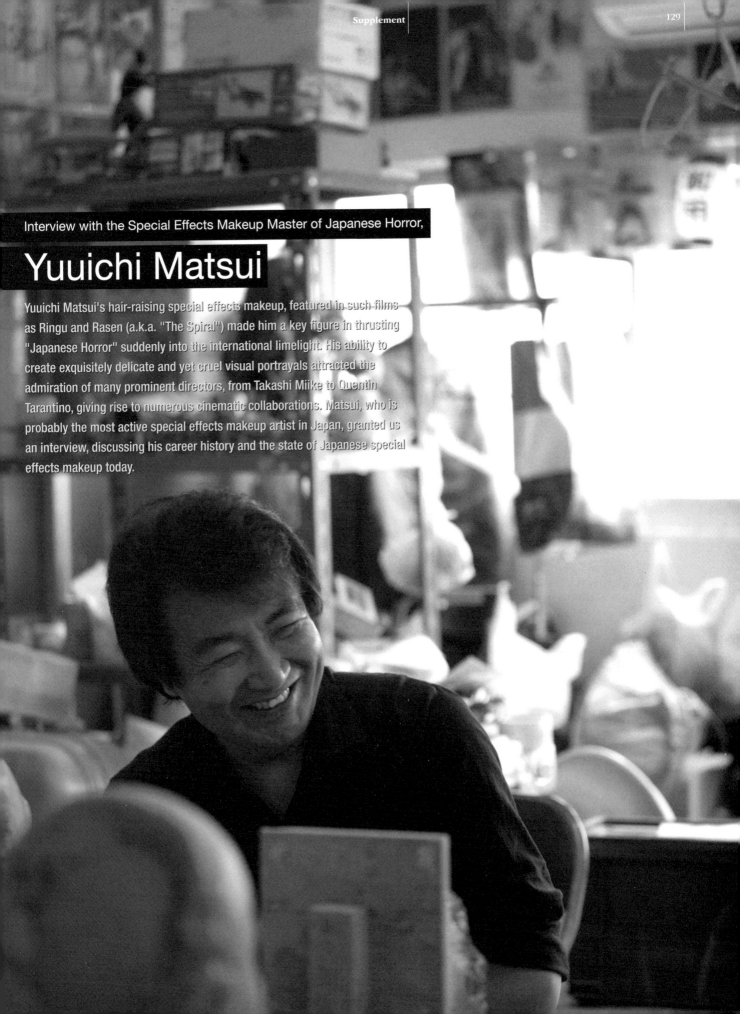

Interview with the Special Effects Makeup Master of Japanese Horror,

Yuuichi Matsui

Yuuichi Matsui's hair-raising special effects makeup, featured in such films as Ringu and Rasen (a.k.a. "The Spiral") made him a key figure in thrusting "Japanese Horror" suddenly into the international limelight. His ability to create exquisitely delicate and yet cruel visual portrayals attracted the admiration of many prominent directors, from Takashi Miike to Quentin Tarantino, giving rise to numerous cinematic collaborations. Matsui, who is probably the most active special effects makeup artist in Japan, granted us an interview, discussing his career history and the state of Japanese special effects makeup today.

Childhood

Since elementary school, I loved painting. I wanted to become an artist. There wasn't an artist whose work I particularly admired, but realism did appeal to me, so I liked still lifes and flower paintings, you know? (Grins) When I was in junior high school, I started to attend art classes, joined the art club, and did some oil painting. I was hopeless at sports, so all I did was keep to myself and paint. I also built toy cars and made plastic models. At either rate, I hated my schoolwork, so virtually all I did was paint. My only A's were from Art Class.

Impetus Fueling His Desire to Create

I guess it was about when I was still in elementary school. Art was my first subject of the day. Whenever I would watch Planet of the Apes and other movies, I really wanted to make something like what I was seeing on the screen. I didn't have the slightest clue about what sort of materials to use. I would just grab fabric, wire, and whatever else I could find, and try to duplicate what I had seen in the movies. Starlog and other magazines came into publication about when I was in high school. At the time, there really were no good reference sources, so I would watch movies, let the images burn into my brain, and then try to reproduce them. We didn't have videotapes back then, so I would only get one shot at memorizing the images. (Grins) I made the Alien monster. I made the alien's head. (Chuckles) I preferred making life-sized pieces to making miniatures. Even in the case of the alien monster, I wasn't satisfied unless the mouth could move, and the tongue could come out. The head had to be that detailed, or I wouldn't have been happy with it. And, I made it just to show my friends.

High School

I still hadn't seriously given thought to special effects makeup by the time I started high school. I just imitated the art in a vague sense. I made heads and other body parts. (Grins) I had no idea how to make molds, so these were all original constructions.

Most Memorable Film from Matsui's Youth

An American Werewolf in London made the biggest impression on me when I was in high school. This was one of the films that made me want to enter the industry. Other films that struck me were The Thing, Jaws, Star Wars, and the like. I would watch any special effects movie. Films from the States tended to be well-made, so I tried to use them as reference. Horror never really appealed to me. I liked enjoyed psychopathic killer films, but I really didn't like seeing blood. Ghost stories didn't do too much for me either. People assume that since I'm in this field that I must like these genres, but the truth is I don't. (Smiles)

How Matsui Ended up in the Industry

I had been considering studying basic makeup after I graduated from high school, so I attended a makeup academy once a week, while I worked part-time at a

Uncommon books line Matsui's bookshelves, such as Shitai shoriho (roughly "Corpse Disposal"), Setsudan to gishi (roughly, "Amputation and Prosthetic Limbs"), All about Ashley, Sekai no inu katarogu (roughly "Catalog of the World's Dogs").

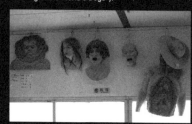

Generations of props hang from the wall. Matsui claims that he sometimes forgets he put them there and scares himself at night.

Fliers from projects Matsui has worked on cover another wall. It is an enormous number of fliers, but, needless to say, it does not include all of his projects. Matsui confesses that he does not display those he does not feel proud of or that embarrass him.

This is a flier of his first project from when Matsui was only 19 years old, Tsuito no zawameki (a.k.a. "Noisy Requiem"). He covered it in vinyl to prevent the colors from fading.

Another wall is covered with shelves filled with tools and supplies. The shelves have ceiling braces to prevent them from toppling over.

neighborhood bookstore. During my first year, a guy who was making his own film came to the academy looking for someone to do the special effects makeup, and I applied. As a result, I ended up dropping out of the academy. Yoshihiko Matsui, who is famous for making cult films, was the director, and the movie was Tsuito no zawameki (a.k.a. "Noisy Requiem").

Matsui's First Project and Salary

I was 19 years old, and the project was Tsuito no zawameki. It was the first time I was ever present when a movie was actually being made, and I learned as I worked. It was a brutal film, and special effects makeup appeared throughout the movie, so I got to work on a whole slew of different assignments. "There's supposed to be blood there." "There's supposed to be a dead body here." (Chuckles) The conditions advertised for the project were that you had to be holed up in Osaka filming for three months during the summer. No one applied, so I figured it was my big chance. I left school (midterm) at 19, and got appointed to chief of special effects makeup. I did get paid, but it was next to nothing. (Smiles)

First Major Work

Tsuito no zawameki finished shooting. I had made a lot of friends amongst the actors and the crew, and ended up landing a number of jobs that originated through them. The cameraman for Tsuito had also been working as Shigeru Izumiya's cameraman. He told me that Izumiya would be shooting a horror video and asked me if I wanted in on the project. That was my first major film. I was about 22 years old.

Career Transitions and Intentions

I never planned on working under someone else. My intention was to work freelance. Joji Iida's debut horror video, Cyclops was my next most memorable project. "Cyclops" refers to having only one eye. The film was jam-packed with special effects makeup. It was hard work but I enjoyed it. At the time, I did all the work at home. Eventually, they gave me some studio space. Later on Tomo'o Haraguchi, who is also a special effects makeup artist, invited me to work with him. We collaborated for four years. He let me work on any project that interested me, so I did some TV and worked in various other media.

Turning Point in Matsui's Career

I went back to working freelance before I turned 30. While I was working on an array of small projects, I received an offer from Nippon Television Network to work on a drama (Japanese soap opera). The drama was Kindaichi shonen no jikenbo (a.k.a. "The Files of Young Kindaichi"). It became a smash hit. For several years after Kindaichi, I did a series of dramas that could be categorized as horrors or thrillers. My work just gradually expanded in that genre. What about now? Now, I am involved in about 40 projects on a busy year. This year (the interview took place in May 2006) I've already finished filming about 15 projects. To me, it doesn't matter if the project is a movie or a TV drama. If it comes my way, I'll do it. (Laughs)

[Top Left] There is a creepy Japanese doll hanging in front of the bathroom that Matsui made quite a while back. Matsui thinks it might be moldy inside.
[Bottom Left] Woman with a burnt face (work in progress)
[Center] This was a chicken used in Chakushin ari final (a.k.a. "One Missed Call Final"). There is a scene where a bullied boy witnesses a chicken being bullied. This is the chicken that was picking on the other. Matsui has a predilection for mechanizing his work, so he installed a lever inside of the chicken, which is urethane on the outside. This allowed him to replicate the movements chickens make when clucking. "The beak is actually soft so the actor didn't show pain," comments Matsui. (Smirks)
[Top Right] This shows a dog's corpse that was used in a movie. The eyes and teeth look so realistic that one cannot help but feel sorry for the dog.
[Bottom Right] This was a doll used in Rinne (a.k.a. "Reincarnation"). The face was supposed to shatter, the eyes were supposed to pop out, and then the face would return to normal, so Matsui designed the face fragments so that they were each attached to wires and could be manipulated.

What Is Out of Matsui's Reach
Extremely large-scale props, like a whale or the like.

Various Projects and Impressions

Matsui's Most Enjoyable Project and Most Difficult Project
My most difficult project? Takashi Miike's films are generally difficult. He never takes a break, and this seems to always use special effects makeup somewhere in a scene. I have fairly good stamina, so can go without sleeping. However, Miike's schedules are demanding. I end up having considerable work to do. My personal favorites of the projects I've worked on are Koroshiya 1 (a.k.a. "Ichi the Killer") and Gozu. Both are Miike's films.

On Meeting Miike
Miike was looking for a special effects artist when he was filming Full Metal Gokudo (a.k.a. "Full Metal Yakuza"), where a yakuza (Japanese gangster) becomes a cyborg. He told me he had by chance seen a splatter video I had made and decided he wanted me for his project. The video in question was Hisayasu Sato's Megyaku (a.k.a. "Naked Blood"). Words cannot express how violent it was. The original Japanese title is written with the character "me" for woman" and "gyaku" from the word "gyakutai" meaning "physical abuse." (Smirks) I was 33 at the time. Miike would always call me from then on. I feel fonder of this character than from any of the other characters from the films I've worked on with Miike.

Projects That Appeal to Matsui
have fun working on realistic projects. What I mean is real-looking wounds or burns. I've worked on too many burns, and now I'm starting to hate them. (Grins)

Successes and Failures
These are all contrived, rigged-up effects, right? I'm thinking bulging blood vessels being or severed arteries and the like. To make a blood vessel, you need to fabricate really, really thin artificial skin and then pass a tube underneath, which serves as the

blood vessel. You then pump "blood" through the tube. I used this technique in early remakes and stage reproductions of the Kamen raida (a.k.a. "Masked Rider") series. For the most part I used techniques that were developed in the United States. I loathe flying, so I have yet to visit the States. So instead, I have to get my supplies from Kujirai. (Grins) I don't import my supplies from the States. Now we have CGI to use as our trump card for covering up anything that doesn't look too good. Before, we had to do everything by hand, so the special effects artist's job has gotten a lot easier since the advent of CGI.

Reference Materials
I look to foreign films for reference****magazines too. I used to go to the bookstore religiously to buy Shinefikkusu ("Cinefix"). I also read Make-up Artist Magazine. With respect to Japanese books, I look at police books, medical books on autopsies, and the like. I have absolutely no desire to see an actual corpse in person.

How Matsui Became Involved in Kill Bill and His Impressions of Quentin Tarantino
I have no idea why I was approached for Kill Bill. (Grins) Initially, the art director told me about it. Next, I was asked to attend a meeting at a hotel in Ebisu, where I met Tarantino. He told me that what he wanted to do most was recreate the look of Kozure okami (a.k.a. "Lone Wolf and Cub"). He wanted heads flying off and spraying blood. Up to then, I usually had left that sort of work up to the mechanical effects artist; consequently, I really wasn't well-versed in these sorts of effects. So, I had a mechanical effects artist attend the meeting with me. The effect is really just created using air pressure. However, Tarantino didn't want it to look real. It had to look like water spraying out of a showerhead. He wanted delicate sprays of blood, like you see in a fountain. That was hard. To be honest, I had never seen Kozure okami. (Chuckles) Tarantino is an intense person. He tends to run on at the mouth when he is trying to convey what he wants to do. The United States side of the production had already decided to go with KNB, but Tarantino insisted that a Japanese artist do the scene where a head flies off. The filming took place

in Beijing. Only a mechanical effects artist and I were able to go. A mechanical effect artist was supposed to pull the head, while I was supposed to make the blood come spurting out. I had never done this before. Our first attempt failed. We messed up the timing. The actor's makeup, costume, and the set were soaked in blood, and everything had to be completely redone. Our second attempt was successful. I felt nervous. Virtually everyone else was from somewhere outside of Japan too.

Overseas Films
The only foreign film I made for which I left Japan was Kill Bill. I have participated in assorted Hollywood films shot in Japan, such as Juon. I just recently did a sequel to Juon. I also worked on 11'09"01 September 11, which was a collection of vignettes by various directors. Shohei Imamura contributed a vignette, and I made a rat and a snake for it. There was one scene where the actor Tomorowo Taguchi ate a rat, and the rat's hind legs and tail were supposed to stick out of his mouth. (Laughs) I designed the rat so that Taguchi had to manipulate a lever with his tongue to make the legs and tail move. I have a penchant for incorporating some form of mechanism into my work. It just didn't seem interesting to see Taguchi munch on a rat that didn't move. Imamura never asked me to make the rat move. I just thought it would be more interesting that way. Everyone on the set got fairly excited about it. I like glancing off to the side and seeing Imamura's smiling face in profile.

Other Projects in Which Matsui Participated
For Mayonaka no Yaji-san, Kita-san (a.k.a. "The Midnight Pilgrims"), I did the scene at the beginning where a dead body tied to a door comes sliding out and a scene where a hand stretches. I also made a snake and other small creatures and a host of other detailed props. For the door scene, I insisted on making about three bodies. Today, I could probably have made more using CGI. For Battle Royale, I made wounds, a floating dead body, a gun shot wound to the stomach, and the like. The special effects makeup in Izo was almost entirely CGI. However, I did make a body to tie to a crucifix and stab with a spear. I made a lifecast of the lead actor. A member of my crew

Interview with the Special Effects Makeup

Master of Japanese Horror, Yuuichi Matsui

[Left and Top Center] All of the dummies hanging from Matsui's wall are life-sized and disturbing.

[Bottom Center] Lifecasts of numerous actors are attached to the wall in rows. Lifecasts are treasures to special effects makeup and may be used whenever there is no time to make a mold using the actor's face.

[Right] This shows a head used in Takashi Miike's unaired segment, "Imprint" from the Masters of Horror anthology (a series aired originally in the United States consisting of segments directed by horror masters). A small face was supposed to emerge from the head, so the head was built around twice the size of the actress's so that quality would not be compromised when shooting close-ups of the head. The head is controlled using levers. A total of three wires attach to each finger with one wire at each joint. When manipulated, the head seems alive.

Miyoshi, did the special effects makeup for Dragon Head. He did a scene with a dead body and then another scene where two children are lobotomized. Then for Tokyo Zombie, I made the zombies' victims. I showed the zombies' biting their victims' stomachs, exposing the viscera, and other similar effects. Now (the interview took place in May 2006) I'm making burns and a dead body for Kon Ichikawa's Inugamkei no ichizoku (a.k.a. "The Inugamis").

On Design

For the most part, I work to give form to the director or designer's vision. For example, if I'm asked to make a dead body, I think about how to make the dead body look gruesome or what colors it should have. This is a design process that I carry out every time. I'm not fixated on producing a specific character. It's just that I like people. It isn't that I particularly care for corpses. I just find the human form appealing. I've made lifelike dolls called, "iki-ningyo." I made about a dozen life-sized iki-ningyo for Rinne. I made to an iki-ningyo craftsman and used his dolls as reference. Wind-up dolls appeal to me as well. I recently bought a kit. (Smiles)

Special Effect Make-up Artists and Model Builders That Matsui Admires

Rick Baker and Dick Smith contributed tremendously to Hollywood, and I watch their films every time I start a new project, without fail. I have seen their movies too many times to count, so now I notice things and think, "That piece has a split in it." (Chuckles) I also respect Rob Bottin's work. He seems to have left the business, because I don't hear his name much anymore.

Directors with Whom Matsui Would Like to Work

Let's see. I'd like to work with YoshitaroNomura, who did Yatsu haka-mura (a.k.a. "Village of Eight Gravestones") as well as brought some of Seicho Matsumoto's work to films. It isn't that I liked his work in particular, so much as that we have similar taste. He also uses a considerable amount of special effects makeup in his movies.

Matsui's Private Life

How Matsui Spends His Weekends

I do nothing but spend all day, starting bright and early, with the remote control in one hand watching DVDs. I don't rent DVDs. I buy them. I have over 1000 DVDs in total, and all of them are somehow related to special effects makeup. (Grins) I rarely watch movies at the cinema. I watch DVDs almost exclusively, and I'm alone when I watch them. I'm totally disinterested in the story, so I only spend about 10 minutes watching each. I watch the same scenes over and over again. This time for me is probably the most relaxing part of my week. I also go hunting for movies at used video shops in Nakano. (Smiles)

Magazines and Television Programs Matsui Enjoys

I like to read otaku ("geek") magazines, like Eiga hiho (roughly "Movie Treasures"). I love the campiness. (Grins) I don't like films that are overly vicious, but I really enjoy B movies that you can laugh at and where the filmmakers seem more to be just kidding around. I don't watch TV at all.

Things Matsui Collects

Um, (chuckles) I collect shokugan (plastic toys that are extremely detailed replicas of food). I'll buy anything, indiscriminately. Kaiyodo carries a number of realistic-looking toys. They carry series of tiny figurines of fantastic creatures, fish, and animals. I become obsessed with getting the whole collection, so I will buy armloads and box loads of these toys. I'll even have members of my crew buy them for me. (Grins) I'm not too familiar with anime or the Gundam series, but recently I picked up Shichinin no samurai (a.k.a. "Seven Samurai"). What a great film! It's not in my field. Well, I guess model-building is not so removed from my field, but watching a film outside of the industry makes me feel peaceful.

DVDs Matsui Has Seen So Often, He's Grown Tired of Them

I would have to say I've seen American Werewolf in London one time too many, but only the transformation scene. I don't watch the movie the whole way through. But, when you watch a movie

over and over again, you make new discoveries. This is true for any DVD.

Matsui's Most Valuable Possession

Um, work. (Smiles)

Matsui's Maxims

Never rush. I'm an optimist. I do get nervous, but I don't panic. Having fun is important to me. Sometimes I think it's all right to fail. Being able to continue working makes me happy. Or rather, I see everything in a positive light. That's it, really.

Profile

Yuichi Matsui was born in 1963. He was born in Kamifukuoka City, Saitama Prefecture. After attending a cosmetology academy, Matsui entered the special effects makeup industry at age 19. Matsui has handled the special effects makeup and model building for almost all of Takashi Miike's films after meeting Miike for the first time during the making of Full Metal Gokudo (a.k.a. "Full Metal Yakuza"). Matsui has contributed to countless other films. In addition to the films and horror pieces mentioned in this interview, Matsui has also been involved in Battle Royale, Rinne (a.k.a. "Reincarnation"), Yokai daisenso (a.k.a. "The Great Yokai War"), Koroshiya 1 (a.k.a. "Ichi the Killer"), Yogisha Muroi Shinji (a.k.a. "The Suspect: Muroi Shinji"), Get up!, Pacchigi!, Ping Pong, Zebraman, and others. Matsui currently works on a host of cinematic and video pieces, spanning a wide range of genres.

Special Effects Makeup Glossary

[A]

Al-Cote
Al-Cote is a liquid mold-release agent used to separate mold from a plaster lifecast. Al-Cote is applied to a plaster base or substructure and then dried. Clay is then added on top of the Al-Cote and sculpted. Upon being soaked in water, the Al-Cote dissolves, and the plaster separates from the clay.

Alginate
Alginate is a harmless agent used when initially making a mold of the model's face. Dentists use alginate to make dental molds. Alginate comes in light green, pink, and other shades, and all are used in the same manner. It is sold as a powder. When using alginate, it is transferred to a large container, mixed with water that is approximately skin temperature, and then applied to the face and body. After about 15 minutes have elapsed, the alginate should have solidified to a firm, gelatinous consistency. If the water is too warm, then the alginate will solidify faster, and may finish solidifying before it has been completely spread on the model's skin. Once the alginate has solidified, it cannot be returned to a liquid state. Alginate has no strength, so it must be reinforced with plaster bandages after it is applied as a mold.

Appliance or Prosthetic
Also called "prosthetic appliance," appliances and prosthetics are special effect makeup pieces that attach to the model's face or body. The prosthetic's inside surface is cast from a mold made from a lifecast of the model's face or body part (see p. 70), while the outer surface is cast from a mold made from sculpted clay, so the prosthetic has a close fit. Prosthetics may comprise various materials, including foam latex, silicone, gelatin, etc.

[B]

Bald Cap
A bald cap is a latex cowl laid over the hair to hold it flat against the head and to protect it when a mold is made of the head or when the model is being made up.

Bath Caulk
Bath caulk is used to fill gaps between bathtubs and walls, around sinks, around the kitchen, and in the plumbing. It solidifies without using a curing agent and also comes in a clear form, making it acceptable to use as a substitute for silicone. Mixing bath caulk with oil paint creates a tint that may be used to color silicone. Bath caulk is often made of silicone.

Benzene
Benzene is a colorless, extremely volatile liquid that is a component of crude oil It is typically used to remove stains or color, etc.

[C]

Cabosil
Cabosil comprises silica powder. It is mixed with Pros-Aide and then frequently used to fill in gaps or smooth out seams. When mixed with Pros-Aide, Cabosil may be applied to the skin and then colored to create the illusion of welt or other injuries (see p. 32).

Crystal Resin
Crystal resin is a clear epoxy resin. The resin is mixed with a curing agent and then allowed to air-dry. It may be used to make eyes (see p. 93) and other parts.

Curefast
Tokuso Curefast is the brand name of a hard, dental resin made by mixing a liquid component and a powder component at room temperature. Curefast was used to create the fangs presented on p. 88.

Curing Agent
This is one type of agent used to solidify foam latex. Latex base, the curing agent, and a foaming agent are mixed at a ratio of 10:2:1, respectively. A gelling agent is then added, and the agents are blended together.

[D]

Dry Brush
This is a technique for applying paint, whereby paint is applied to a brush and then the bristles are lightly wiped, leaving the brush partially dry. The paint is then applied by moving the brush in a scrubbing motion. Paint will stick to those parts of the surface that stick out. This technique is often used to produce a scratched effect or to blend or blur colors.

[E]

Epoxy Putty
This is a type of resin that is strong, light, and durable once it has solidified. The epoxy is mixed with a curing agent and then used. Epoxy takes longer to solidify than polyester or urethane. However, it is easy to eliminate air pockets, making it uncomplicated to use. Epoxy putty is also used when making gelatin casts (see p. 101). Epoxy is toxic and requires the use of gloves.

[F]

Fiberglass Mat
Fiberglass is the reinforcing material used in FRP (fibre-reinforced plastic) and is its core component. Fiberglass mat comprises exceedingly fine glass fibers woven into a mat. Fiberglass can be harmful to the lungs, so a dust mask and gloves must be worn when working with it.

Foaming Agent
Foaming agents are used to produce a foaming effect when mixing foam latex. See "curing agent."

Foam Latex
Latex is used to produce soft, spongy prosthetics. It is easy to color, cushiony, and flexible, so it fits perfectly against the model's face and body and allows the model to move comfortably. It has a matte finish, so it is more frequently used to create the illusion of flesh than to create teeth or eyes. Latex base, a curing agent, and a foaming agent are mixed at a ratio of 10:2:1, respectively. A gelling agent is then added, and the agents are blended together. The mixed latex is then poured into a mold that has been coated with a release agent, and then it is fired (see p. 77).

Foam Release
This is a foam latex release agent.

[G]

Gelatin (For Special Effects Makeup)
This is a clear agent for use with prosthetics. Its texture is close to that of human skin and it may be tinted, making it perfect for use with zombie makeup (see p. 100) or aging effect makeup. However, it does break down in water, so be prudent when determining its use. To make gelatin, combine glycerin, technical gelatin, and sorbit at a ratio of 2:1:2 and mix thoroughly in a bowl. Allow the mixture to set in the bowl for one day and then heat it in a microwave oven. This should yield a clear gelatin. Stir in grease paint to tint the gelatin.

Gelling Agent
A gelling agent is used when curing foam latex. See "curing agent."

Glue Gun
A glue gun is a tool used to melt sticks of glue, which then are able to act as an adhesive once they harden.

Grease Paint
Grease paint is used as a foundation cosmetic in special effects makeup. It may also be used as a liner. Coming in a cream form and made of an oily base, grease paint neither cakes nor comes off easily, making it suited to use in theatrical, cinematic, and video productions, where actors tend to produce considerable perspiration. Grease paint comes in dozens of pigments, ranging from white to red, black, and flesh tones, which may be blended to create new tones. After applying grease paint, add talcum powder and blow dry to eliminate stickiness. To remove grease paint, apply cold cream, cleansing oil, or cleansing lotion to a cotton ball and then use the cotton ball to massage the skin. In Japan, grease paint is also called, "Dohran."

[H]

Heat Gun
Heat guns are technical blow dryers that emit extreme temperatures between 200°C and 600°C (approx. 392°F to 1112°F). Heat guns have a variety of applications, including drying, melting, gluing, and shrinking.

[K]

Keloskin
Keloskin is a product of Mitsuyoshi Costmetic Co., Ltd. and is a transparent liquid used in special effects makeup that resembles clear nail polish. Keloskin is used to create the illusion of scratches or burn scars. Dry Keloskin with a blow dryer after applying it. Mix

Keloskin with grease paint or lining color to tint it. Do not use Keloskin around the eyes.

Key

When making a prosthetic that covers the entire head, the front portion and the back portion are cast from separate molds and put together at the very end. When the front and back are put together, a ball-and-socket style joint is constructed from clay with one half of the mold having the "ball" part and the other half having the "socket" part. This ensures the front and back of the prosthetic align perfectly. The ball part of the joint is called a "key" (see p. 76).

[L]

Latex

Latex, used exceedingly frequently in special effects makeup, is a spreadable rubber-like substance that contains natural rubber as a component. It is often used to make prosthetics. It continues to be soft, even after it has dried. To make a bald cap, a sponge is dipped in latex, patted onto a lifecast of the model, and then dried. This process is repeated about eight times. Bald caps are worn over the hair and underneath head prosthetics and other headpieces. Latex may be purchased at an art supplies or craft supplies shop. Prices vary greatly.

[M]

Mold

Mold refers to a form cast directly from the model's face and cast from sculpted clay.

[P]

PAX Paint

PAX paint is a mixture of Pros-Aide and acrylic paint that is used as a foundation when making up a model's face or a prosthetic.

Permek

Permek is a curing agent for polyester resin. It is a clear, oily liquid that has a unique odor. Permek is harmful to the eyes and is flammable, so use it with extra caution.

Plaster Bandages

In medicine, plaster (gauze) bandages are used to make rigid casts, once the bandages harden, for dressing bone fractures and the like. In special effects makeup, plaster bandages are used to reinforce alginate.

Plus Art

Plus Art is a clear wax putty that is available through Mitsuyoshi and other vendors. It is soft and can be sculpted with a spatula or similar tool.

Polyester Resin

Polyester resin is a thermosetting plastic often composing the polymer in FRP. It is used in prosthetic pieces that must be light and sturdy, such as those worn on the head or that are put on and taken off repeatedly. It is also used to make molds from sculpted materials. A curing agent is added to solidify polyester resin; however, when it solidifies, it becomes hot and smells, so when using it with plastic, extra caution must be taken with the resin's changing states. It is able to melt Styrofoam at room temperatures and is harmful to skin, so it should always be transferred to a paper cup or other container and then applied with a house paintbrush or hake-style brush.

Positive Mold, Negative Mold

"Negative molds" are cast from sculpted clay forms, while a plastic lifecast of the model's face is called a "positive mold." The material to compose the prosthetic is poured into the negative mold, and the positive mold is pressed own into the liquid. The resulting prosthetic's interior (the positive mold) matches the model's face, while the exterior reflects the target (sculpted) design.

Pros-Aide

Pros-Aide was originally a medical (surgical) adhesive that is used to attach prosthetics (of foam latex) to the model's skin. Pros-Aide comes as a liquid and a cream. It is milky in color in its liquid form but becomes transparent and colorless upon drying. It is waterproof and sweat-proof, and will keep holding the prosthetic in place, even when pulled. In addition to functioning as a glue, Pros-Aide is also used to fill in gaps between skin and the prosthetic; is mixed with Cabosil and applied to the skin to create the illusion of raised welts (see p. 32); is used to make body carvings (see p. 166); and is used for a host of other purposes. Pros-Aide should be dried with a blow dryer after application. To take-off Pros-Aide, apply cleansing oil or cream to a cotton ball and then massage the skin with the cotton ball, removing the Pros-Aide.

Pros-Aide/Cabosil

This is a paste comprising a mixture of Pros-Aide and Cabosil.

[R]

Resin Cast

Resin cast is nonporous urethane, made by combining two-part resin casting agents at a ratio of 1:1 and allowed to solidify. Resin cast is used to create stiff parts, such as the bolt presented on p. 36. Resin cast should be used with silicone molds rather than plaster molds.

Roma Plastilina

Roma Plastilina is a brand of clay. It is soft, making it suited to creating monsters. It comes in a range of consistencies.

[S]

Sheeting

Sheeting is wide muslin. It is used as liner, is inexpensive, and typically comes in white.

Silicone

Silicone comes as two liquids, silicone rubber and a curing agent, that are mixed together until they solidify into the consistency of rubber, which is used in mold-making. Two-part silicone consists of thoroughly mixing together 1 kilogram (approx. 2.2 lbs.) of silicone rubber (KE-12) with 1 to 3 grams (approx. .03 to .1 oz.) of silicone curing agent (catalyst).

Silicone Caulk

This is caulk used to fill gaps in corners and edges around the bathroom and kitchen. Applying a thin layer of silicone caulk to silicone adhesive or plaster allows for the creation of small prosthetic pieces.

Spandex

Spandex is a polyurethane, woven, stretchy fabric.

Spatula

Also called a "putty knife," a spatula is a small, flat, metal tool used to separate out foundation and lipstick. In special effects makeup, the spatula is also used to apply Pros-Aide/Cabosil.

Super Sculpey Clay

Super Sculpey is a low-fired clay. After sculpting with Super Sculpey, bake it to make it harden. It is not sticky and may be kneaded.

[T]

Tamiya Color Acrylic Paint

Tamiya Color Acrylic Paint is intended for use with toy plastic models. Tamiya Color Acrylic Paint comes in glossy lacquer (which dries quickly and has the smell of paint-thinner), regular acrylic (which is flexible and resilient but is water-soluble and requires a specialized solvent when it is to be thinned), and glossy enamel (which dries slowly and has a beautiful glossy finish, but is not very resilient) finishes. Paints with a glossy, lacquer finish cannot be used over the other two.

[U]

Undercut

Undercuts are parts of the body onto which molds catch when they are removed. When an overhead light is cast on the model, the undercuts are those parts where shadows form. Example, when a mold is made of the model's face, including the neck, the mold tends to catch on the depression (where a shadow forms) underneath the chin. In such a case, the undercut may be filled in with wet clay (in a process known as "filling in the undercut") before making the mold. A mold of the neck should be made separately.

[V]

Vaseline

This is a brand of transparent petroleum jelly. It serves a protective function when it is applied to the eyelashes and eyebrows and other areas to which alginate tends to stick if a mold is being made of a model's face. It is also used as a release agent with plaster molds.

This is the shop that professional special effect makeup artists favor.

Mitsuyoshi Cosmetic Co., Ltd.

Mitsuyoshi produces professional cosmetics used in a wide variety of fields,

including the theater, cinema, and television.

Official website: http://www.mitsuyoshi-make.com/

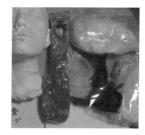

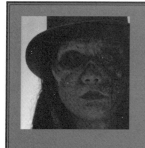

Degu Zombie, owner of the famous Trick or Treat pub located in Roppongi, appears in this book as the male model for the zombie pictured in the opening gallery (pp. 11 and 12). Bedecked in the mode of a Gothic horror fantasy, Trick or Treat is the pub where the nighthawks flock. Macabre decorations and crosses cover the interior, creating a sinister atmosphere. The pub's menu is full of delicious dishes, such as pasta and pizza, handmade by Degu Zombie, himself. Mari, who appears in this book's opening gallery as the female model of the Lolita zombie in a maid uniform is actually a member of the Trick or Treat staff. Visit to check it out!

 Trick or Treat

Address: Toda Bldg., Fl. 2, 7-16-5 Roppongi, Minato-ku, Tokyo

Phone: 03-3403-5115

Hours: Monday through Thursday from 6:30 pm to 2:00 am

Friday and Saturday from 6:30 pm to 5:00 am (The owner reserves the right to extend the hours at his discretion.)

Closed: Sundays and holidays

Official website: http://www5f.biglobe.ne.jp/~trick_or_treat/

Conceptual Special Effects Makeup Workshop

Artists' Profiles

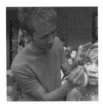

Akihito

Akihito was born in 1972 in Fukuoka Prefecture. Between January 1998 and October 2000, he won TV Champion's "Special Effects Makeup King" competition three times in a row ("Special Effects Makeup King" competition numbers II, III, and IV). He won the Avant-Garde Make-up competition at the International Make-up Artist Trade Show held in the United States in 1998. In 2002, Akihito moved to the United States. He participated in the Japanese film Another Heaven, as well as various television projects, including Gakko no kaidan (a.k.a. "School for Ghosts"), Another Heaven: Eclipse; "Nagai yume" (roughly, "The Long Dream"), "Oshi-kiri" (the title refers to both a cutting tool and a sumo move) and "Hakaba no machi" ("The Graveyard Village") from Ito Junji kyofu korekushon (roughly "Junji Ito's Horror Collection"); Ultraman Cosmos, (as the head monster designer), etc. He has worked as a theatrical designer and has participated in countless other projects, including television commercials. Involved in the sculpture production of assorted Hollywood movie creatures, Akihito is presently a member of the KNB EFX Group, Inc., where he is engaged as a sculptor as well as a key artist. Since living in the United States, he has participated as a special effects makeup artist and a special effects artist in Hulk (as the starfish sculptor), Alien vs. Predator (designer and sculptor of the queen alien), The Chronicles of Narnia: The Lion, the Witch and the Wardrobe, Land of the Dead, House of Wax, The Island, and many feature films.

Tomonobu Iwakura

Tomonobu Iwakura was born in 1985 in Kagawa Prefecture. He graduated from the special affects makeup program at Tokyo Visual Arts in 2005. Since his childhood, Iwakura enjoyed carving and working with wood, and created a collection of artwork. His yearning to create gradually expanded, and his projects grew to encompass silver jewelry and special effects makeup. He eventually began to show his work at exhibits. Iwakura won the Konica Minolta Award at Kawasaki Halloween in 2003 and won the Kawasaki Halloween grand prize in 2004. He won second place at Velfarre in 2004 and second place at Kawasaki Halloween in 2005. His cinematic projects include Yokai daisenso (a.k.a. "The Great Yokai War"), where he participated as an assistant model builder. He is enthusiastic about continuing to produce his own pieces.

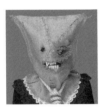

Keizo

Keizo was born in 1975 in Yamaguchi Prefecture. He developed an interest in special effects makeup at the age of ten, when he saw Dick Smith's work in a special feature covering the making of the horror film, Sweet Home. Keizo graduated from a hairstylist academy, still hoping to someday work as a special effects makeup artist. He later learned the art of cosmetology by observing others at work, and became employed in the cosmetology department of a cosmetics company. Then in the summer of 2005, he made his way to Tokyo. While working as a freelance hairstylist, he began to work in the field of special effects makeup and model building. His current goals are to hold a show that merges special effects makeup with hairstyling. Keizo has participated in the film Dororo as well as other projects. His close friend Kaori Ebe appears as a model throughout this volume (pp. 20 to 23, pp. 26 to 28, pp. 34 to 35, and p. 38).

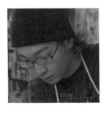

Yuya Takahashi

Yuya Takahashi was born in 1981 in Hokkaido. In 2002 after graduating from the academy, Tokyo Visual Arts, he began working on a part-time basis at Make-up Dimensions, Inc. He has participated in television, cinematic, theatrical, and commercial projects, as well as media. The movies he has worked on include Warau lemon (a.k.a. "Eternal Love"), Quill, Rinjin 13-go (a.k.a. "Neighbor No. 13"), Zoo, Yokai daisenso (a.k.a. "The Great Yokai War"; engaged in the mask production for extras), Spector, Kogitsune Helen (a.k.a. "Helen, the Baby Fox"; engaged as the model builder for mechanical objects), Mizuchi (a.k.a. "Death Water"), Dororo, Freesia, and others. He has worked on the television programs Ichiban kurai no wa yoake mae (roughly, "It's Darkest before Dawn") and Ultraman Max. His commercial projects include Cinq-Art Co., Ltd.'s Humbert ad (as a model-builder). He contributes to the special effects makeup appearing in the magazine Gothic & Lolita Bible.

Akiteru Nakada

Akiteru Nakada was born in 1974 in Saitama Prefecture. He studied under prominent special effects makeup artists, Dick Smith and Kazuhiro Tsuji. After working as an assistant, Nakada embarked on his own in 1994 and is now the representative of M.E.U. (Make-up and Effects Unlimited). He has worked on a number of films, including Sennen no koi-Hikaru Genji monogatari (roughly, "A Thousand Years of Love: The Tale of Genji"), Cha no aji (aka "A Taste of Tea"), Swing Girls, Runin, Devil Man, Yaji x Kita: Mayonaka no Yaji-san, Kita-san (a.k.a. "The Midnight Pilgrims"), Yogen (a.k.a. "Premonition"), Mushishi, LOVE DEATH, Kisarazu Cat's Eye: World Series, Tokyo Tower o.b.t.o, and many more. Nakada has participated in numerous television projects, which include Shiritsu tantei Hama Maiku: Bitaazu endo (roughly, "P.I. Mike Hama: The Bitter End"), Garo, Yo ni mo kimyo na monogatari: Eijizumu (a.k.a. "Tales of the Unusual: Ageism"), Furin kazan, and many others. His television commercial efforts include Aiful Corporation's "Haircut" commercial, "Suntan" commercial, and "Bodybuilding" commercial, Ezaki Glico Co., Ltd's Glico Pretz "Open Your Mouth and Say 'Ah'" commercial, Ezaki Glico Co., Ltd.'s Glico Pocky "Marriage Arrangement" commercial and "Horror Movie" commercial, and more. He has also worked on the stage productions, such as the theatrical group Shinkansen's "Dokurojo no shichinin" (a.k.a. "Seven Souls in the Skull Castle"), etc.

Manabu Namikawa

Manabu Namikawa was born in 1981 in Kyoto. He is a chief staff member at Hyakutake Studio, K.K. Namikawa studied special effects makeup through Yoyogi Animation Gakuin's SFX Makeup Course. He cites the works of H.R. Giger, Gerard Di-Maccio, Joel-Peter Witkin, Salvador Dalí, René Magritte, and René Lalique as artistic influences. Cinematic pieces that have influenced him are Alien and Hellraiser. He has also found inspiration in paintings, sculptures, photographs, accessories, and other works of art by artists who he admires. Namikawa has participated in the films Casshern, Yokai daisenso (a.k.a. "The Great Yokai War"), Dororo, etc. He has also worked on the television program Sarujie as well as others.

Tomo (Hyakutake)

Tomo was born in 1972 in Iwate Prefecture. He studied special effects makeup at the Nikkatsu Visual Arts Academy. Tomo is the owner of Hyakutake Studio, KK. He has participated in Casshern, Yokai daisenso (a.k.a. "The Great Yokai War"), Ashura-jo no hitomi (a.k.a. "Ashura"; poster artwork), Dororo, and numerous other films. His television projects include Mokuyo no kaidan (roughly, "Thursdays' Ghost Stories"), Yo ni mo kimyo na monogatari (a.k.a. "Tales of the Unusual"), SMAP x 2, Waratte ii to mo (roughly, "Go Ahead and Laugh"), Sarujie, and others. He has also worked on promotional videos for artists such as Eikichi Yazawa, Mitsuhiro Oikawa, Thee Michelle Gun Elephant, Guitar Wolf, Ego-Wrappin', Gackt, Kishidan, Supercar, and others. His design projects include Casshern (the suits); Yokai daisenso; Dororo; Ashura-jo no hitomi (the concept sketch); 13 Doors, the haunted house attraction at the amusement park, Korakuen, and numerous other projects. Tomo is responsible for the current series "Monster Channel," featured in the magazine Gothic & Lolita Bible.